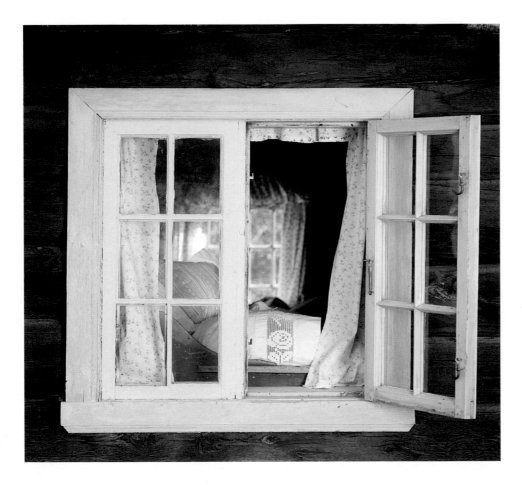

Perfect
COUNTRY
ROOMS

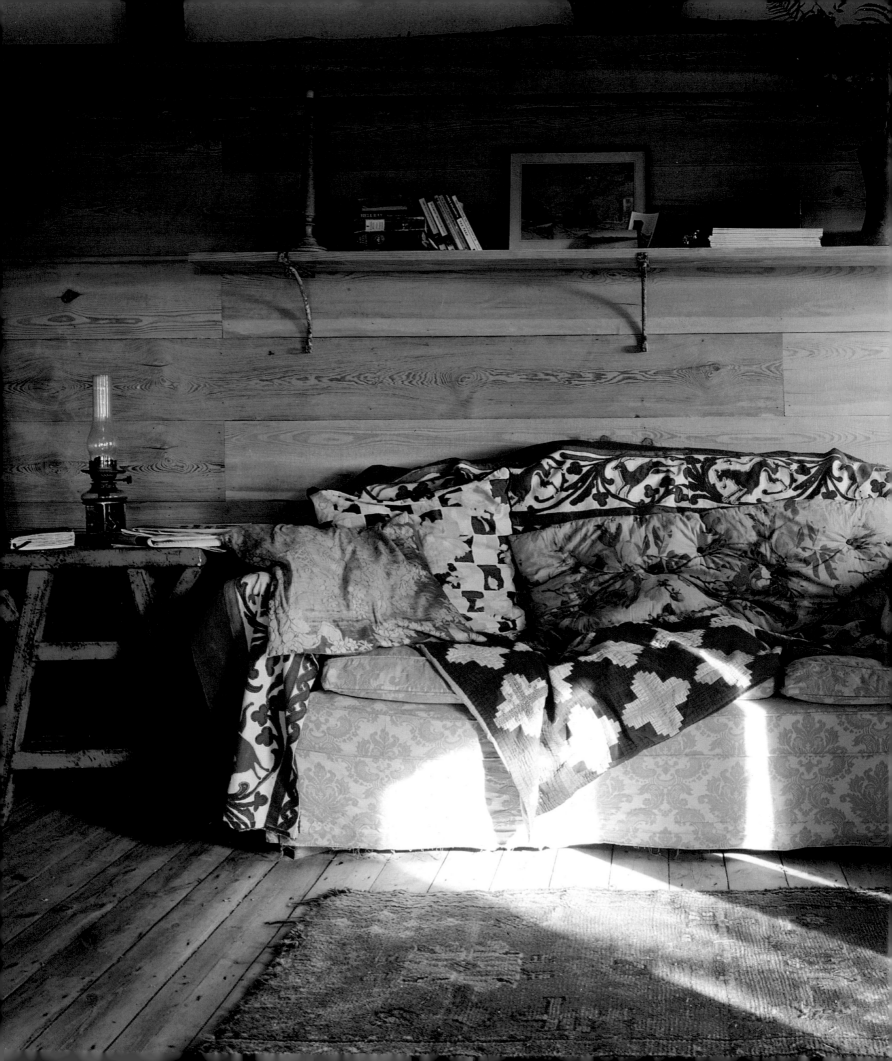

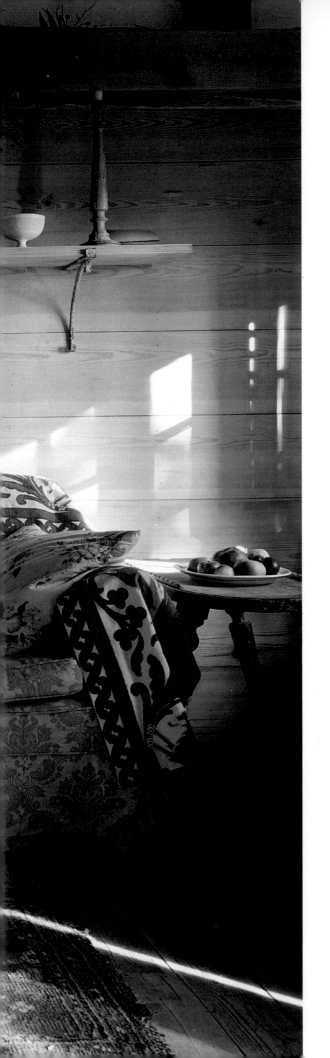

Perfect
COUNTRY
ROOMS

EMMA-LOUISE O'REILLY

ABBEVILLE PRESS PUBLISHERS
New York London Paris

First published in the United States of
America in 1996 by
Abbeville Press
488 Madison Avenue
New York, N.Y. 10022

First published in Great Britain in 1996 by
Conran Octopus Limited
37 Shelton Street
London WC2H 9HN

Commissioning Editor: Suzannah Gough
Senior Editor: Jenna Jarman
Editorial Assistant: Helen Woodhall
Copy Editor: Sarah Sears
Art Editor: Karen Bowen
Picture Researcher: Julia Pashley
Production Controller: Mano Mylvaganam
Indexer: Indexing Specialists

First edition
10 9 8 7 6 5 4 3 2 1

ISBN: 0-7892-0121-6

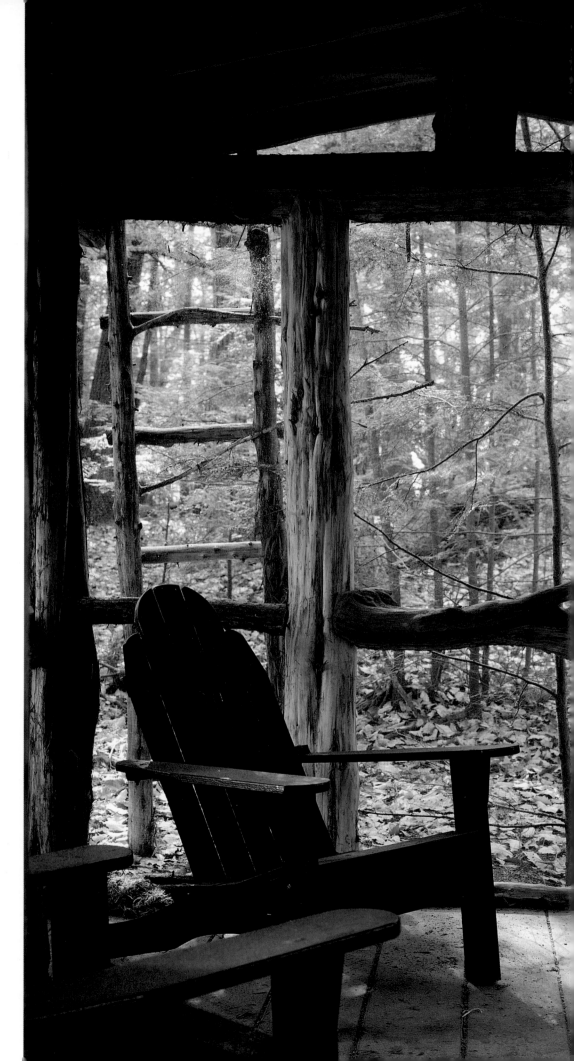

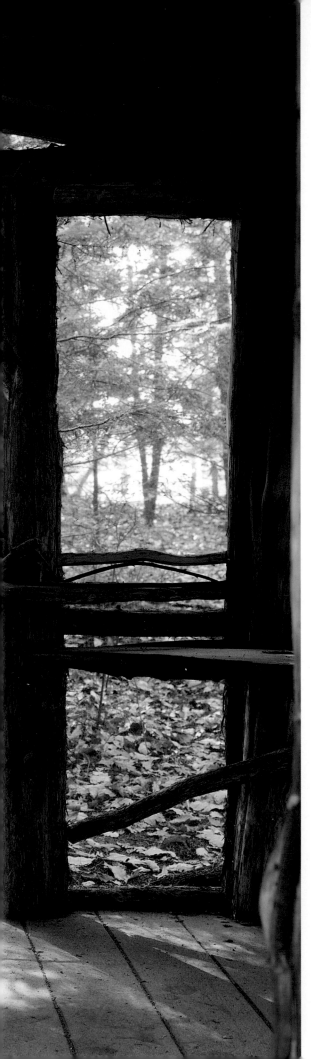

CONTENTS

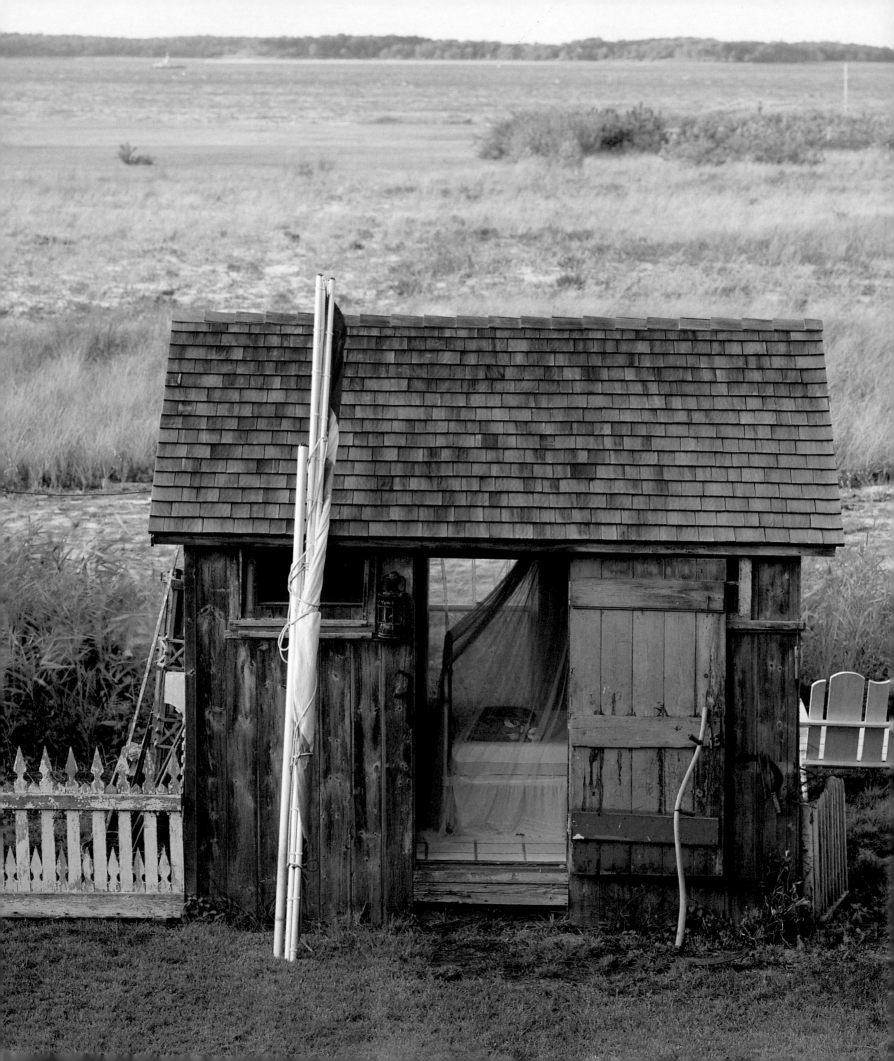

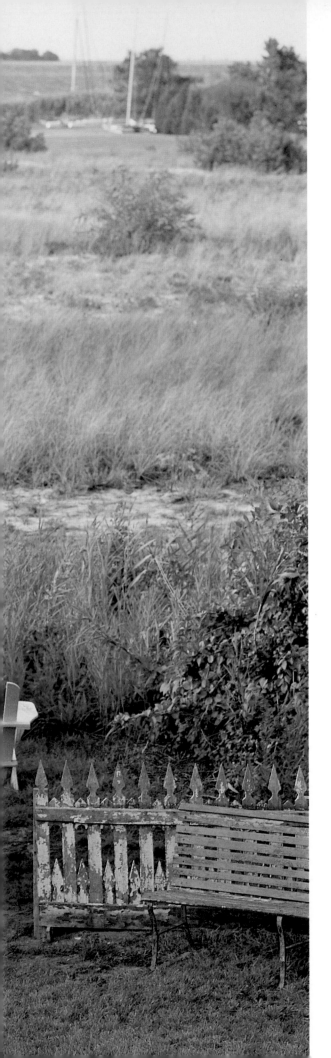

*I*NTRODUCTION

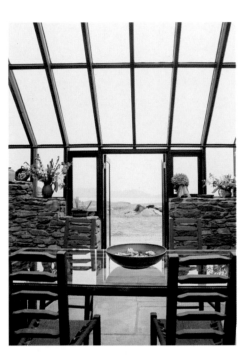

*W*E ALL THINK WE KNOW WHAT THE PERFECT COUNTRY ROOM SHOULD BE LIKE. A SERIES

OF GENTLE IMAGES DANCES BEFORE OUR EYES IN DAYDREAMING MOMENTS. THERE IS MORE

URGENCY TODAY IN THE LONGING FOR THE REALIZATION OF THIS IDYLL BECAUSE OF THE

RAPIDITY WITH WHICH UNSPOILED COUNTRYSIDE IS BEING EATEN UP BY UNSYMPATHETIC

DEVELOPMENT. SO WE DREAM OF THE PERFECT RETREAT, FAR FROM THE BANALITIES OF

MODERN CARES AND ANXIETIES, WHERE WE CAN ATTEMPT TO LIVE A MORE PEACEFUL LIFE.

LEFT AND ABOVE
*A bed in a hut in a landscape—the perfect
country room connects with its setting in new
and imaginative ways. Individuality and a
lightness of touch are its hallmarks.*

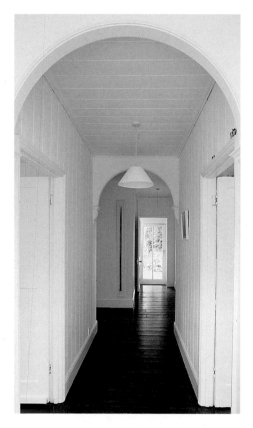

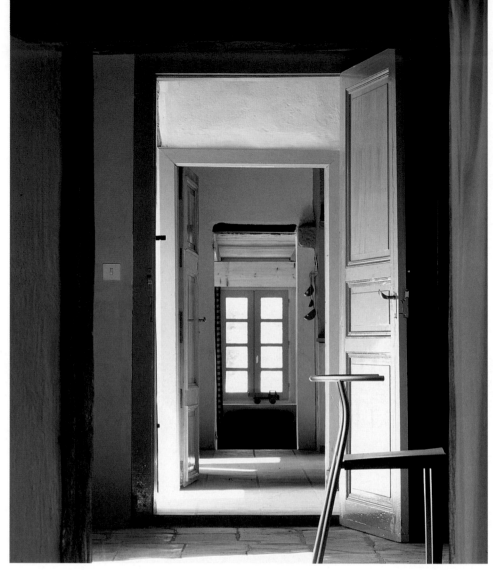

ABOVE *Stripped of ornament and empty of furniture, the architecture and space of a hallway take on new interest, and the simple designs of ordinary details like moldings, door hinges, and handles are revealed.*

ABOVE RIGHT *In imitation of a stately enfilade with its glimpses of gilded furniture and pictures, this sequence of rooms has a more light-hearted character with its hot, bright colors and modern furniture.*

FAR RIGHT *The matte finish of new paintwork is juxtaposed with the battered surfaces of an old sideboard. Rich yellow and grey-brown walls provide an unusual and sympathetic backdrop for its simple, generous design.*

*T*here is no shortage of ideas on how to create the perfect country retreat; it is a rich seam of design, philosophy, and tradition that has been mined in every generation to produce a new interpretation. From the Roman villas on the Bay of Naples to the converted farmhouses of New England and the woodland cabins of today's romantic spirits, country interiors have tried to combine an atmosphere of informality with differing measures of comfort and the joys of life in the country.

In our own century the Arts and Crafts Movement represented a purposeful revisiting of rural building traditions, at the same time that cottages were being bought up by the middle classes and an appropriate country look was being sought to furnish them. Since then, these two directions have been strong themes in the history of country interiors. Although it is easy to laugh at the quaintness of supposedly appropriate rustic interiors of the 1920s, the subjectiveness of taste and the speed with which it changes makes this inevitable. In the 1950s and 1960s, a specifically English country house look evolved—influencing taste on both sides of the Atlantic—in which well-behaved arrangements of good furniture and pictures looked quietly elegant in a sort of "Georgian" interior. The discipline of this look gradually relaxed its grip as more and more people began to grow confident about expressing their personalities in their interior decoration.

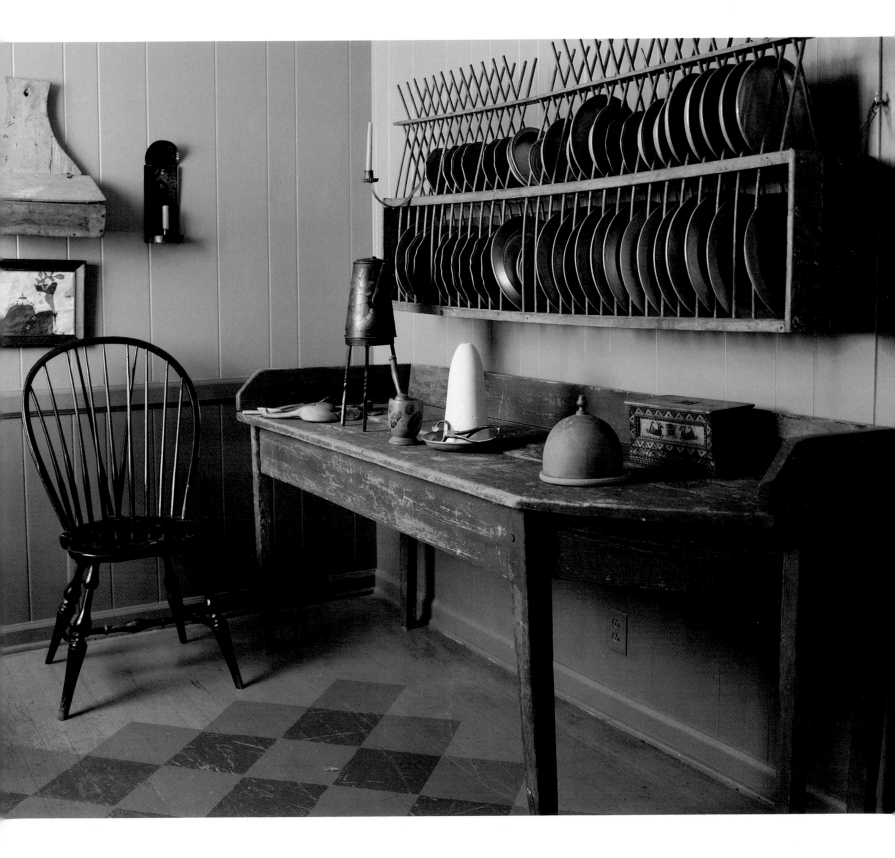

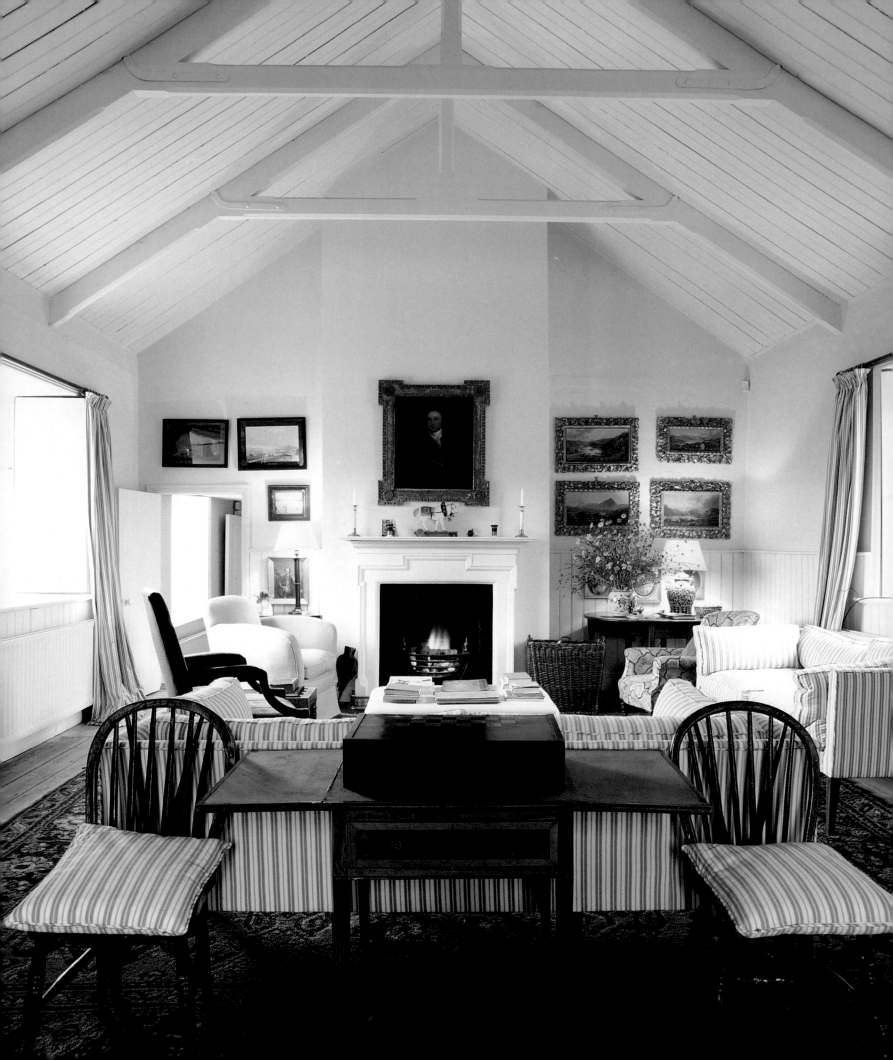

"With the sure touch of a stage manager, associations and evocations of different styles and atmospheres are deftly made, while a discerning eye enjoys the good honest design of simple things alongside more refined antiques."

LEFT *In a converted Irish schoolhouse, a living room draws on grand, country house drawing room layouts to furnish a lofty space. The proportions make this solution plausible and the simple architecture and humbler detailing loosen the formality traditional in such rooms. The elegant pictures on the fireplace wall are convincingly aristocratic but if the eye travels up into the roof space it is apparent that no effort has been made to continue the theme. The easy way two ordinary kitchen chairs fit into the scheme illustrates that this lightness of touch is evident throughout the room.*

RIGHT *Unfussy cottage furnishings sit quietly in a determinedly simple room. The only unexpected drama comes with the generous draping of a high-backed settle.*

*A*s a result of wider travel and greater access to all sorts of inspirational sources, there has been a tremendous appetite for country things in the last twenty years and in response country interiors have been decorated and redecorated a hundred times, with endless textile ranges being dedicated to the "country look," kitchen designs conceived around it, and furniture built for it. More recently, it seemed that the country cottage was in danger of disappearing in clouds of flowery fabrics and hedges of dried herbs. Between the clichés of traditional country interiors and the new country products being marketed, the vision of a simpler life seemed to have become blurred. The country cottage had become like the aged actress who wears so much rouge that it is impossible to make out the dear old features.

So things have begun to swing back the other way, and along the route new ideas have been incorporated in sparer country interiors. Most importantly, it is now the architecture of the house or converted barn or water tower that sets the pace, and its history, its setting, and its individuality are much more often the cue for the decoration of the interior than this or that "look." The dignity of the architecture is paramount however humble the building and whatever new building work is carried out. The personality of the owner expressed in the evidence of particular hobbies or interests and in collections of books or pictures is then threaded through the house to create a new and individual synthesis of ideas in the interior.

*T*he new spareness is about restraint rather than minimalism, but as much as anything else it has a lightness of touch and a sense of humor. The weight of too many possessions, the clutter of china in a dresser, the padded-cell atmosphere of the overly upholstered country bedroom is gone and instead a less acquisitive attitude prevails. A more discerning eye arranges two or three pots on a shelf rather than twenty and enjoys, alongside antiques, the good honest design of all sorts of more recently made simple utensils that, in a light-hearted imitation of conventional display, are laid out for appreciation on the mantelpiece.

In playing with conventional notions of the country interior every twist and turn in its twentieth-century history is revisited. Associations and evocations of different looks and atmospheres are made deftly, with the sure touch of a stage manager. Sometimes the traditional arrangement of a room will be respected but the furniture will have been made for other rooms or other countries. Color schemes will be picked up by the oddest assortment of elements in a room rather than using a carefully coordinated matched-lampshade-and-curtain approach, and illusions of depth and flatness are created by painting furniture the same color as the walls. Objects themselves are juxtaposed to almost surreal effect, with polished surfaces next to rough-hewn masonry walls, humble things mixing happily with grander neighbors, and furniture with surfaces both hard and soft.

Above all there is space in the new country interior, space to appreciate the wide floorboards of an old house or the soaring loftiness of the roof space in a new barn-house. The quirky tastes of the owner are advertised splendidly when an object or a piece of furniture is allowed to blossom in isolation rather than being overlooked in a jumbled arrangement of too many bits and pieces. Scruffy worn objects set against brand new paintwork accentuate their patina and celebrate their long and useful life.

The most versatile interiors are those converted from rural industrial or farm buildings. Unhampered by the small scale of cottage architecture, the bolder owner can create a gently whimsical or grandly theatrical interior. A grand country house drawing room is evoked in the spaciousness of a converted schoolhouse—if you raise your eyes above the picture lights you see the roof timbers, but at ground level the proportions are those of an eighteenth-century gentleman's residence. In an old garage a bedroom the size of an opera set might be splashed with acid colors in a quite different vision of a perfect country room.

At the extremes of the new country look are the most romantic and simplest of rooms, those where modern conveniences have been removed in order to enjoy the essential comforts of life with no distractions. Ever more imaginative homes are set up in woodland cabins and seaside huts, or in the modern version of a hermitage—a tree house far from the madding crowd. Natural materials are used and these spare interiors are peppered with little luxuries because the search for simplicity does not deny the need for small concessions to comfort.

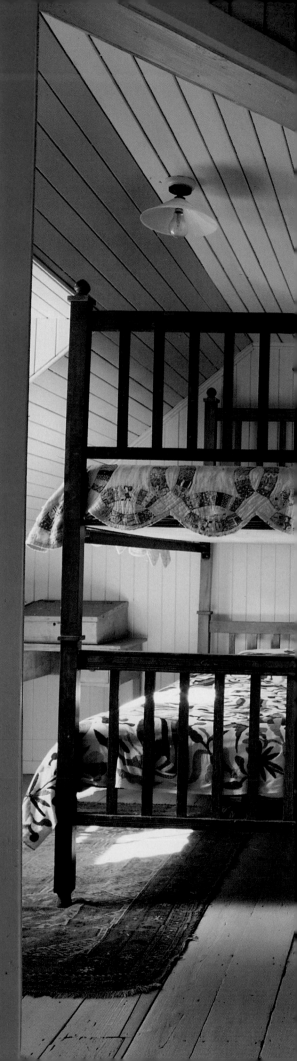

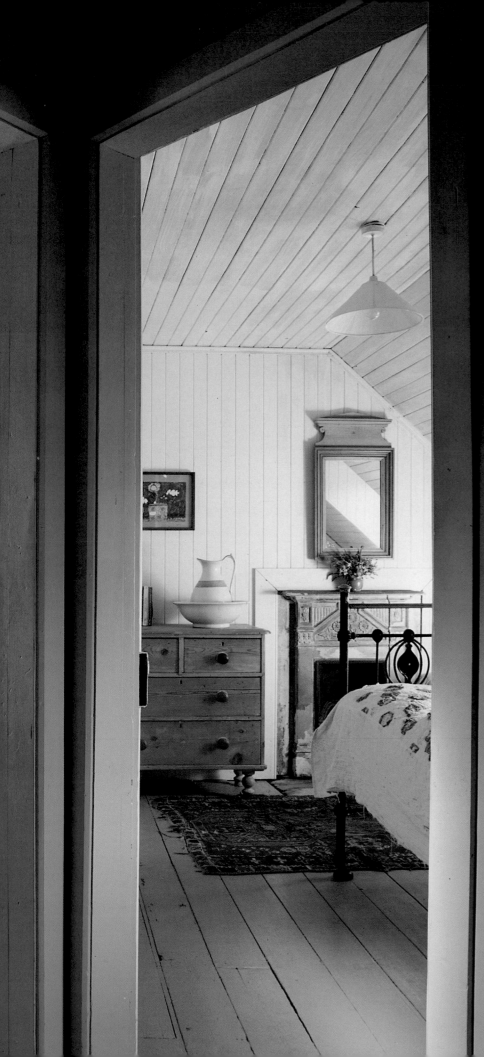

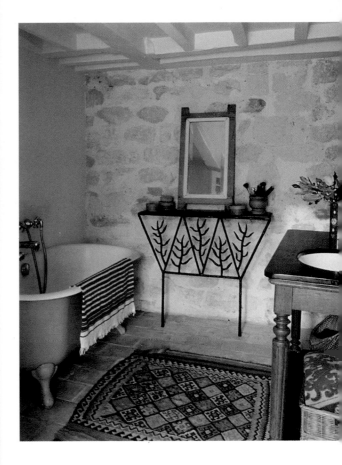

LEFT *A view into two airy bedrooms whose simple, comfortable interiors are schematically colored in a decisive but subtle way. Within this defining frame the individual character of quilts, rugs, and pictures shines out, celebrating both special and ordinary things in a unified approach.*

ABOVE *Although in reality this bathroom is quite sophisticated, a rugged stone wall gives it a country feel. Architecture has been brought into the decorative scheme but only for scenic purposes. Modern fittings, meanwhile, deliver comfort in a pared down, rather than naturally simple, way.*

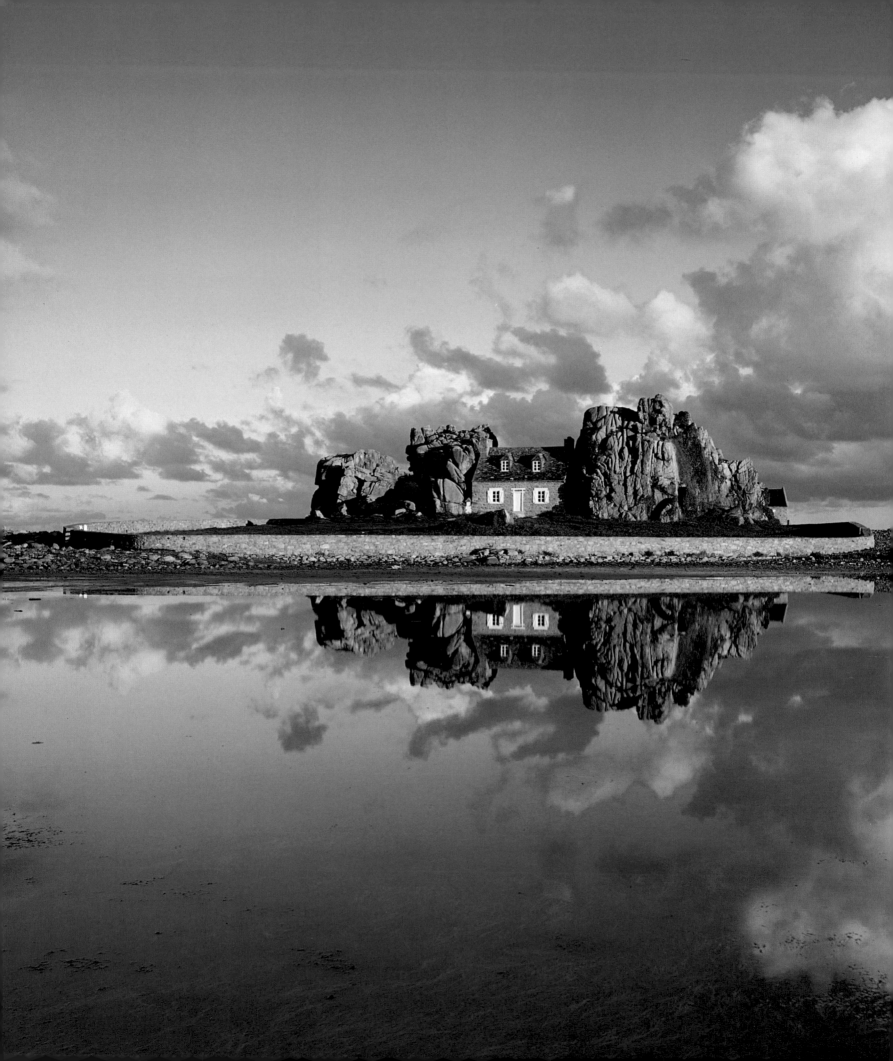

Perfect
SETTINGS

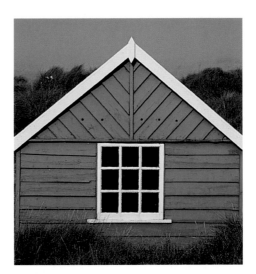

TO FIND A LITTLE CORNER OF UNSPOILT COUNTRYSIDE WHERE THE AIR IS GOOD, THE

EARTH IS FERTILE, AND THE VIEWS UNBROKEN, IS TO FIND A LITTLE PIECE OF HEAVEN ON

EARTH. THE PERFECT SETTING FOR A HOME IN THE COUNTRY IS ALMOST ALWAYS, IT SEEMS,

OFF THE BEATEN PATH, WHETHER IT IS UP A MOUNTAIN OR DOWN A SECRET VALLEY, BY A

FLAT MIRROR OF A LAKE OR ON A LONELY HEADLAND SURROUNDED ON THREE SIDES BY THE

SEA, WITH THE WAVES CRASHING ON THE SHORE.

LEFT AND ABOVE

*Wedged between rocks, with the biggest
views of sky and sea, this cottage promises
refuge in a dramatic setting. The gable
decoration above mimics a dinghy's hull.*

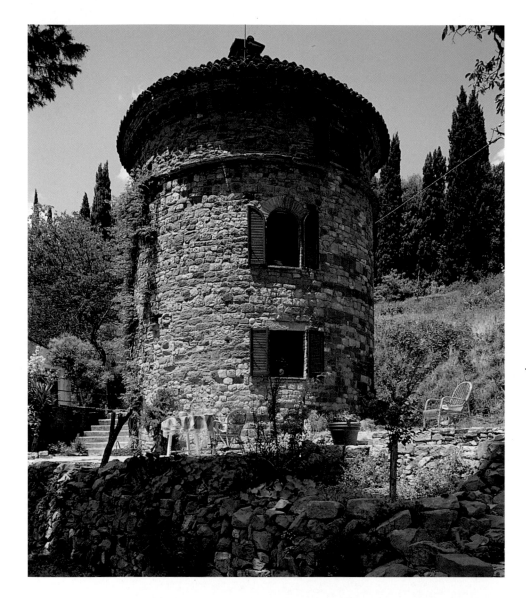

LEFT *A tower for a modern-day Rapunzel on an Italian hillside; its rugged construction looks as if it has been thrown up by its stony landscape. Roof tiles and cypresses dent the summer sky; shutters are thrown open to air the cool, dark interior.*

BELOW *In the heat of the afternoon the only shade is cast by the whirling shape of a bell frame on this brilliant white wall.*

BOTTOM *The warm colors of terra-cotta air bricks are combined in a framed design of diamonds and squares.*

RIGHT *Golden broom shimmers around the ankles of a sturdy Umbrian farmhouse. Its jumble of roof pitches makes no concessions to symmetry or prettiness.*

A garden can be created and a house can be turned upside down but the setting is made by nature, and though man might have the temerity to intervene here and there, the matter is really out of his hands. An element of happy chance rather than design makes a house in a perfect setting all the more precious.

The relationship between the house and this precious setting is an intimate one: the house is not an independent box of treasures but is tied to its landscape by the materials with which it is built. The local stone, locally made bricks, timber, roof tiles, shingles, or slates of its construction give it a sense of place. Blending in color and texture with its setting, it takes up its position on the spur of a hill or a bend in the river as if it had always been there.

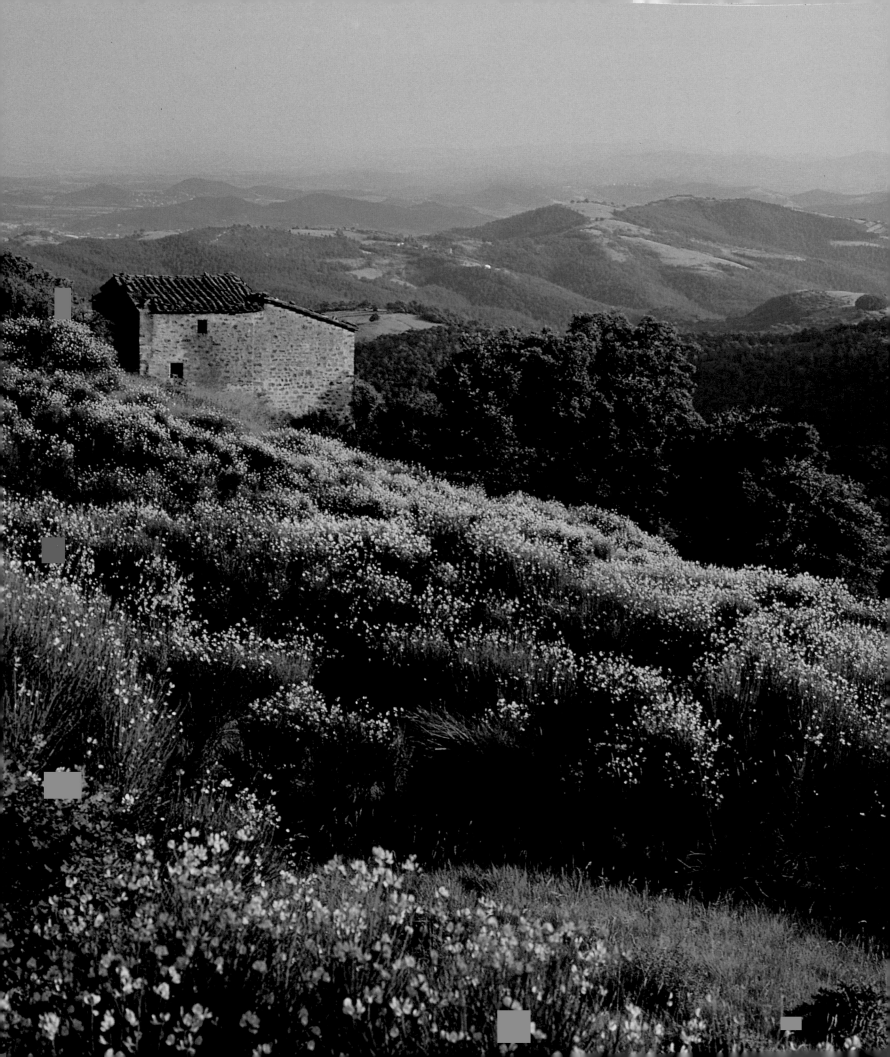

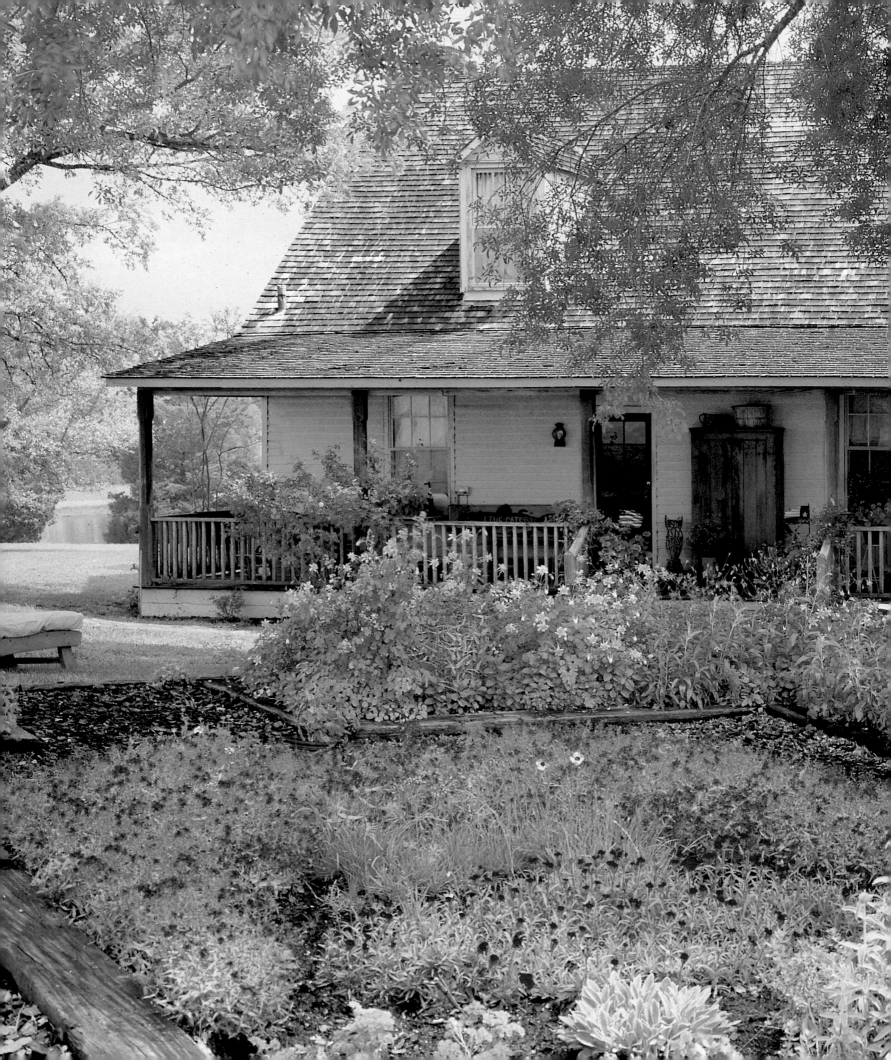

"*Blending with its
setting, a house takes
up its position on
the spur of a hill or
a bend in the river as
if it had always
been there.***"**

LEFT *Peace and calm hang in the air
around this Texan farmhouse surrounded
by oak and elm trees, an herb garden, and
flower beds. Built by German settlers, it is
substantial but not grand, and its long,
shady veranda and widely spaced windows
give it an open, welcoming aspect. The
gentle landscape setting with its mirror of
a pond bordered by weeping willows makes
it an idyllic spot.*

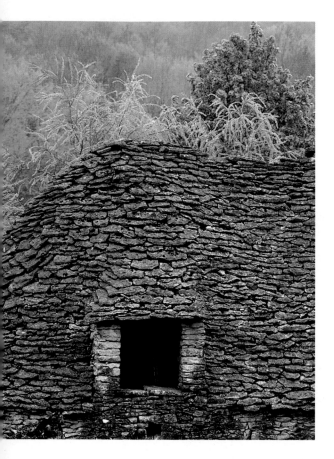

ABOVE *The comfortable undulations of this traditional stone roof in the Perigord may result from slow settling or from the use of riven rather than straight-sawn timbers in its construction. Together with the color, texture, and shape of the stone tiles, they reinforce the impression that this house has grown out of the landscape it inhabits.*

RIGHT *A lake with waterlilies and a towering backdrop of green frame a house in rural France, and balconies and a terrace provide vantage points from which to enjoy the views. Elongated windows and doors and tall chimneys enliven the facade of this otherwise simple building, and cresting adds distinction to its plain roof.*

*I*t is not just the materials that make this perfect home seem as if it had somehow grown out of its landscape; the climate influences aspects of its design such as chimneys, verandas, window shutters, and outbuildings, and local tradition provides a range of decorative features—some purely ornamental, others that have evolved for practical reasons. Ornamental wood-carving traditions flourish where timber grows and the same patterns are found on balcony details outside as on stair balusters inside. The setting is the point of departure not only for the exterior of the house but also for the interior.

Different types of buildings—the forester's hut in a woodland setting, a mill house by a river with its hunch of a wheel-housing—are built in response to the landscape and as an expression of man's harnessing of its powers. The interiors of these buildings reflect their functions in their room spaces, shapes, and materials so that indoors as well as out they project a strong sense of place. A farmhouse with its barns and farmyard may differ in style from one region to another—the huge profiles of the *masserie* on the flat plains of Apulia in Italy are quite different from the hill farms of the English Lake District—but each shares its history with the landscape in which it sits.

Old buildings express this sense of belonging simply and eloquently, and new buildings can, too, when they have been designed using local materials and respecting local traditions of proportion and scale. New houses more often make better use of beautiful settings than older houses, which were built at a time when hilltops or beaches were thought too exposed. New architecture often works better when it only has to relate to its natural setting rather than trying to blend in with older buildings as well. While it may use local materials and proportions, its design has generally been touched by influences much wider than local building tradition, including the availability of high-tech building components that make possible all sorts of design solutions to cater to modern needs.

For some, modern needs may consist of no more than the basic requirements of a simple, almost monastically austere life. The little woodman's hut in the middle of a forest sits silently under a canopy of green—the beech woods of southern England, the pine forests of central Europe, the silver birch woods of Scandinavia stretch into the distance—as the smoke curls above a chimney on its roof. Built of rough timber from trees that grew where its little clearing now lies, the hut may have only one room and an outhouse—cooking is done on a tiny stove and the bed is a little cot. A hut like this features in fairy tales as the home of the seven dwarves or the wicked witch or myriad other fantastical woodland dwellers. It evokes the life of the seasonal workers who came to cut wood or burn charcoal and the life of the hermit communing with nature and God. For some this is the perfect setting for a hideaway, built out of the landscape to which it will one day return, a place to withdraw to from the stresses of modern life, to be close to nature and refresh the spirits.

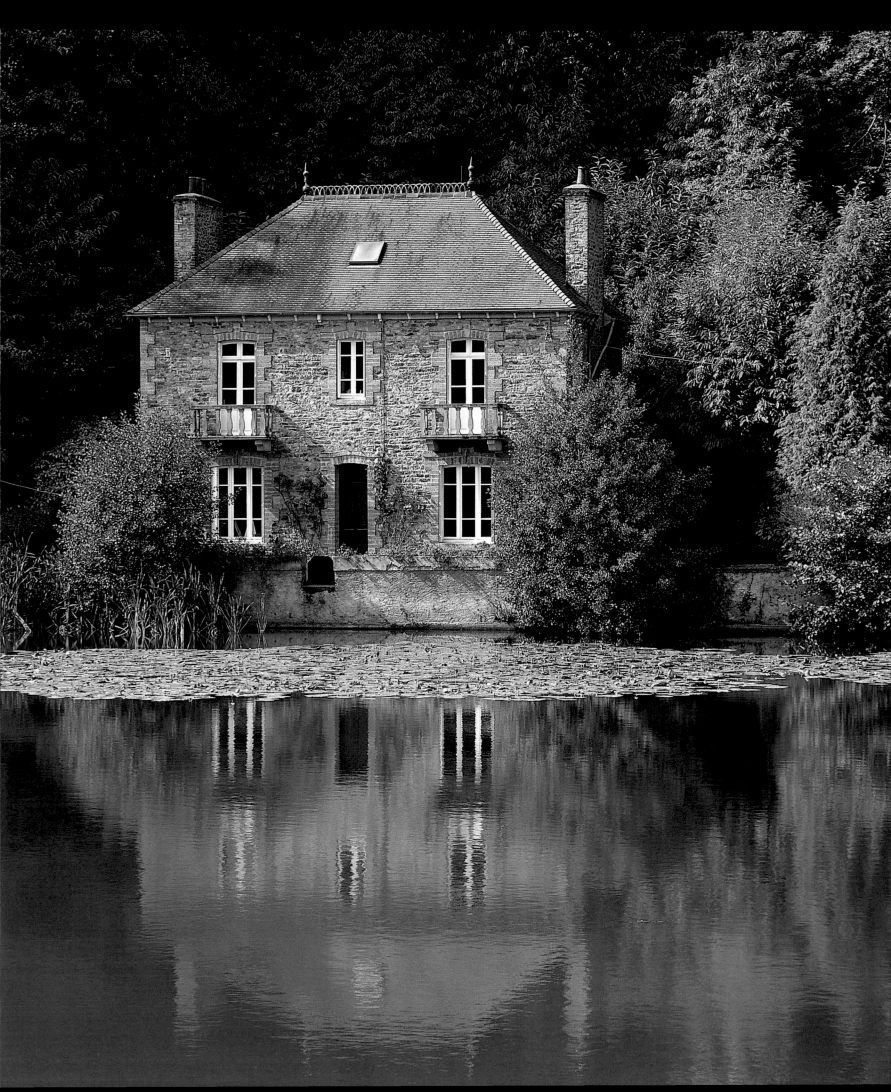

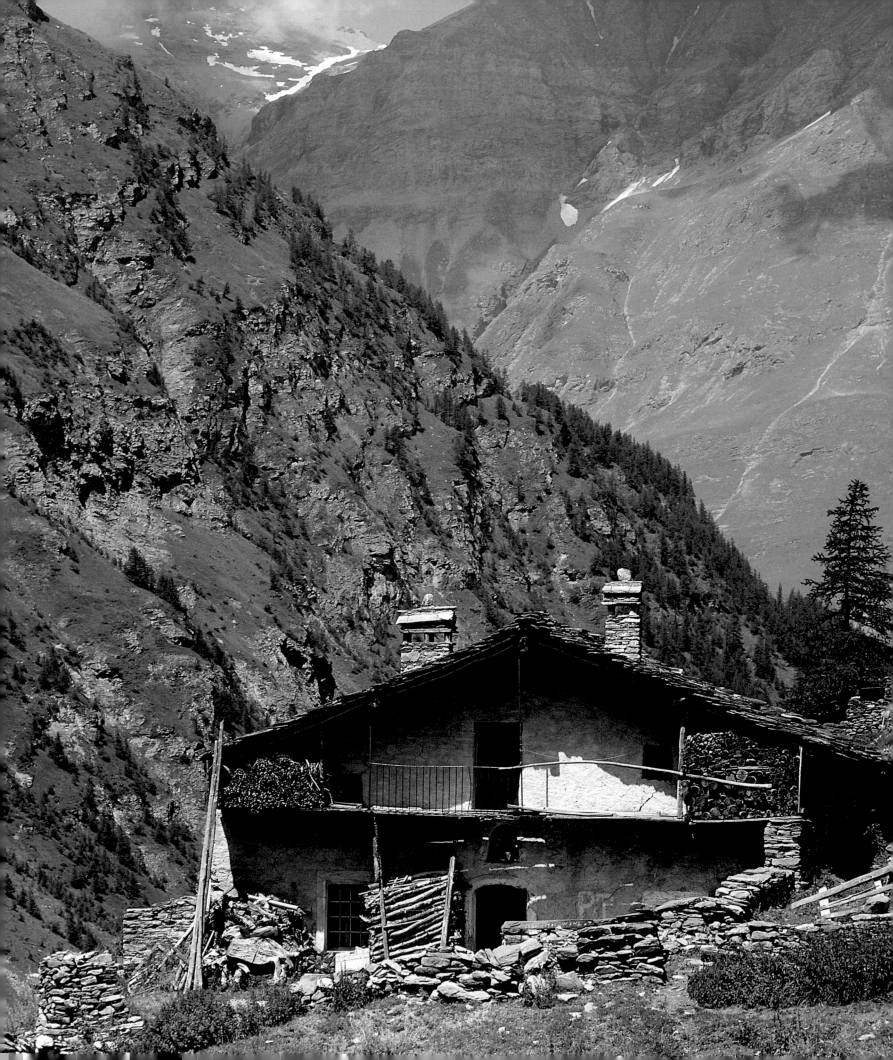

LEFT *The grandeur of crags and peaks makes a human dwelling seem tiny and fragile, but in fact a mountain chalet needs to be of sturdy design. Built using local stone and timber, its overhanging eaves and chimneys, log stores and enclosing walls all hint at a way of life that is dictated by its isolated setting.*

RIGHT *A childhood dream comes true in the building of this ultimate refuge: a wooden tree house with a biblical-looking ladder, a balcony, a pitched roof and windows. Going back to nature never seemed such fun before. An occasional feature of myths and fairytales, the idea of living in a tree must spring from some atavistic longing. As dawn breaks and the sun comes up, there is no one around but the birds and the wind in the branches.*

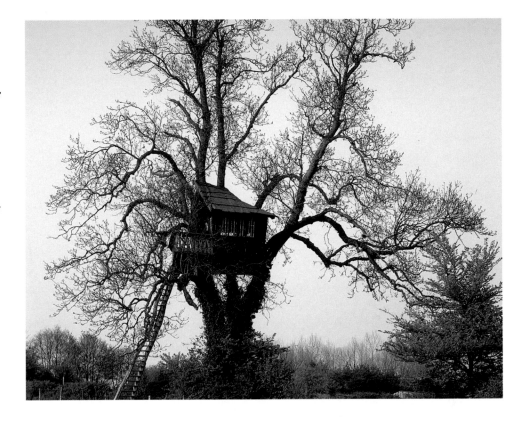

"*A hideaway built out of the landscape to which it will one day return brings back childhood dreams and stories; here one can be close to nature and refresh the spirits.*"

Others would find it easier to recharge their batteries in a house in the middle of a rolling plain, big skies and endless open spaces lying outside their door. At night you can look up and feel you have a ringside view of the heavens. The building will probably be long and low, blending with the flat landscape; and the interior, which cannot hope to echo the great spaces outdoors, will be simple and comfortable.

Far from the endless landlocked plain are the fishermen's houses and coast guards' cottages on a rocky coastline. A house here may seem built into the rock which embraces and shelters it. It has views only out to sea, for its back windows look out onto the dark and craggy cliff. Fishing villages built in a natural amphitheater around a little bay are among the most picturesque of settings—whether soaking up the sun in the Mediterranean or coping with storms in a more northern climate. When these houses were built rough seas meant only danger for their inhabitants, but the romantic appeal of the sea in all its moods means that for some it is the only perfect setting. Houses in the dunes of Jutland in Denmark, on the shores of Maine, or on a bleak pebble spit stretching out to sea all take a beating from the elements, and both exterior and interior express the toughness they need to withstand the storms. Previous generations may not have built where people want to live now, so often houses in these exposed settings are early twentieth-century cabins, or even new houses.

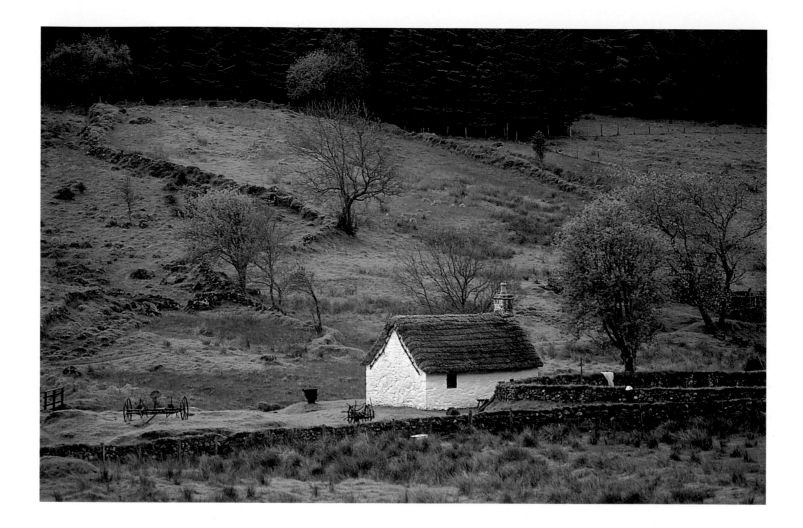

ABOVE *Snug in the landscape, minding its own business, a small traditional Scottish croft has modest proportions but projects a powerful sense of place.*

RIGHT *This woodland hut was built as a granary, but transported to a new setting it now provides a one-room retreat in a little clearing where you can fling the doors and windows open and feel as if you are living in the trees. The lack of amenities and the absence of a manicured garden mean freedom from a few of the things that bring responsibilities and complications.*

*I*t has been one of the challenges of our age to try to blend brand-new design with traditional buildings in village streets, but the perfect village house for most tastes is still one that has sat quietly on the main street for a good many years, respectful of its neighbors and part of the drama that is village life. A village setting expresses a real sense of belonging to a community and to an area, whether in a tiny hamlet in Normandy or Brittany in France or a village in northern Spain or in Holland. Doors open directly onto a public space, perhaps a village square or green that is like an extension of the village house—an open-air living room where people meet. In a village many things are shared, including a spiritual life centered on the church and the year's cycle of seasons and traditional feasts. The interior of a village house, while always expressing the individuality of its owner, also reflects this sense of belonging: not only in little details, like lace curtains at the window, which seek to maintain some privacy from the street, but also in the scale of rooms and architectural features that are similar, if not identical, to those of its neighbors.

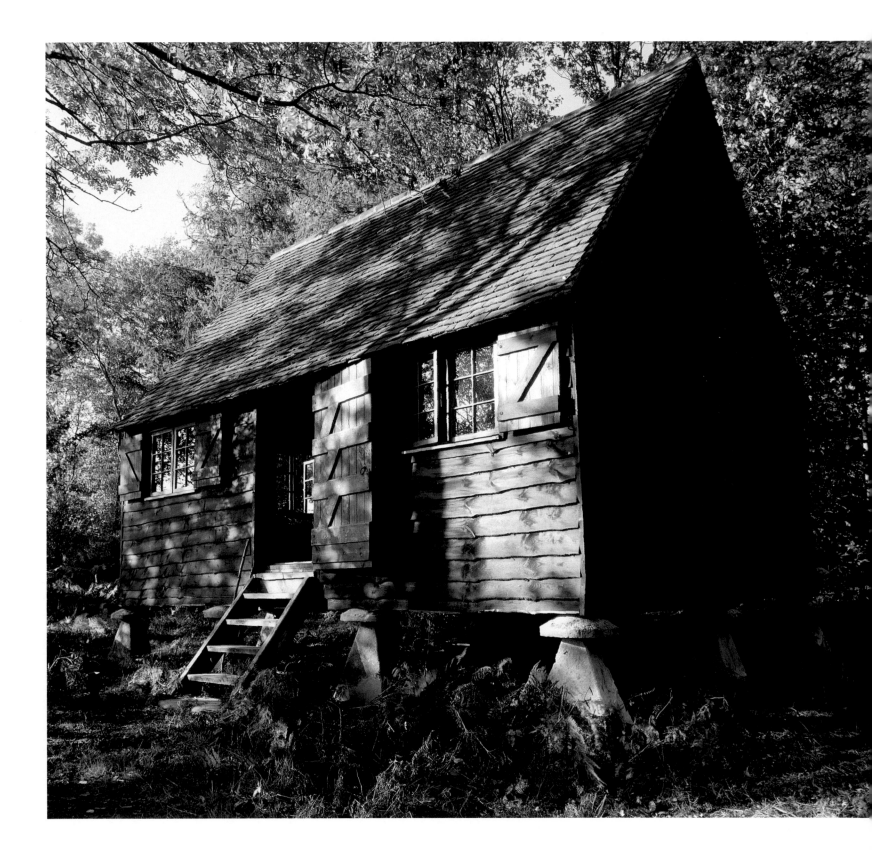

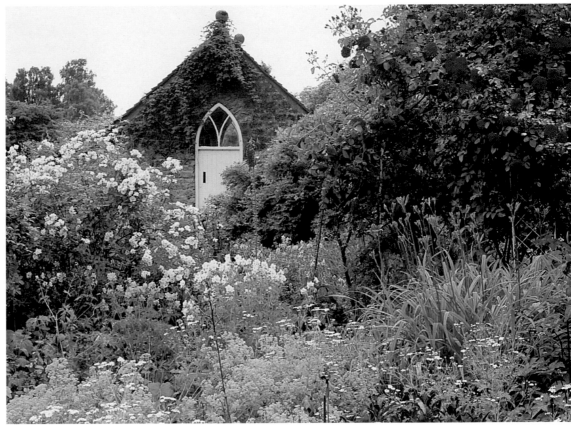

On the other hand, grander country houses in their own tailored landscapes and farms with their land around them were always more aloof and often self-sufficient. The appeal of a self-sufficient holding is as old as history. How many people long to live on their own land, to grow a few vegetables, to have a little orchard, some chickens and beehives? How many frustrated city dwellers dream of a peaceful life in a setting like this? An Italian *casa colonica* bordered by its olive trees and a vineyard in the rolling Umbrian hills, an English Cotswold house nestled in a verdant valley with its walled garden, neat rows of vegetables and espaliered fruit trees, a Greek farmhouse with beehives nearby: each is in its way perfect and offers the opportunity of living in true harmony with nature and enjoying the careful husbandry of land that has been worked by generation after generation.

LEFT AND ABOVE

A walled garden sits in a gentle landscape and a cottage door emerges from behind the glorious colors of an English garden in summer.

" *The climate influences aspects of the design of a house, and local tradition provides a range of decorative features—some purely ornamental, and some that have evolved for practical reasons.* **"**

RIGHT *Simple shapes, a picket fence, and a flagpole give this waterside house toytown clarity. Crisp white and blue paintwork highlight its details, and it is framed by clear sky and water. The orderly layout of buildings is sheltered and self-contained and looks like an outpost in a wilderness of rocks and scrubby bushes.*

FAR RIGHT *Enjoying a ringside seat on a sunny slope, with wide views of a fjord and trees and meadow around it, this Norwegian house is of a traditional construction: timber on a stone base platform. It follows a regional style and sits happily with the outhouses around it in its proportions, materials, and detailing.*

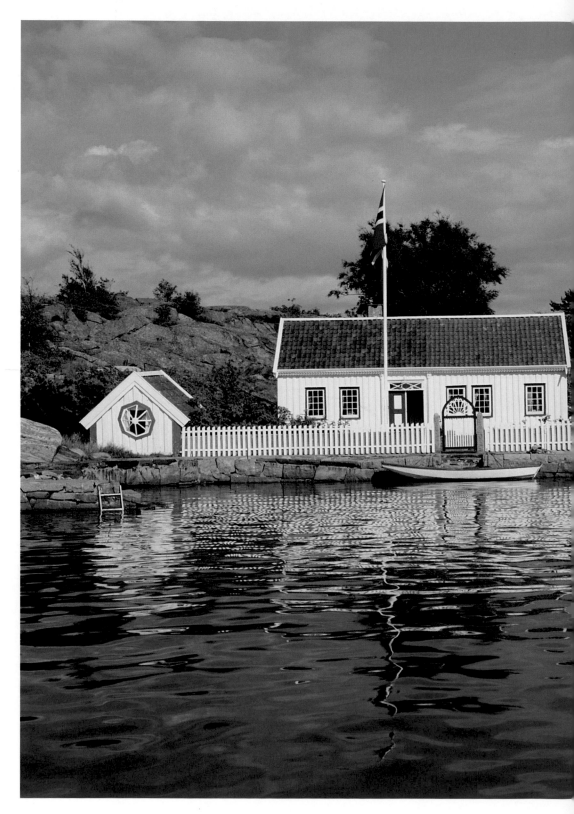

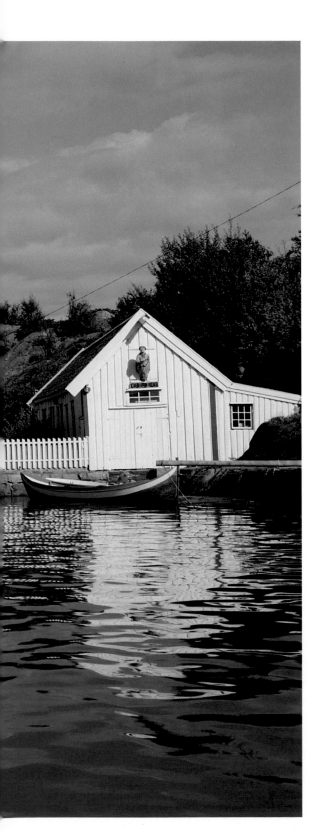

*R*omantic spirits in search of a retreat might look for rather less responsibility in a more modest house. While some might imagine their perfect home as an elegant and substantial English Georgian manor house at the head of an unspoiled wooded valley leading down to the sea, others would opt for the tiny cottage perched at the water's edge. Sheltered to some extent by the steep cliffs rising on either side, it looks out on the widest views of sky and sea, is lashed by the gales in autumn and winter, and feels as if it is at the ends of the earth.

Humble houses in isolated settings are perhaps a rarer find nowadays than farmhouses because they were often built on poorer land that failed to support successive generations, leading them to be more often abandoned. Today it is more likely that the isolated croft down a dirt road, or mountain hut way above a village, holds out the hope of a peaceful life rather than the anxiety of surviving in a harsh landscape. While those whose grandparents struggled in a drafty old cottage and who see only backbreaking work in its setting may be more interested in warmth and modern comforts in town, those who have tired of convenience and city life often long for the drafty old cottage and its setting of boulders and gorse bushes or heather and moorland.

LEFT *More than any other building, a log cabin seems a part of its landscape. It is the perfect house in the woods: simple architecture blends with its surroundings, promising the cozy picturebook homeyness of a gingerbread house. Those searching for peace today find its simplicity is its biggest attraction, but straightforward building design, local materials, and modest aspirations are also part of its appeal.*

RIGHT *This gothic hut is an eye-catcher at the end of a meadow walk; rather than blending into its setting it stands out boldly against a woodland backdrop. Essentially a simple wooden cabin, it has been transformed into a picturesque and striking garden building with pointed arches, door surround, and trefoil window picked out in black. It is the perfect writer's retreat, a private little world probably furnished with inspirational talismans and a favorite armchair. No one enters without a special invitation, and no one knows how much hard work and therapeutic, solitary day-dreaming goes on here.*

*A*lthough the joys of a pastoral life away from worldly cares have been celebrated by many generations of poets, statesmen, and kings, there were only ever a few people who could afford the luxury of a villa or country retreat. From the Roman villas of Capri to the *faux*-rustic inventions of the eighteenth-century European aristocracies and the lodges of American industrialists and bankers in the Adirondacks or along the east coast, there have been attempts, at times of prosperity in every age, to try to capture the elusive rural idyll in new intepretations reflecting the preoccupations of the time. But it was not until the end of the last century that the worker's cottage became an object of delight for the professional classes wanting to get away from it all to a simple rural setting. The English love affair with cottage architecture had gathered momentum during the nineteenth century with variable results, and threatened to turn into a headlong dash for every dilapidated country cottage within reasonable distance of the big cities.

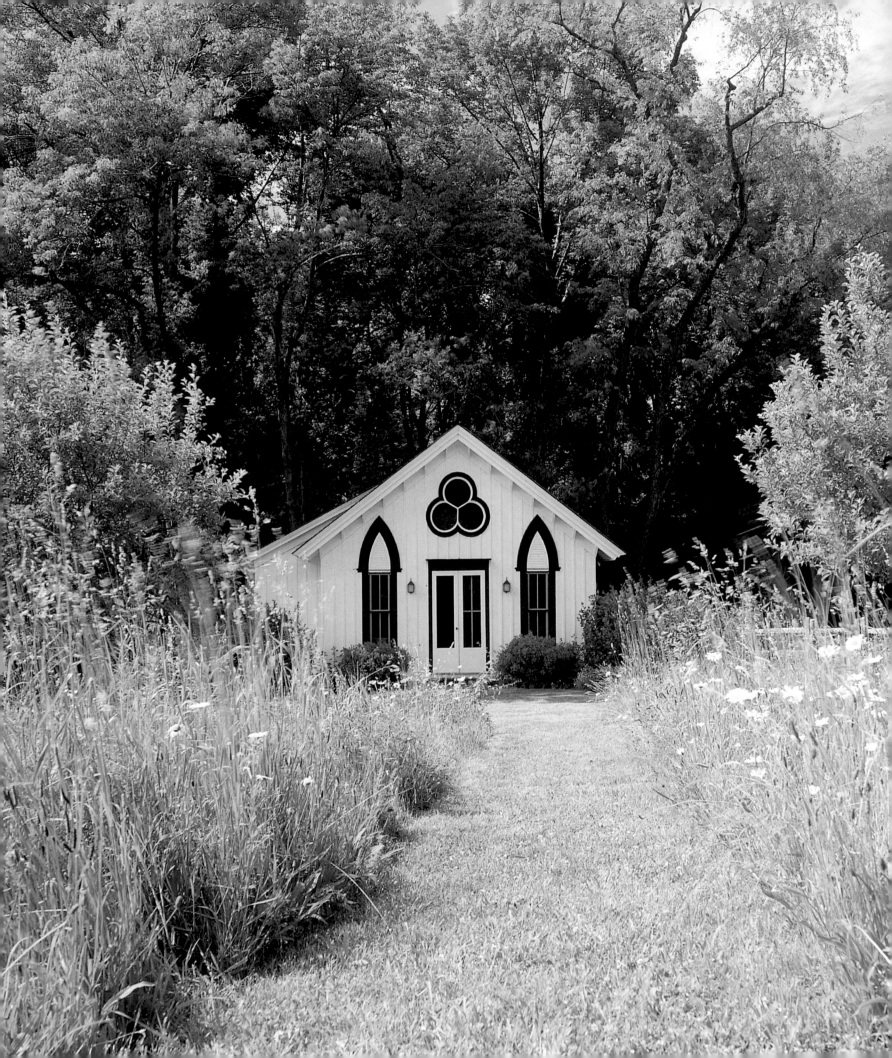

"A farmhouse with its barns and farmyard may differ in style from one region to another, but each shares its history with the landscape in which it sits."

*A*t this time the Arts and Crafts Movement, which specifically revisited and treasured a vernacular rural tradition in Britain and America, and to a lesser extent in other European countries, was reinventing "simple," though often substantial, perfect country homes. This was probably the last burst of country building activity, in England anyway, when a lack of planning controls allowed great choice of setting.

Recently a quiet rebellion has taken place against the idea of the obvious big country houses, the conventional polite manors and farmhouses, plantation houses and rectories furnished with suitable antiques, in favor of simpler and sometimes quirkier homes. There is a new interest in creating country interiors in unconventional spaces, which might be anything from the clever conversion into several homes of a very large country house or the conversion of abandoned agricultural buildings, mills, water towers, garages, and train stations that have all found new lives as homes. Their settings and their architecture tell their histories and give a hint of what their interiors might reveal: mills standing by rivers, train stations on closed lines, boathouses on lakes. For those prepared to go one step further, and who do not want to be tied down by the permanence of bricks and mortar, the only answer is a treehouse, a trailer, or a train car parked in a field, huts and cabins where the great outdoors is the living room. These homes celebrate spontaneity, a string of picnics, and the simplest of simple lives. Pared-down country living like this, in the perfect setting, is an uncompromising new departure that many long for but few achieve.

FAR LEFT *The colors of the weathered timbers of this building soften its lines and give it character. From silvery whites to dark browns, the knots and striations create strange and beautiful patterns across the surface of its walls.*

LEFT *Rugged stone slabs are used as steps outside this Norwegian shepherd's house. A porch with carved detailing provides a shelter from which to watch the surrounding fields, and there is no garden or enclosure to separate the house from its landscape.*

ABOVE *Crude classical detailing has been applied here to a simple wooden house in a snowy Scandinavian landscape. Borrowing selectively from the classical tradition, the builders of this house have ended up with a provincial interpretation, the detailing of which has been picked out in different colors.*

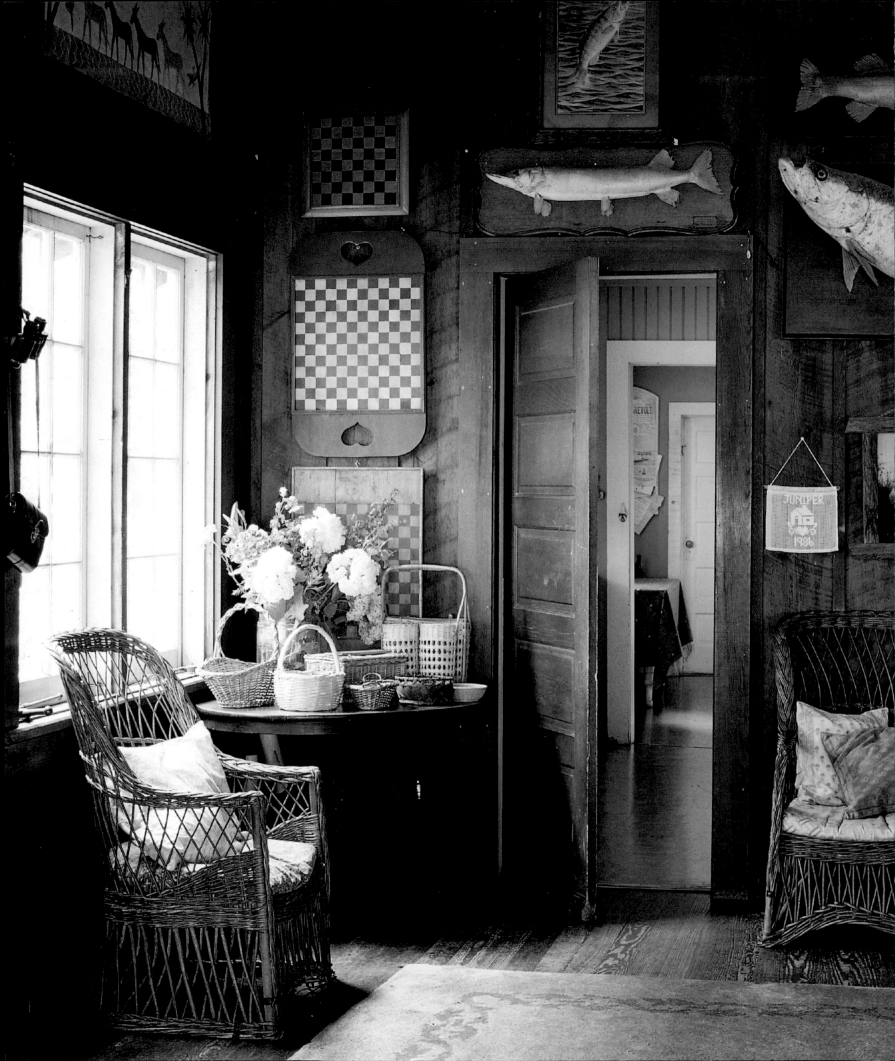

Perfect
LIVING ROOMS

*T*HE COUNTRY LIVING ROOM NEEDS TO BE A VERSATILE, PRACTICAL SETTING FOR ALL

SORTS OF ACTIVITIES, PROVIDING A SERENE BACKDROP FOR READING OR WRITING IN

COMFORT, MUSIC-MAKING, TÊTE-À-TÊTE CONVERSATION, PARTIES—PERHAPS DANCING—

AND CHILDREN PLAYING. IT NEEDS TO WORK AS WELL BY NIGHT AS IT DOES BY DAY.

THE MANY DEMANDS MADE UPON IT ARE BEING MET TODAY BY INCREASINGLY IMAGINATIVE

AND IDIOSYNCRATIC SCHEMES THAT TAKE THEIR CUE FROM A WIDE RANGE OF SOURCES.

LEFT
*Garden furniture mimics a formal living room
arrangement in a dark wood-panelled setting,
and instead of pictures on the wall there are
checkerboards and mounted fish.*

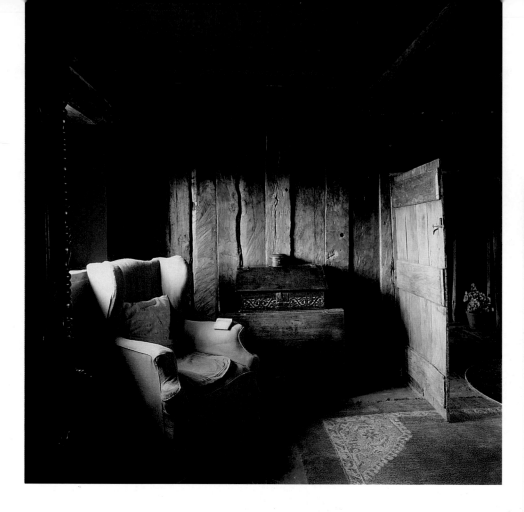

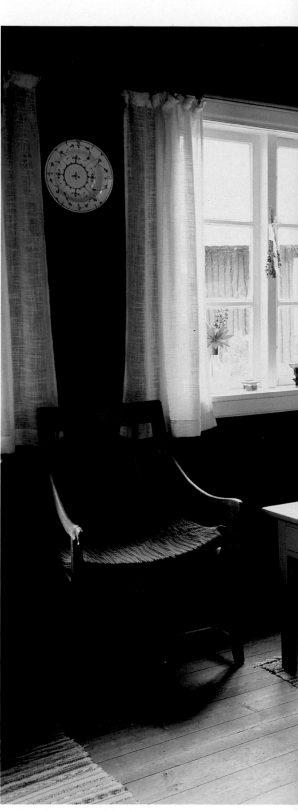

*T*he best country living rooms seem to be those where a mutual respect is evident between owner and house, and where people seem to have listened to their house to discover what it wanted before they embarked on redecorating it. The result is a personal synthesis of ideas and elements that are creative and inspirational. And it is in the living room—perhaps of all the rooms in the house the one most given over to enjoyment and the pleasures of life—that the opportunities are greatest for fun, wit, and quiet elegance.

As elsewhere in the house, it is the architecture that tells the story of the room and sets the tone for the decorative scheme. In a cottage or old farm there may well not have been a "parlor" before, so the room may have changed its function, windows may have been blocked up, there may be a stone door lintel inexplicably jutting out of a wall. Conversions of rural industrial or abandoned farm buildings are full of these oddities, and enjoying them, or at least not covering them up, is seen today as a mark of respect to the house. There are many ways of drawing the architecture into a decorative scheme: by focusing on the materials of the building—whether rough-finished door planks or stone window moldings; by introducing or making use of architectural furniture like window seats; by not crowding the room with furniture or smothering the floor space with rugs. In sympathy with this approach there has recently been a reaction against tricksy wall treatments and busy wallpapers in favor of texture: bare, even unplastered walls, or strong smoky colors and traditional paints. So much country building is straightforward—if not humble—that dignity is its main virtue, and if that dignity is compromised by superficial showiness or by too many possessions, it loses its appeal.

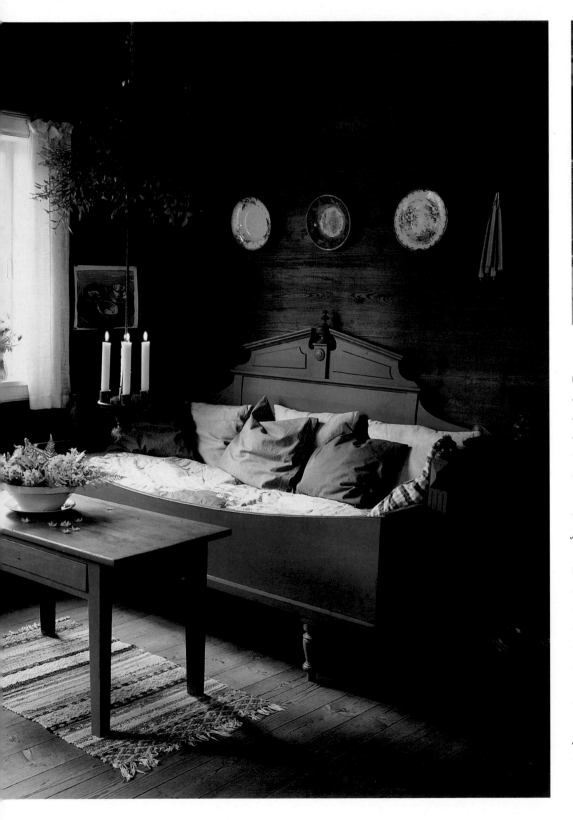

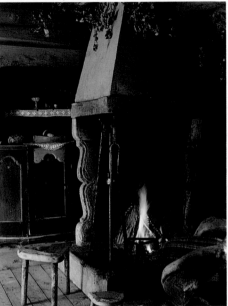

FAR LEFT *A quiet corner, a favorite chair, and a book hold the promise of a peaceful afternoon. Comfortable furniture is set against the simplest of architecture, where the bones of the building are an essential part of the decorative scheme. The colors, patterns, and texture of an ancient panelled wall and door need no further ornamentation.*

LEFT *A scheme of blues in this Swedish living room engages the eye, from the weave of a rug to a bunch of candles hanging on a hook. The sophisticated detailing of the day bed provides a striking contrast with the unabashed plainness of the rest of the room.*

ABOVE *A traditional fireplace design is a reminder of the house's setting and always gives a living room a sense of place and history. Old-fashioned bellows, wrought iron pokers and tongs are as decorative as they are practical.*

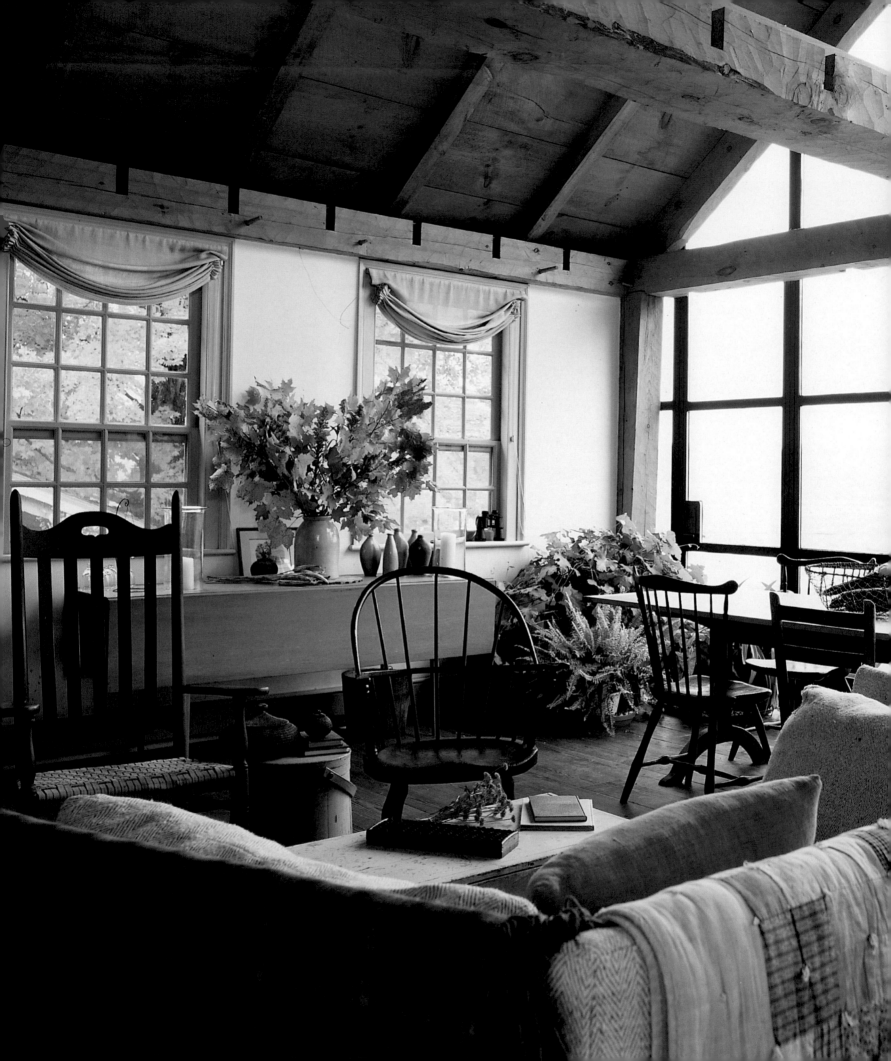

LEFT *In this farm-building conversion the end wall has been replaced by glass, emphasizing the spaciousness of the room, which needs the oversized tables and sofa to complement it. The collection of bottles displayed on a table is tightly grouped in a disciplined, contained area; they make a stronger impression like this than if they were positioned apart on many surfaces.*

RIGHT *The restrained elegance of a historic interior extends to the choice and layout of modern and antique furniture. A playful note is struck by the farm ladder that leans up against the wall urging us not to take the sophistication too seriously.*

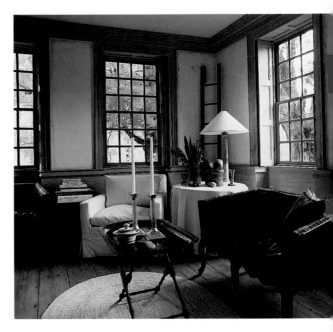

*T*he same restraint applies to newly built country living rooms and converted barns. The tendency today is for simple interiors, where light and space are more of a priority than decorative features for their own sake. In a new building in the country local materials like stone and wood are used boldly as both structure and decoration. Wooden roof structures zigzag across lofty spaces, and suspended sleeping platforms provide occasional ceilings down the length of an opened-up barnhouse. Walls are likely to be plastered and washed with a single color, perhaps a bright one in a warmer climate, so that the eye can follow their shapes right up into the roof. Little bites of color are missing where the roof joists meet them, so that each wall looks like a piece of a jigsaw. Where rooms are lined with tongue and groove panelling the planks and joints provide texture and pattern so that nothing more elaborate is needed as decoration, except perhaps pictures or furniture set against them.

In a small cottage it often seems that everything about it is perfect, except that it lacks just one sizeable room as the living room. One spacious room can open up a house; larger furniture that would be difficult to accommodate elsewhere can be used, and the room can have a drama and interest quite different from the other rooms however attractive they might be in their own way. A sizeable living room is most often achieved in a smaller house by knocking through walls on the ground floor or by building an extension in the spirit of the old house.

From the end of the last century, when country living was becoming more informal and the country look was more homey, country house design for architects might include adding relatively low-ceilinged but otherwise generously proportioned

"If grand things can feel at ease in small living rooms, so too can humble things sit happily in more formal rooms."

informal living rooms to older houses where rooms were deemed too small and where floor plans could not adapt themselves to modern requirements. These extensions were executed with great flair using the same materials and similar proportions in all the details of windows, doors, and other internal joinery as the rest of the house, so that they blended in discreetly. Unlike a modern house built all of a piece, an extension needs to spell out its links with the old building and to defer to it, while establishing its own identity in the spaciousness of its design and proportions.

Perhaps nothing is more important to a living room than space and airiness—a recurrent theme in the search for the perfect interior not only in the recently popularized Scandinavian interiors but in the Arts and Crafts interiors of Britain and elsewhere from the beginning of this century. Space creates a restfulness not only

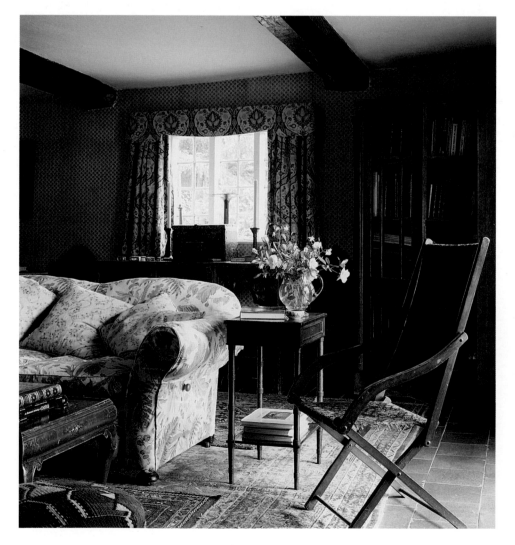

LEFT *A deeply comfortable sofa makes any living room perfect. It makes no concession to daintiness, dominating a small room, but its friendly profile is a welcoming sight. Here a traditional English living room follows a conventional path with layers of rugs and a plain, old-fashioned pelmet over the window. Unfussy and relaxed, this room is quite modest in scale but successfully combines a civilized level of comfort with the proportions of a simple cottage room.*

RIGHT *A room of contrasts with a nineteenth-century sofa made for a rather more bourgeois setting than it now enjoys. A rough stone floor and the exposed workings of a timber and tile roof contain a living room that hovers between outdoors and indoors—with double doors opening directly onto a courtyard. No amount of pictures or ornament would be able to disguise the rugged character of this room, which is completed by country ceramics, a painted cupboard, and a chunky table, but the blue and cream striped silk upholstery and the polished arms of the sofa are a sophisticated foil for it.*

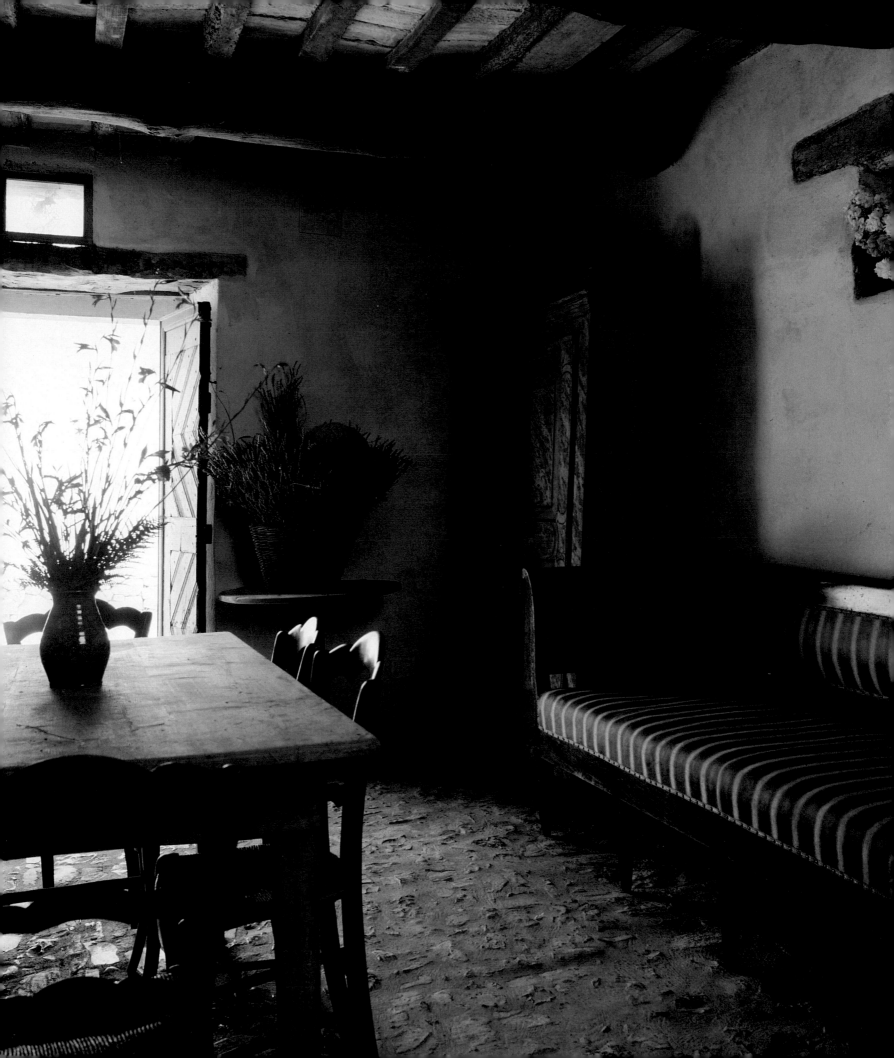

LEFT *Wood is used in three different ways in a corner of a living room: roughly chopped as logs for fuel, hewn into chunky structural timbers, and fashioned into the solid designs of country furniture. The color and patterns of wood provide decorative interest in many country rooms.*

RIGHT *A fireplace that draws well is perhaps the most important element in any successful living room. Here, in an unconventional twist, the vases on the mantelpiece have been placed as if they were samples in a showroom. A sure eye has collected and arranged them to display their graduating shades of milky colors in an orderly parade that also allows appreciation of their individual designs.*

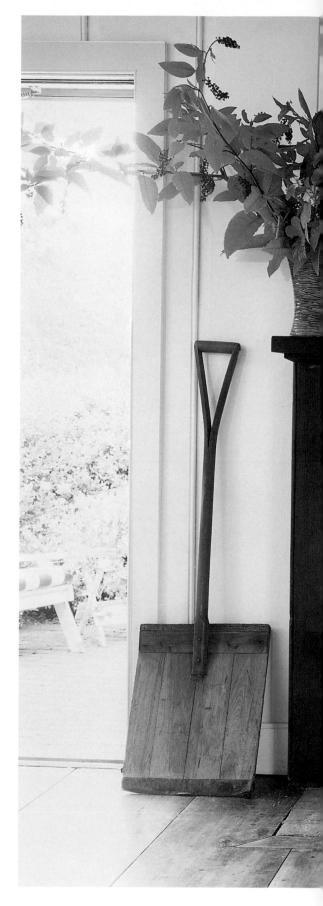

for the mind but also for the eye. Space around a piece of furniture makes it easier to appreciate; it links the room to the outdoor world, to the countryside around; and space and fewer possessions make the room more practical. Space is the greatest luxury too—the invisible expense—particularly in a small country like England where the old farmhouses and cottages are of smaller proportions than those, for example, in the open landscapes of North America.

Where money has been set aside to put a house in order, the creation of space is the first priority and comes before any plans for decoration are made. The living room is probably the most worthy recipient of attention if it is only practical to create one spacious room in the house. Decoration and ornament, the arrangement of furniture and the collection and display of treasures are all things that can be left and finalized gradually. The creation of the perfectly proportioned space ensures the success of the living room.

Where this is not possible and the rooms are tiny, there is perhaps even more need to create the impression of space by including very few pieces of furniture and little in the way of decorative detail that would distract the eye from any architectural character the room possesses. Another solution is to go in the opposite direction and to treat the room as if it were a *Wunderkammer*, a little cabinet of treasures, filling it with closely hung pictures, books, interesting ornaments, and a great variety of decorative clutter that add character and help create the impression that it is a private little corner of a larger room.

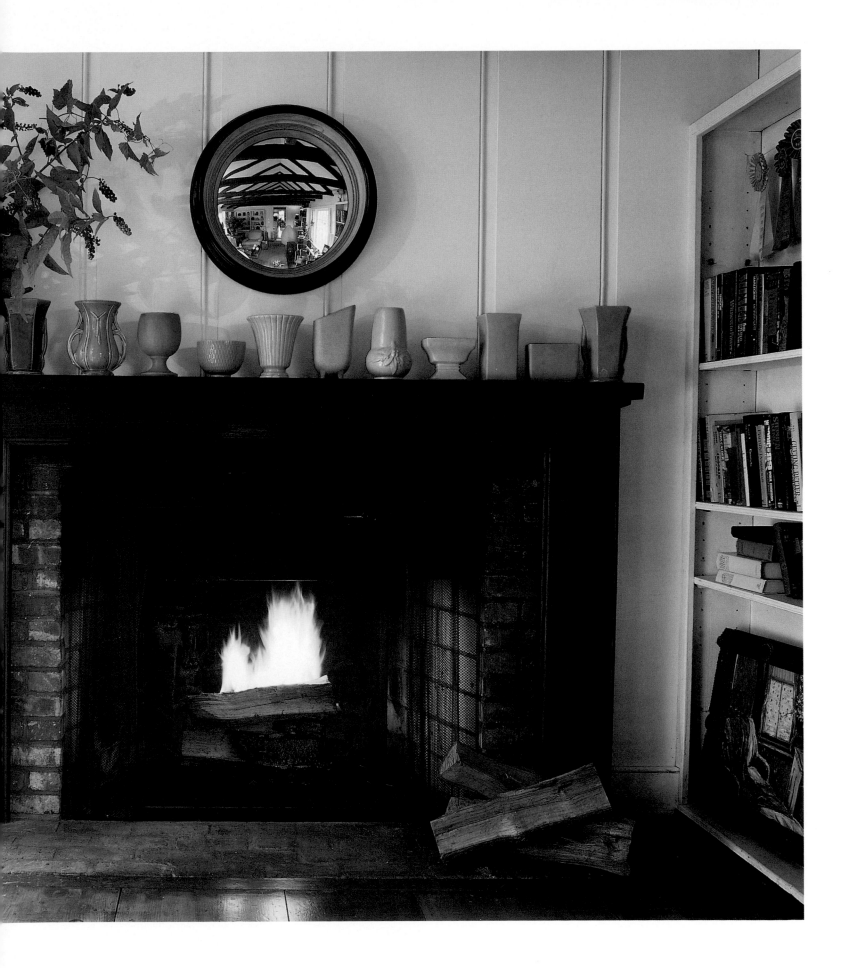

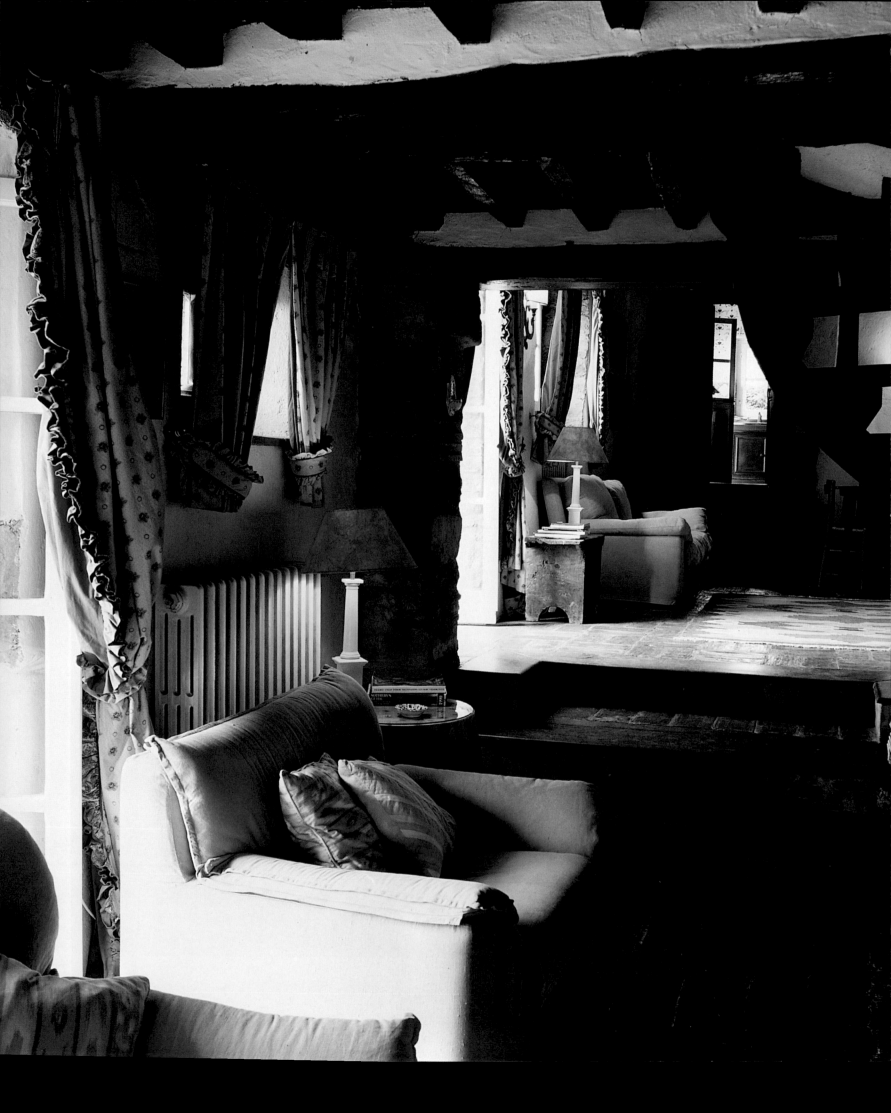

LEFT *A long, low room in this Tuscan farmhouse makes the most of its spacious ground floor as terra-cotta paving stretches away into the distance. Rough masonry walls, timbers above, and an open wooden staircase emphasize the room's robust character, which is, however, softened at the edges by fresh blue and white cotton curtains, comfortable sofas, and low table lights with warm red shades. They help to make the room elegant but informal.*

RIGHT *A massive stone fireplace dominates a living room in the Alsace region of France. Pock marks left by a chisel on the hearth stones show what a job the stonemason had when he created the enormous speckled-gray sculpture that reaches to the ceiling. Architectural oddities like the door lintel, with its classical detailing that juts out of the wall, tell the history of the house. Blue and white cotton covers on an armchair and cushions pick up the blues of the painted decoration on two traditional painted chests.*

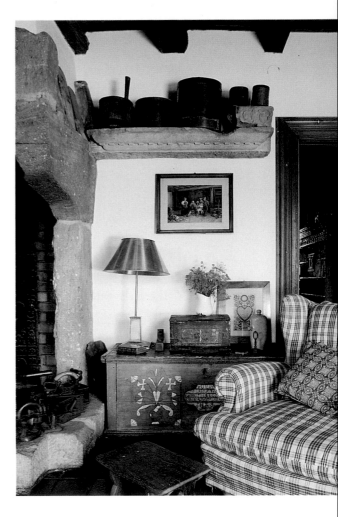

*A*s a public room the living room has a recent history of conventions, dictating what should be displayed here, and how. In the 1990s a country living room might continue this traditional path with a few good pieces of furniture, the mellow colors of faded spines of books, the cracked browns and greens of an old leather club fender, and the symmetrical order of the mantelpiece, with a mirror or picture placed centrally over pairs of ornaments and a clock passed down through the generations. It might, on the other hand, choose a different route and play a little with the well-behaved arrangements of our grandparents.

In their day the furniture and ornaments in the living room were the best in the house, and were polished and cared for with rigor. Everything knew its place. Now new interpretations play with that traditional order, which is juggled to a greater or lesser extent to produce a variety of dramatically different effects. At one end of the scale is the minimal disturbance of the balance of a room: introducing larger or smaller pieces of furniture or decorative objects than might be conventional. At the

"The fireplace or stove as a focal point is the still center of this turning world and is recognized as an icon of home and warmth everywhere."

RIGHT *The warm browns and pinks of bare brickwork and a plain wood mantelshelf dominate this interior, but there are signs of more sophisticated tastes: in the elaborate fireback which has come from a grander fireplace and in books and satirical prints scattered around the room. Intellectual interests are represented in a personal interpretation of the simple life.*

FAR RIGHT *The barest cottage interior appeals to those with ascetic tastes, to those who long to do away with the soft furnishings of a traditional living room, such as electric lighting and other modern conveniences. A candle-lit room warmed by a roaring fire is as far from modern cosseting as you can get. Yet the comforts it does offer are enough to make living with the bare but romantic essentials an enjoyable experience.*

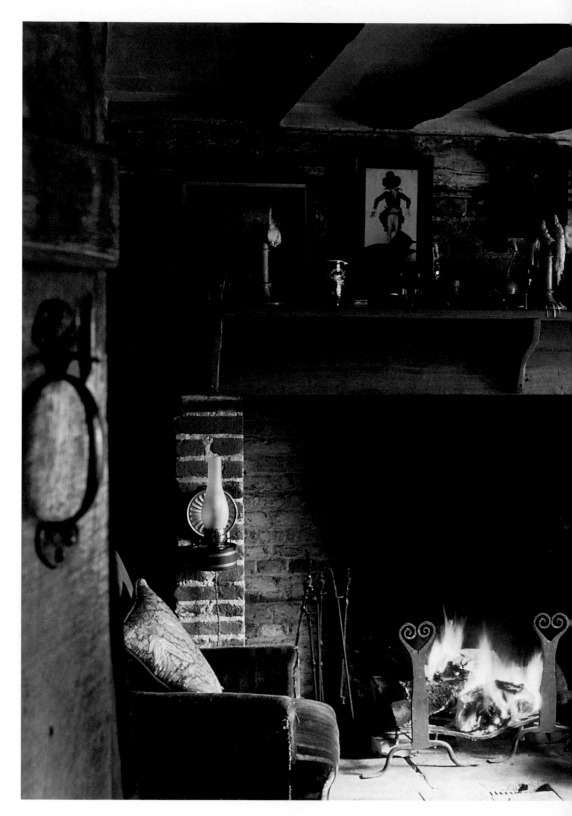

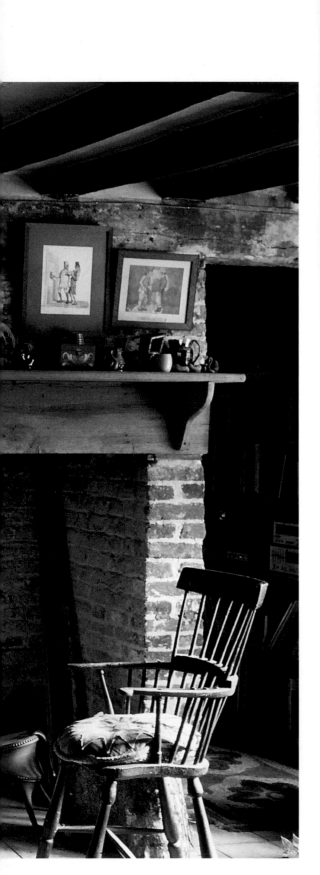

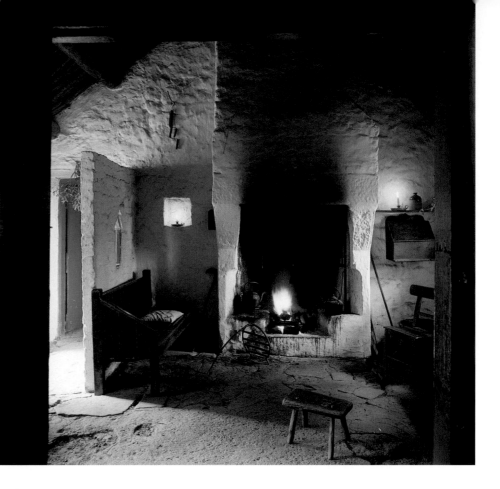

other end of the scale there seems to be a determined—almost savage—break with the traditions of a living room, which leaves links with the past hanging by a thread as a result of combining the most unexpected and outlandish decorative elements for a dramatic and eccentric effect.

Into the "minimal disturbance" bracket might be put ideas such as hanging a tapestry made for a much larger formal interior in a small cottage living room so that it covers an entire wall. It may not have been designed for examination at such close quarters (though this is how the weavers would have seen it), but the craftsmanship that has gone into it can be more easily appreciated this way than if it were hung high on the wall of the hall around the staircase. Large pictures can look very striking in small rooms too, although conversation pieces and landscapes are probably more congenial at close quarters than acres of mythical flesh.

As grand things can feel at ease in small living rooms, so can humble things made for less important rooms or for other countries or even for the garden. Chipped and scruffy, they have found their way into the best room in the house, where they mix happily with their neighbors. An old glass-fronted cupboard of sturdy design that might have hung on a cloakroom wall now sits on the floor with piles of books on top of it, as if it were a table. Old cane garden chairs look quite at home too, and can be dressed up with comfortable, even opulent, cushions. The idea is carried into the display of ornaments: checkerboards hung as pictures, worn garden tools arranged on a shelf, and a series of flower vases from the same pottery in similar milky colors ranged along a mantelpiece as if they were in a manufacturer's showroom. Sometimes a happy overall unity emerges where disparate objects and ornaments all share similar color tones, and the unconventional *mise en scène* suddenly

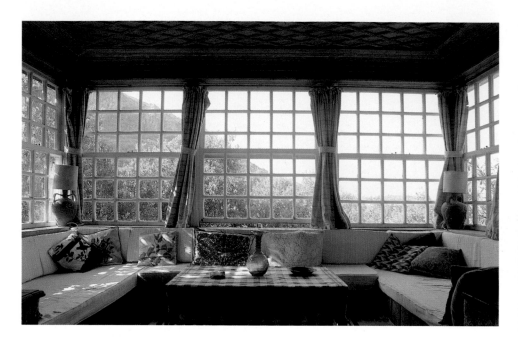

looks carefully thought out. This same effect can be achieved or reinforced by painting pieces of furniture in the same colors or in the color chosen for the walls, producing an impression of strange serenity.

At some point these new and personal visions become eccentric. Somewhere between displaying a toboggan—a hint of the setting of the house—in the living room and arranging three watering cans on an elegant mantelpiece, a line has been crossed between informality and quirkiness. That quirkiness might be a matter of chance or one of personal taste. The same assurance that places the watering cans on the mantelpiece might just as well place there a smart parade of old lead soldiers or a single, unexpectedly grand candelabra. Splendid isolation can turn almost anything into an object of contemplation and can ask us to appreciate all kinds of design and objects for their individual merits, for the materials and methods with which they were made, and for the way of life that they recall. Putting an old wooden farm ladder in the corner of an eighteenth-century parlor with calico-covered furniture, a few carefully chosen antiques, and spare decoration is probably the 1990s version of the trend in the 1970s for artful arrangements of pebbles and twigs that people collected. The difference today is that a sense of humor is very much part of these quirky elements.

An extension of the idea of placing unexpected pieces in isolation is the juxtaposition of mismatched objects: a rich gilded and carved picture frame resting on the humblest pantry table, a silk-pleated lampshade in the most austere of settings. No one could pretend that a country cottage was ever meant to look like this, but these new ideas break not so much with a historic tradition of decoration as with a set of

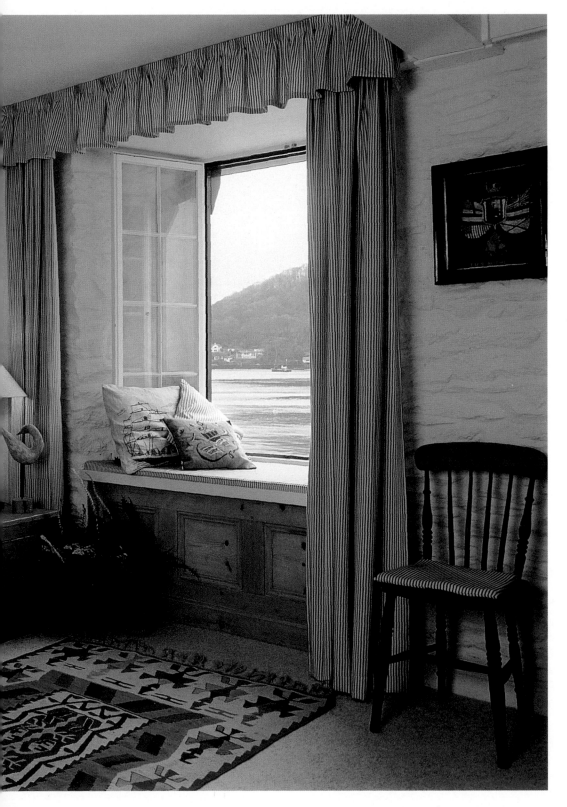

FAR LEFT *Like a glazed veranda, this sunny living room provides boxy divan seating around a low table in the Near Eastern tradition. Bright cushions are essential for propping up guests as they enjoy long afternoons of coffee and conversation.*

LEFT *A window seat with a view offers the prospect of long hours of idle contemplation of the sea and its changing moods. Fitted carpets and curtains make the modest interior quite warm and comfortable, and apart from the white-washed stone walls few clues remain of the less sophisticated life of the Cornish fishermen who once lived here.*

" *The concept of lounging is central to a country living room: whether you choose to lounge on beanbags or oriental divans, the important thing is that the demand for comfort is satisfied.* **"**

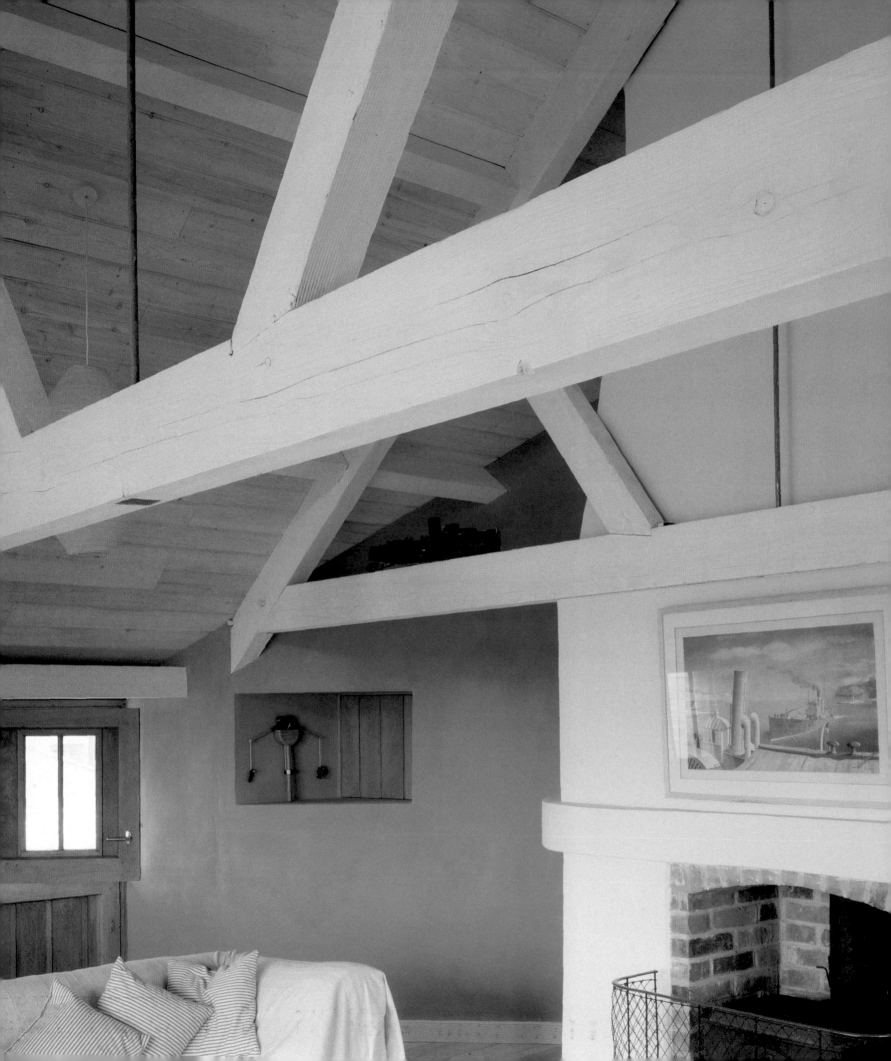

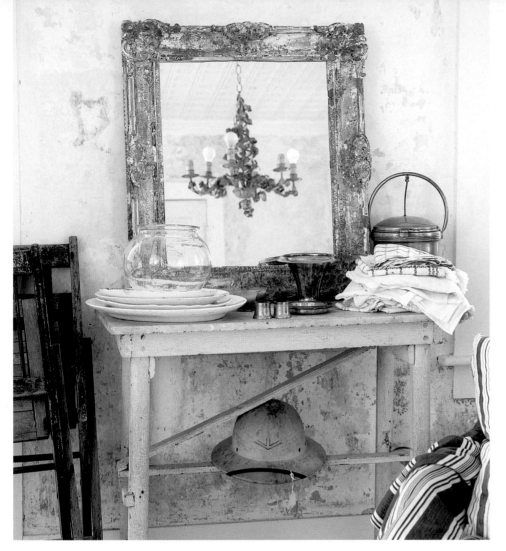

LEFT AND BELOW *In a jumble of bits and pieces the eye picks up the linking elements of a display: the chipped gilding of the picture frame and the flaked plaster of the wall, or the blues and whites of a pile of towels and a cover thrown over an amchair. In the same way a worn white suitcase— an odd intruder in a living room—fits in with the distressed colors of the walls and the different whites in the folds of the chair's upholstery, making it a harmonious corner.*

received notions evolved over the last hundred years of how things might have been in a cottage. It is arguable whether the careful speculation of prewar arbiters of taste, for example, with their quaint suggestions for cottage decor, is any closer to the original cottage reality than the new country look, which presents a sort of joyful domestic anarchy.

Some of the most playful and disconcerting interiors today put the gauziest of textiles next to the roughest of stone walls, mix shiny with dull, ancient with modern, grand urban with simple rural. The confidence to create ever more striking and individual combinations without compromising the dignity of an old building or destroying the tranquillity of a new one requires a particular sensitivity to the character of the house, which is why this approach only works where the ideas are a natural expression of an owner's personality and interests, or where collections of objects or pictures have been brought together gradually and with curiosity and love. Collections of local pottery, for example, books, pictures, and maps describing the surrounding area give a sense of belonging and make the room a pleasure for visitors, hinting at expeditions that could be made from this comfortable base. Regional furniture connects visually as well as historically with the setting and architecture, being made of the same wood as any panelling or floorboards and for rooms of similar proportions, and local textiles made up as rugs or curtains almost seem made for the room.

FAR LEFT *Exciting angles and bright fresh yellow and blue on the walls make a room that looks like a giant child's toy. The timber roof structure and just enough architectural detail saves this new country interior from plainness, while light, blond wood, and an ethereal painting remind us of the great outdoors, of big skies above a landscape stretching into the distance, and the freedom of unrestricted space.*

"Somewhere between displaying a toboggan —a hint of the setting of the house—and arranging three watering cans on an elegant mantelpiece, a line has been crossed between informality and quirkiness."

RIGHT *A purposefully blank green wall and uncurtained windows are matched by straw-colored flooring so that the room appears almost empty even though it is furnished. Things have been laid out here as if they are on temporary display or as if they might be changed around—like scenery on a set. A picture is propped up on the mantelpiece rather than hung above it, and although there is no obvious restraint in the choice of furniture and objects, the overall effect is of clean, sharp outlines and an intentional arrangement. An asymmetrical and eccentric display of old-fashioned metal watering cans also appears contradictorily casual and careful.*

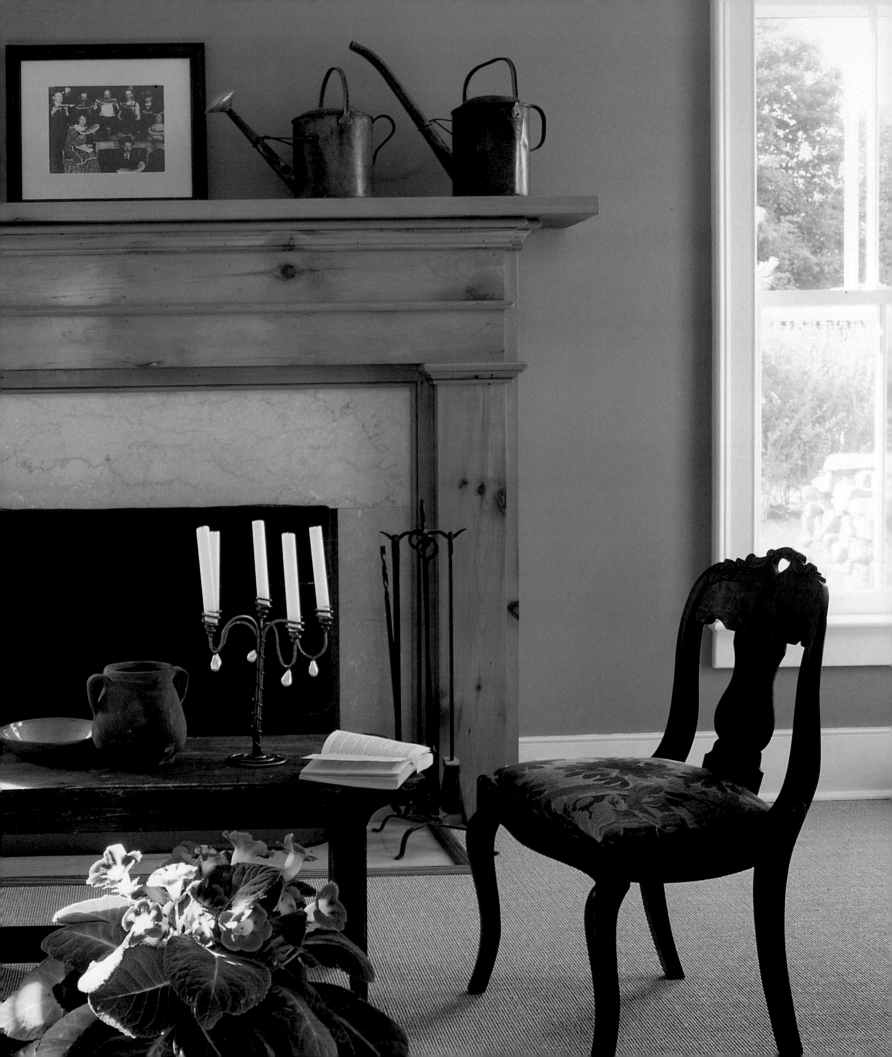

RIGHT *Exotic objects decorate the heavy architecture of a fireplace in a spare decorative scheme that juxtaposes nineteenth-century furniture with ethnic furniture and rugs.*

FAR RIGHT *Evening light infuses this room with the atmosphere and colors of the oil painting, which makes the sea seem like a painting within a painting. The pumpkin half-visible in the fireplace and the arrangement of pots, jugs, and bottles above are like two still-life paintings.*

BELOW *A fireplace painted in the blue that has been used for the door frame and dado rail provides a platform for a trundling elephant and a sparkling candelabra.*

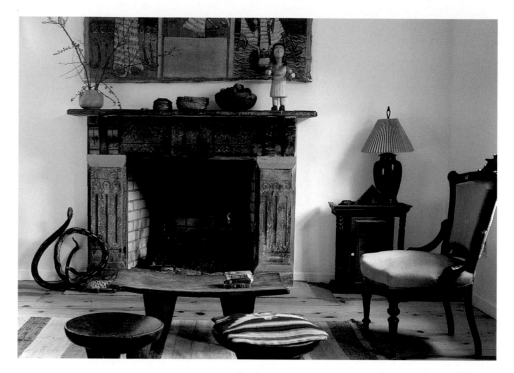

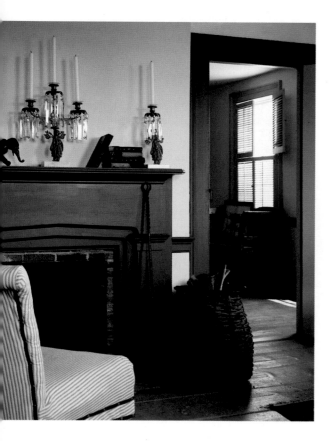

*R*ugs complete the room by providing warmth—underfoot and in their colors. Layered they are cozier still. As individual objects, however, they can be used to mark out areas within bigger rooms very effectively. One end of a living room might be decorated as a study or library, the other with a sociable circle of chairs and sofas around a fire. When rugs are laid well, with the best underfelting system, they allow you to appreciate the beauty of the floorboards, parquet, or flagstones around them while enjoying their warmth and pattern.

Curtains, like rugs, provide punctuation in a room. Weight and feel can be more important than pattern; worn velvet in rusty colors, linen union, or thick wool contrast boldly with the rest of the decor or complement it discreetly. Recent pelmet designs have become very elaborate and, perhaps as a reaction, curtain poles have become more popular for country homes, but pelmets are more practical for blocking out the light, and designs for the simplest pelmet shapes that were used in country house decoration up until the 1960s can provide straightforward yet elegant solutions.

Comfort is crucial to the success of every country living room, and even an austere decorative scheme can be comfortable—though perhaps only to its owner. Of course, comfort means different things in different countries. In the villas of the Bosphorus, lounging sofas around a coffee table in an alcove with windows overlooking the sea are essential for entertaining friends at protracted parties of conversation, coffee, and sweets. The concept of lounging is central in a country

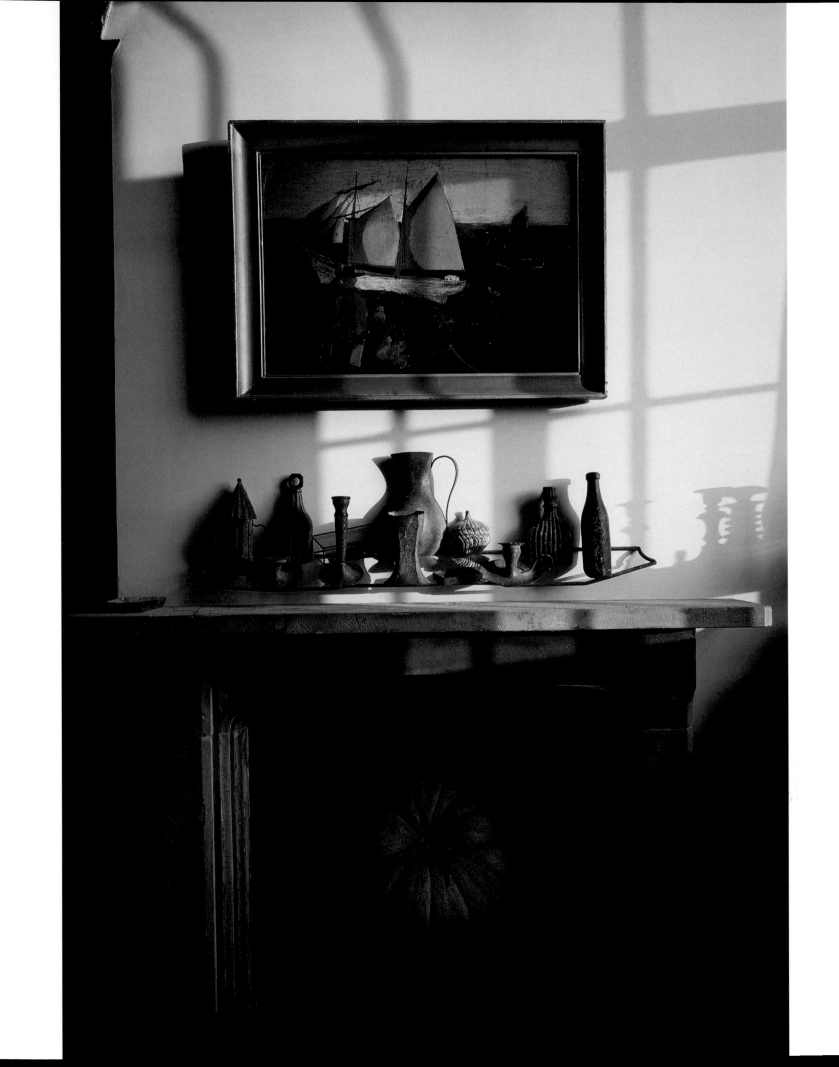

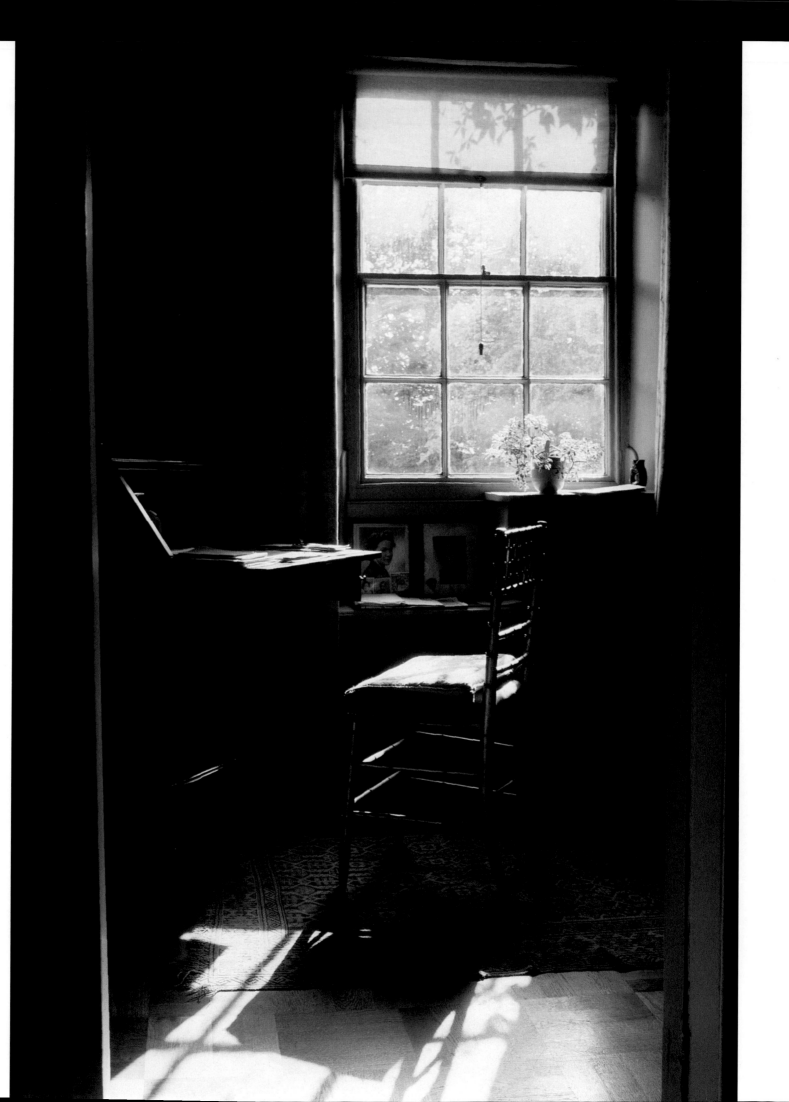

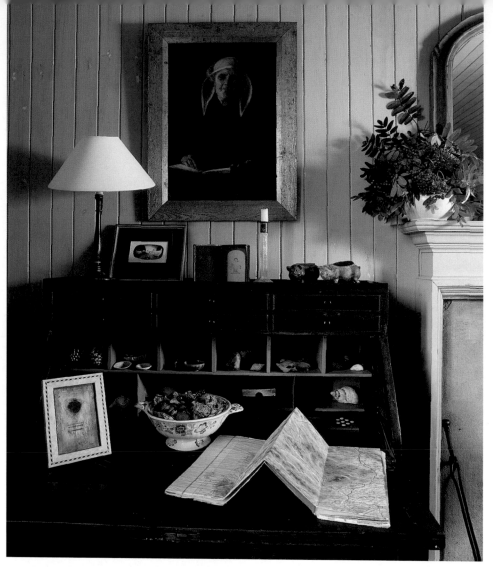

LEFT An old-fashioned canvas sun-blind on a sash window, family photographs, and the comfortable accumulation of country house furniture express continuity and calm in this warmly lit study.

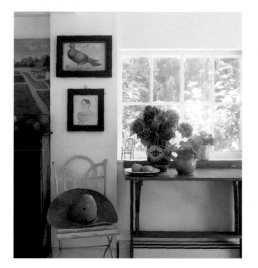

ABOVE Furniture that is scratched and scruffy from the knocks of long years of use is introduced into a pristine yellow room emphasizing its scars and making them a decorative element. At close quarters the bold perspective of a garden view makes a compelling picture crammed into a framelike space.

ABOVE RIGHT An open map hints at expeditions that might be made while shells that have been collected locally are displayed in a desk that has been turned into a collector's cabinet. Clues to the setting of a house spark curiosity: a tongue-and-groove panelled wall is an unusually humble backdrop for this handsome desk, but reflects the fact that all sorts of buildings in the country have been converted to homes.

living room and it makes no difference whether you choose to lounge on oriental divans, 1960s beanbags, or chesterfield sofas, as long as the demand for comfort is satisfied.

In northern Europe and east-coast America stiff parlor furniture speaks of an era when formal visits from neighbors were uncomfortable, tense affairs, and a room full of these antiques can look more like a historic furniture museum than a living room—but one or two pieces do act as a counterpoint for those indulgent, sinking sofas, tying the decor to a tradition without compromising modern needs. Nothing can beat the appeal of generously proportioned, well-upholstered sofas and the welcome of the favorite armchair. Their friendly shapes, with piles of unmatched cushions to prop up the occupant in a semi-comatose state on a wintry afternoon, are an essential element of the country living room.

The fireplace or stove as a focal point is the still center of this turning world. The fireplace is recognized as an icon of home and warmth everywhere, not just in colder climates but in sunnier places as well. The range of designs and the possibilities for decorative treatment of fireplaces are enormous, but the most important thing is that it should work; a fireplace should draw efficiently and throw its warmth out into the room. Almost anything can be forgiven in a living room if its fire or stove functions perfectly.

"Space creates a restfulness not only for the mind, but also for the eye, so that an object can blossom in splendid isolation."

RIGHT *A living room that combines conventional furniture and ornament in an adapted space has picturesque appeal. Roof timbers dip and dive as if they were supporting a complicated fabric tent. A bare terra-cotta floor, a solid stair, a simple window seat, and ledges here and there make it an informal and engaging interior.*

FAR RIGHT *A warm wood barn interior that is cozy and modern, with lots of traditional features and furniture. It also includes less conventional elements like a wooden toboggan, which is a clue both to the setting of the house and to the outdoor life enjoyed here.*

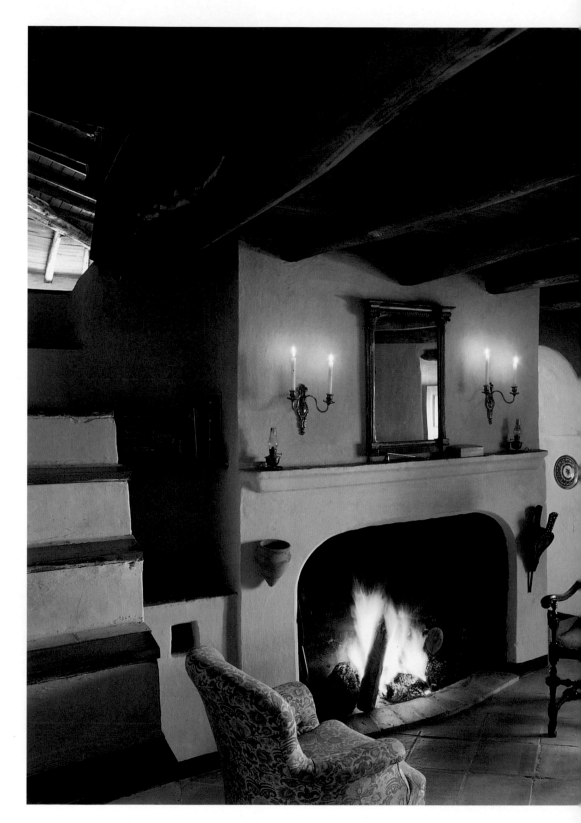

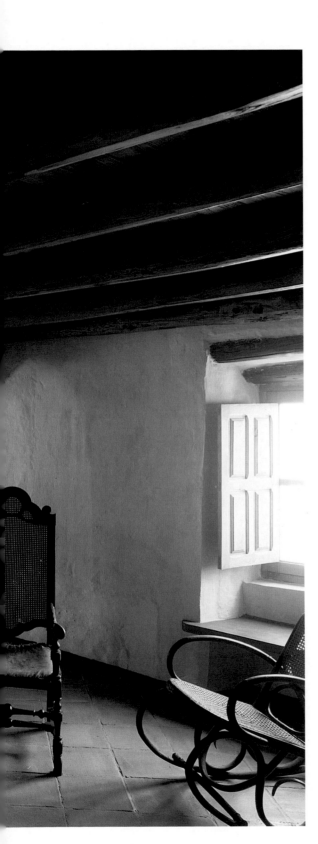

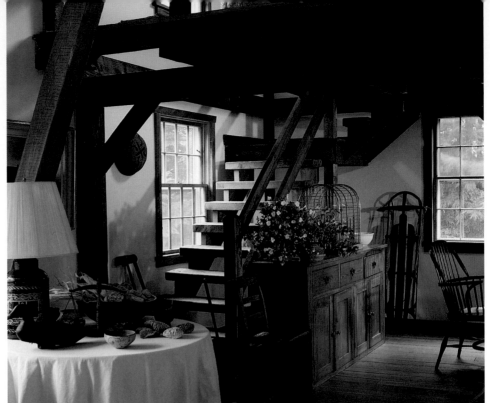

*F*rom the huge organic shapes of Mediterranean farmhouse fireplaces to the simplest molding around an English hearth, the architecture of the fireplace is an integral part of the room's decorative scheme. In small cottages it often takes up an entire end wall and is the dominant feature of the building and the inglenook fireplace with its built-in seating has a special place in people's hearts. A chimney breast of stone boulder construction is like a primitive stepped sculpture climbing ponderously to the rafters, and has the aspect of an archaeological monument expressing the continuity of life in the house and linking the interior with the landscape setting. It can be the only focus for the room and everything else defers to it.

Besides this rugged creature there is an infinite variety of fireplace styles, shapes, and surrounds. Local building tradition and climatic conditions influence them, and those that are original to a building are generally the most satisfying, both aesthetically and practically. Fireplace design is probably the least satisfactory feature to borrow from another region for precisely this reason. The most adaptable part of the fireplace, where the opening is simple and relatively small, is its decorative surround. It is sometimes linked with other architectural features in the room, door and window frames, shelving, and possibly dado rails, by painting them all the same color. This imposes a gentle discipline on the room by dividing up its wall spaces, and from this the rest of the decoration follows easily.

The country living room of the 1990s reflects the ever-widening range of people's travels and the mixture of influences on tastes. While some feel the greater need to defer to local traditions, others seem to cut themselves loose entirely and trust their own individuality. Never before has there been so much source material available: from books and paintings to the increasing number of historic houses open to the public, as well as films where sophisticated teams of location researchers and set designers create ever more inspirational interiors.

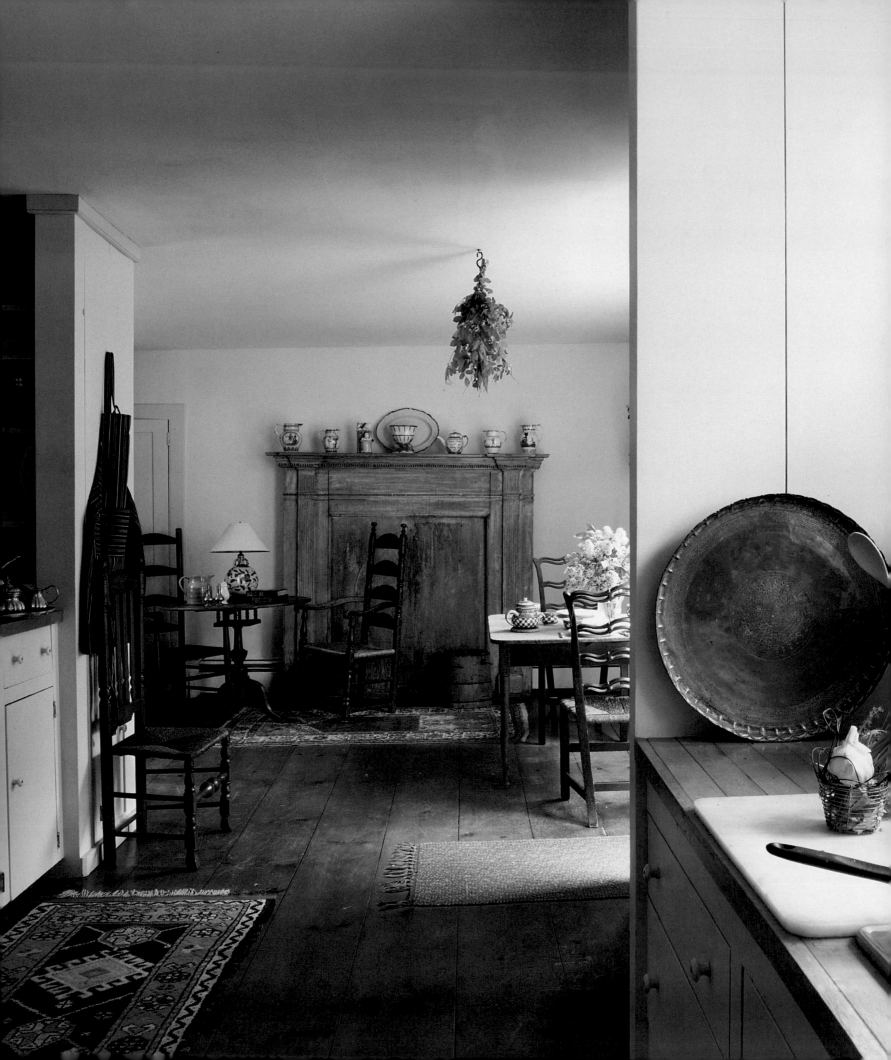

Perfect
KITCHENS & DINING ROOMS

*H*OWEVER MUCH IDEAS CHANGE IN THE DESIGN OF A COUNTRY KITCHEN, ITS AIMS REMAIN THE SAME: TO CREATE A WARM, WELCOMING ATMOSPHERE FOR FRIENDS AND FAMILY, AND TO BE A CONGENIAL AND PRACTICAL PLACE FOR COOKING AND STORING FOOD, POTS AND PANS, AND CROCKERY. TODAY, A REACTION AGAINST THE CLUTTERED AND OVER-EQUIPPED KITCHEN OF PAST YEARS IS PROMPTING THE CREATION OF AIRY, SPACIOUS COOKING AND DINING AREAS WHICH ACHIEVE A SIMPLE ELEGANCE WITH THE MINIMUM OF FUSS.

LEFT
*A balance has been struck in a kitchen built
into a larger room. It is practical and
spacious but its low-key design defers to the
elegance of the fireplace and furniture.*

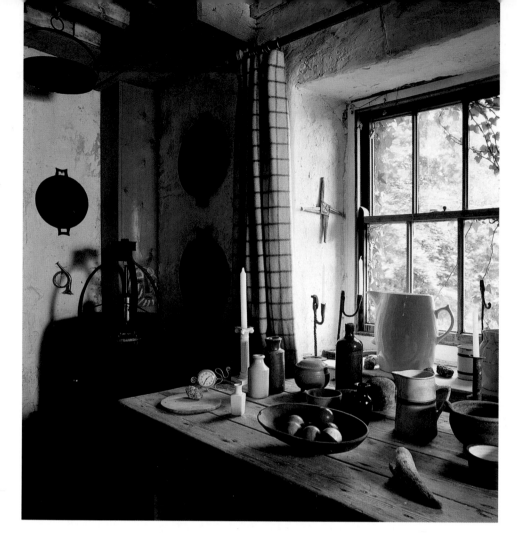

"As cooking becomes simpler—depending on fewer high quality ingredients—so kitchens are becoming correspondingly less elaborate."

A kitchen reflects the priorities of its cook and all cooks are individuals, but trends do emerge and it seems no accident that as cooking becomes simpler, depending more on fewer high-quality ingredients, so kitchens are becoming correspondingly less elaborate. The country kitchen also now depends on fewer, better-quality utensils, solid furniture, and good joinery. That can mean old or new, and it can mean quietly expensive or quietly modest.

Retreating from the extremes of the two major themes in kitchen decor in the last twenty-five years—the crowded displays of bric-a-brac and dried herbs that made the country kitchen and the clinical lines of the approach that borrowed its aesthetic from industrial kitchens—there are middle ways, traditional and quirky ways of arranging a kitchen. Some of these alternative visions have probably been around all along, especially in the unmodernized kitchens of old houses. In them the focus is quite different. The eye is not forced to notice the sleekness of the fitted units to the exclusion of everything else, nor is the spectator so bowled over by the sheer profusion of the china on a dresser or expensive saucepans on the shelves that the possibility of enjoying the individual character of any single piece is removed.

Restraint rather than minimalism is the key and the result is sometimes a kitchen that, unintentionally, begins to look more like its historic antecedents and, more appropriately, complementary to the simple architecture of an old cottage or farmhouse (although there are very few who could forego all the appliances that make modern cooking less of a chore than it was when the house was built).

LEFT *Blackened griddle pans hang on the wall—part decoration, part storage solution and a modern variation on the more traditional display of shiny copper pans. The display of more mundane utensils signals a new enjoyment of their design and materials. Roughly boxed-in plumbing and patchy plaster walls are a picturesque backdrop for the carefully chosen heavy checked curtains.*

RIGHT *This spare modern dining room illustrates a sophisticated version of simplicity where structural features are central to the character of the interior. The lofty space allows full appreciation of the colors and textures of the timber roof and floor, which are separated by the disciplined lines of dark blue painted joinery in a fitted sideboard and pairs of internal and external glass doors around three sides of the room.*

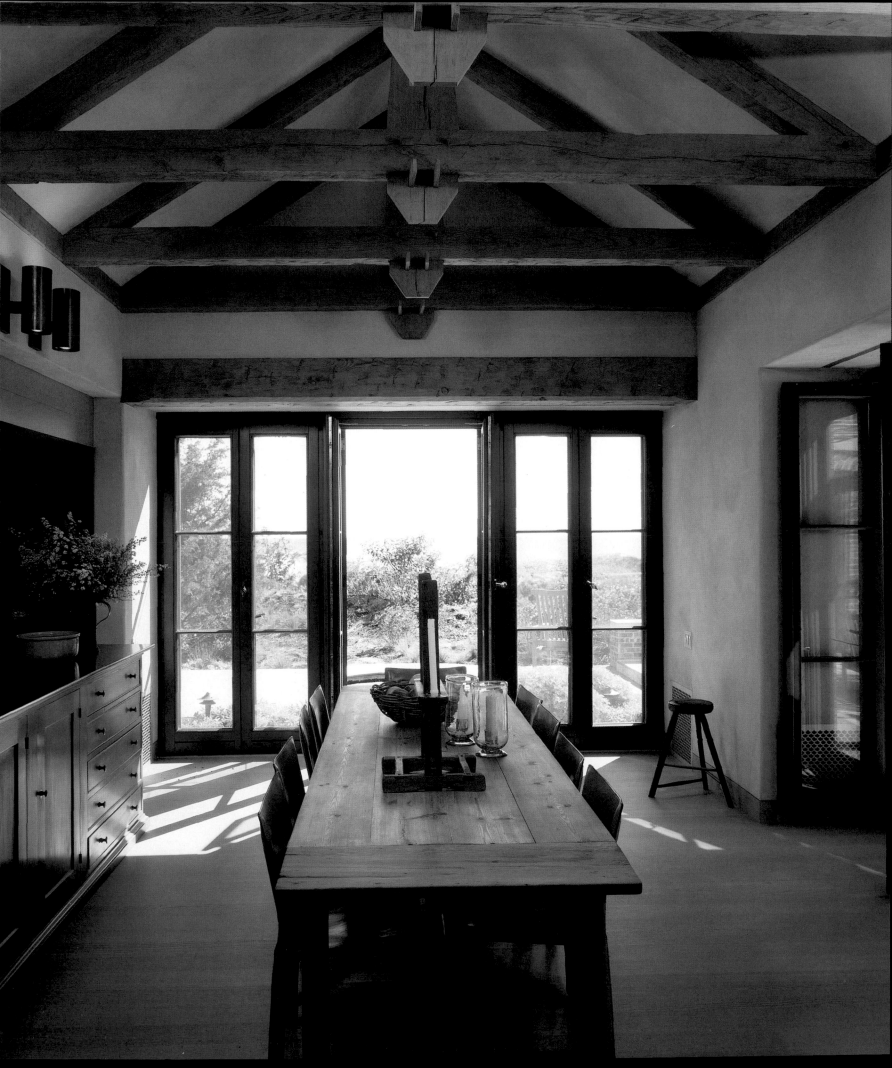

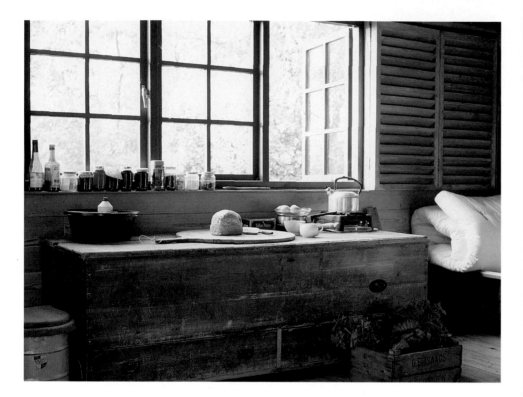

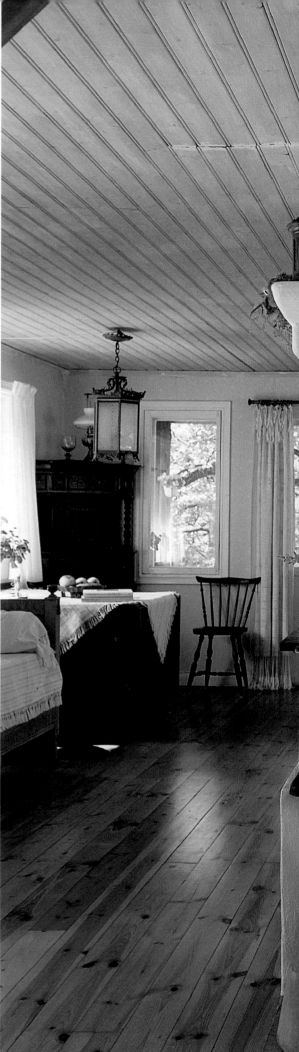

*I*t is surprising how difficult it is to break away from the recent conventions of the fitted kitchen which, as a convenient design solution, has penetrated almost every kitchen in Europe, America, and many other parts of the globe as well. As a simple idea it works well enough, but the repetition of banal design in the mass-produced units ranged along three walls of a kitchen can have a similarly desecrating effect on an interesting room as slapping a jazzy but inappropriate shop front onto a beautiful building. A fitted kitchen can be cheap and cheerful (though it can also be extremely expensive) and in a tiny kitchen particularly it is often the best solution; but there are other ways of doing it.

It sometimes seems as if mass-produced units force a kitchen into submission rather than letting it have its say. In Mediterranean countries, where there is a ceramic tile manufacturing tradition, country kitchens often have tile-covered counters with open spaces for pans underneath. They are practical, hygienic, and architectural in character, so they complement a room rather than looking as if they have been applied to it like make-up. The sharper edges and corners and chunkier proportions make them look like the kitchens of professional cooks, or at least cooks who mean business, rather than those kitchens that look as if they cannot decide whether to be purely decorative or purely functional.

Most of all, these counter-tops have different proportions to the standard fitted unit, 24 inches (60 cm) deep, and one of the most refreshing and successful

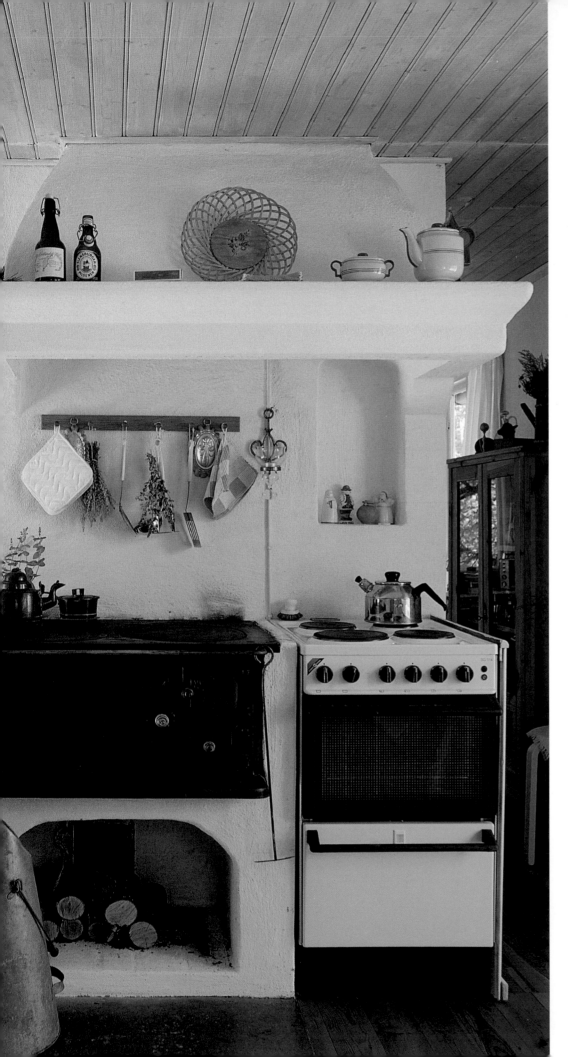

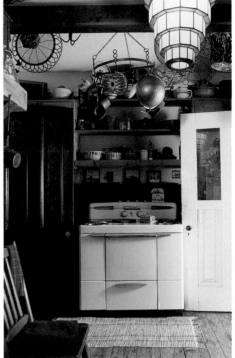

FAR LEFT *One gas ring perched on a long wooden chest is enough of a kitchen in this woodland cabin where simple meals can be prepared without any fuss.*

LEFT *Side by side the old range and a new cooker fit neatly under the broad mantelpiece of an unusual centrally placed chimney, combining the best of the old with the best of the new. In a large open room that serves as kitchen, dining room, and living room, this layout is an ideal informal arrangement.*

ABOVE *A generous-sized old-fashioned electric cooker and an unselfconscious and attractive assortment of cooking equipment of different vintages together reflect the priorities of a cook who uses the best tool for the job—regardless of its pedigree.*

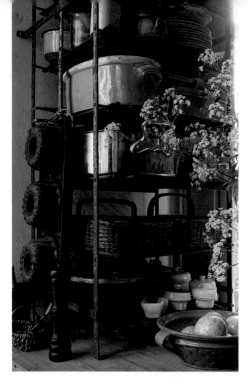

LEFT AND RIGHT *The height of this room and the length of its windows give an otherwise average-sized kitchen panache. A disciplined approach to storage and display makes full use of the space: an iron pot stand reaches to the ceiling and shows off the subtle splendors of a collection of toffee-colored casseroles, terrines and molds, and between the windows three pot-bellied meat covers have been mounted on the wall.*

approaches to decorating the kitchen is to introduce different proportions in these details—not just for their own sake, but where it would make a kitchen work better. Where the tyranny of the standard depth of worktops and kitchen appliances has been cast off, the effect is startlingly different and liberating.

The kitchen furniture designed between the 1920s and the 1950s, when manufacturers were working slowly toward the fitted kitchen but had not quite got there, is beginning to surface again as an alternative to more recent solutions. A 1950s dresser with its let-down worktop, in the sort of pert bright green found also in the glassware of the time, seems almost quaint in its modest pretensions to convenience, compared to the acres of bogus marble on offer today in every kitchen warehouse. Its clean lines and slim storage capacity are characteristic of a period when cookery and cooking equipment was simpler, in the years before it became an expensive mainstream leisure activity with constantly changing fashions. The large scrubbed-pine kitchen tables of sturdy design around which a large family can eat comfortably have long been popular, but there are also the same tables in miniature that would have stood against the wall or beside the stove, where they doubled as work and storage space. Wooden vegetable racks with little printed labels to indicate their contents and straightforward shelves on straightforward brackets are old-fashioned and using them would be merely nostalgic if they were not so obviously practical even today.

We have become very used to the idea that counterspace is the priority in a kitchen and of course it is important, but it means that storage—however extensive—is often limited to shallow, high cabinets or squat, deeper cupboards under the counters. Much more practical and generous is a good, deep floor-to-ceiling cupboard with double doors that can fit things in different combinations—huge carving plates and tea things, piles of plates and pie dishes. Like the butler's pantry of a hundred years ago, green baize is used to line the shelves where silver is stored, and the glasses can be lined up in regimented rows of graduating size to satisfy the most orderly mind.

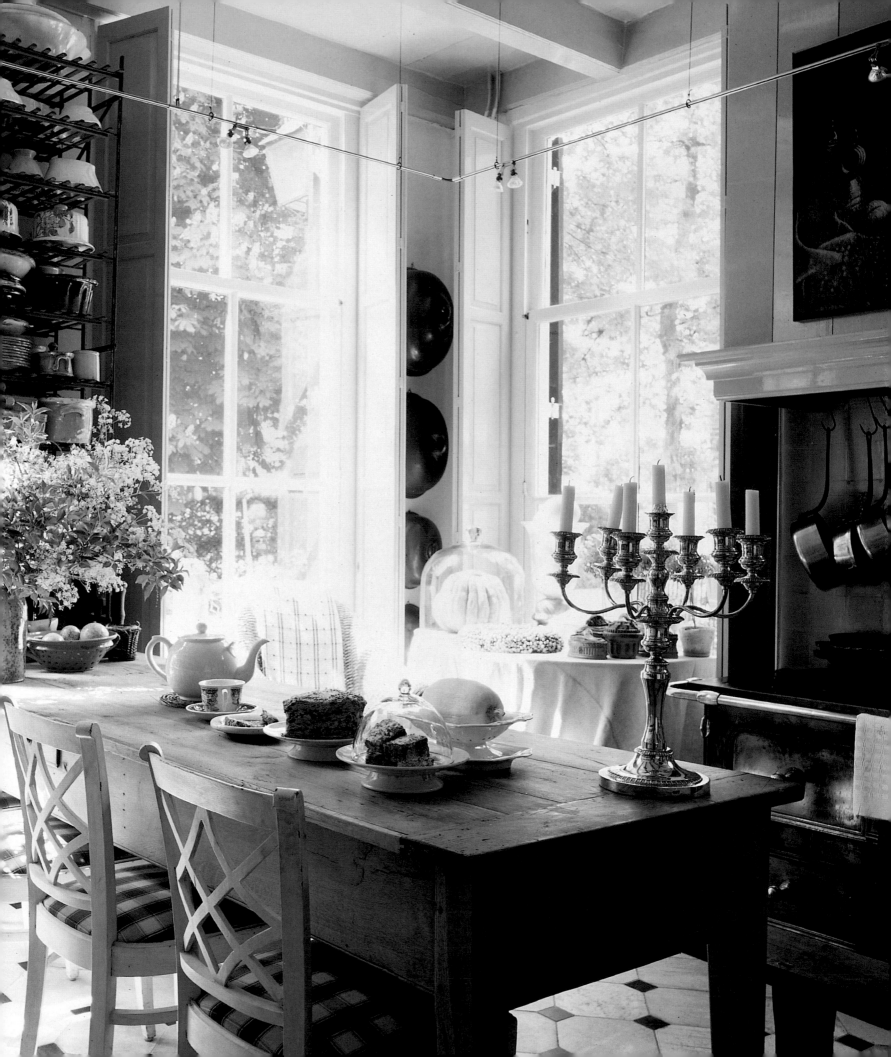

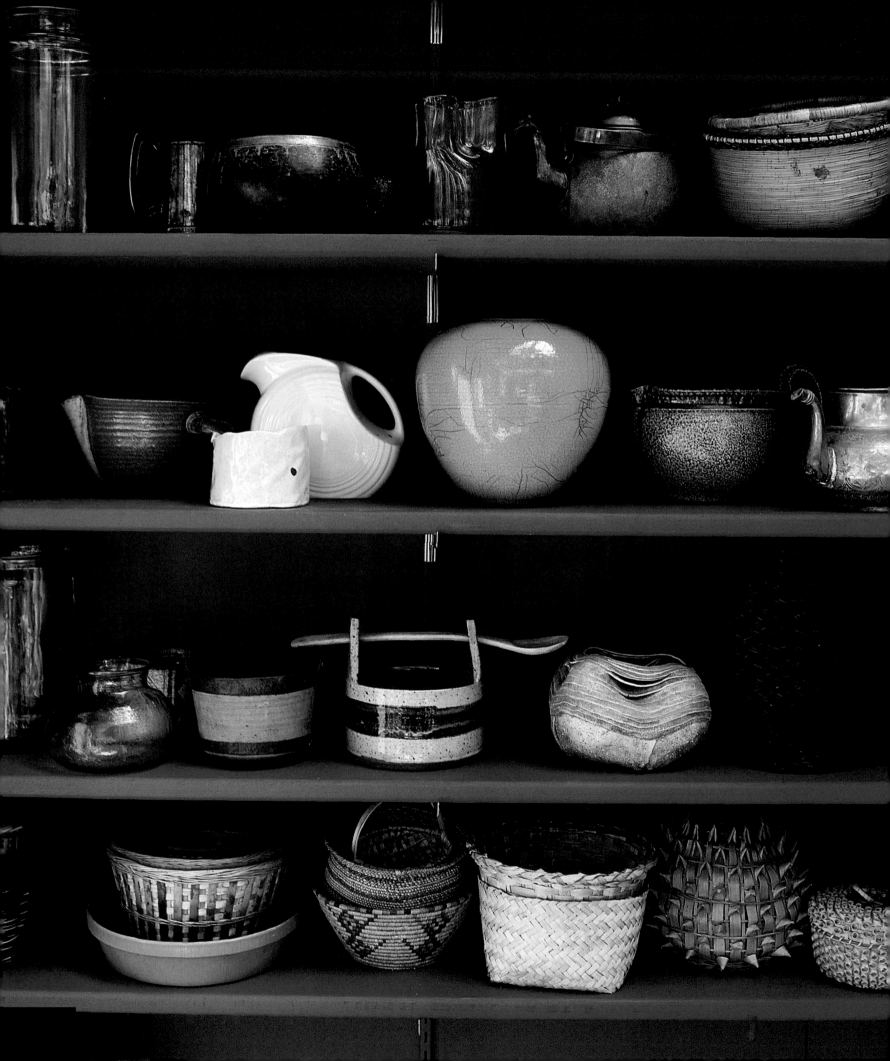

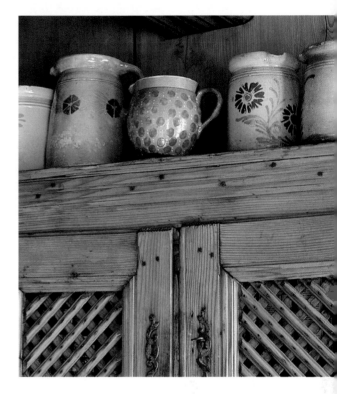

*V*ery often today when a local joiner is fixing some cupboards, the design he uses is not a preciously guarded traditional one, but an amalgam of recently evolved ideas that other people have used and which is guided by the availability of new mass-produced timbers or timber substitutes. By looking again either at local joinery traditions or traditions from other countries, either a simple new solution or a simple old solution can be found. Using a Provencal cupboard design in a New England setting may be wrong-headed in a historic reconstruction, but in a home it becomes a practical answer to a problem.

This need for practical answers means that it is most often the kitchen that comes in for radical rethinking when an old building is being updated for modern living. At the rear of a Dutch colonial farmhouse in upstate New York, or a Georgian house in Herefordshire, England, the old service rooms may be of a different and later date than the main house—poky, unappealing and impractical, for whatever reason. Two hundred years ago large windows and light were not priorities; the former were expensive and therefore the latter minimal, and in an age before the wonders of refrigeration food conservation required cool, dark, well-ventilated rooms for storage. Today the country kitchen often needs to double as a dining room as well, because people like to cook with their guests around them and anyway there is often not enough room in a house for a separate dining room. With these modern demands being made on the cramped layout of an old house a total redesign of this part of it is usually the best solution.

Most owners today try to achieve a solution in sympathy with a historic building, and never before has the source material for solutions and ideas been so rich. This can create as many problems as it solves, but it also means that the kitchen can become the most imaginatively perfect country room and attempt to fulfil that ever-elusive ideal. As one of the drawbacks of many old and simple historic buildings is the relatively small room spaces, the possibility of choosing larger proportions in the kitchen and bringing in airiness and space becomes most exciting. Perhaps one of the best solutions is the top-lit kitchen such as you might find in a Portuguese manor house or an Edwardian English house. The single-storey kitchen block has a long history; quite often it formed a separate unit and was built a little way from the main

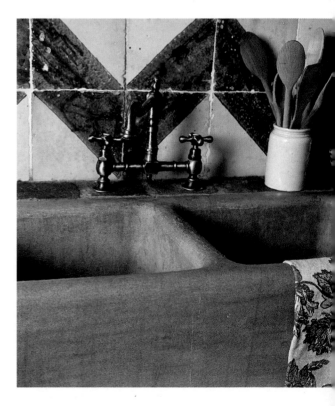

LEFT *At first glance this seems an arbitrary array of pots and baskets, but the display they construct is as harmonious as it is intriguing. The eye is drawn in by the bright turquoise vase and begins to explore other patterns, textures, and shapes. Earth colors are common to most of the pieces, giving the shelves a tranquil sense of unity.*

ABOVE RIGHT *A collection of country jugs on top of a honey-colored kitchen cupboard shares similar patterns and coloring that make for a coherent display.*

RIGHT *The simple design of these traditional tiles makes a bold splashback that complements a modern sink and faucets.*

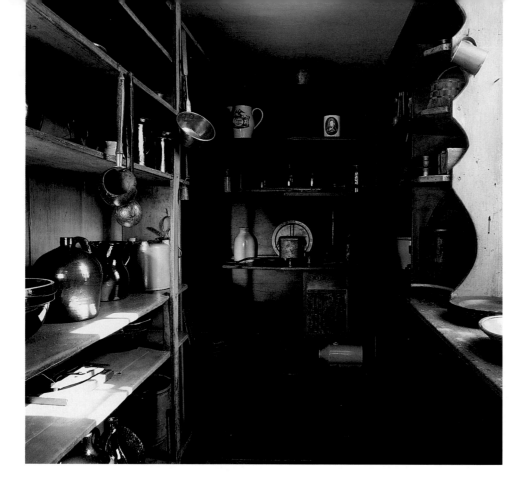

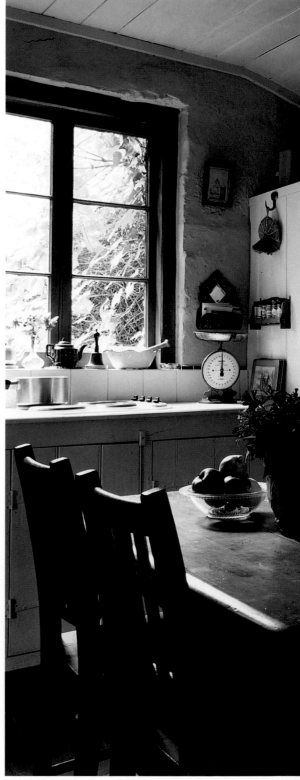

house as a fire precaution, so a plan that includes a new extension might even find some historical justification. Combining a top-lit design with traditional-sized windows to match the rest of the house can give a refreshing impression of spaciousness without compromising the exterior, and represents a modern departure in so far as the service block has become a presentable part of the house.

Establishing a new space and airiness in a kitchen connects it psychologically to its country setting, but it also focuses attention on the fewer things in the kitchen. Suddenly you can see and appreciate the great flagstone slabs on the floor—which might be the same as those used outside the back door—or the width and pattern of the floorboards in an old house. Building materials are constant echoes of a sense of place, connections that are reinforced, of course, by traditional regional design. The style of a Tuscan kitchen fireplace, for example, built upon a platform about 18 inches (45 cm) from the ground is quite different from the wider, lower fireplace in an English farmhouse. The latter usually has a stove installed in the opening today, whereas in Italy the fireplace is still used for a good blaze or perhaps some cooking *alla brace*. Logs are stacked up in an arched recess underneath, ready to stoke the fire.

Unchanging rural tradition also has a lot to teach about good honest design, in everything from pots and pans to bread ovens and smoking chambers, cool larders, and flooring materials. The simplest things—like a wooden towel hanger on the back of a door, the carefully gouged channels of a wooden draining board, the colors of slate shelving in a pantry or the texture of green baize in a cutlery drawer—catch the eye because of the care that has gone into their manufacture and because of their obvious practicality.

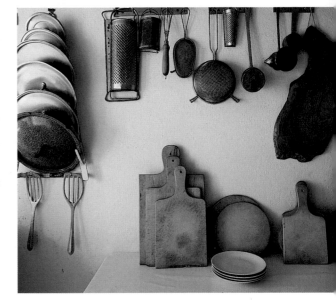

FAR LEFT *The glazes of dark brown and black ceramics catch the light while the outlines of a wooden barrel and basket emerge as dull shapes creating strange chiaroscuro effects in this kitchen storeroom. A soothing atmosphere has been achieved by rigorously excluding anything that does not blend with its limited color range.*

LEFT *This Australian dresser's functional design, unfussy lines, and locks and plain panelled doors give it the look of a kitchen safe. In contrast to the open shelves of Welsh and English dressers, everything is shut away, and instead of yellowy pine it is made of richly colored native timbers.*

ABOVE *Humble kitchen utensils make a wonderful display even in everyday use. Graduated sizes of wooden chopping boards are patterned with the crosshatching of years of use, while different shapes of sieves and metal saucepan lids catch the light across their uneven surfaces.*

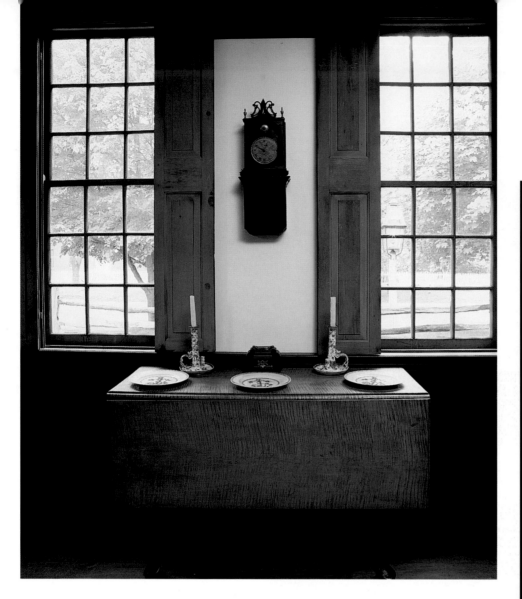

Sensitivity to the pleasure given by small details is evident in the quieter and more discerning way that pots and pans are collected, used, and displayed. Two or three colored glass bottles on a window sill instead of twenty focus the mind on their shapes and colors. The most humble utensils can make the most startling and appealing display: four darkened, much-used griddle pans hung like pictures on a wall, three modest 1950s coffee pots on a mantelpiece where before you might have expected to see china dogs, the chalky colors of old enamelware against a white backdrop. All these things are a rebuke to the garish ugliness of modern food packaging, blown styrofoam, and plastic. It is as if, in a country setting, one can rediscover subtlety in color, texture, and shape, in nature and in man-made things, so that time spent here is a cure for the senses.

As a retreat from modern urban life, the country kitchen can be most effective when it is almost monastic in its austerity. A sink, one gas burner, and the bare minimum of pans and crockery is perfection for some, and people have of necessity lived—and still do—with less. The quality of the cooking does not depend on the size of the *batterie de cuisine,* and we all know that things often taste better when eaten round a campfire than they do in the predictable ordinariness of a well-appointed kitchen.

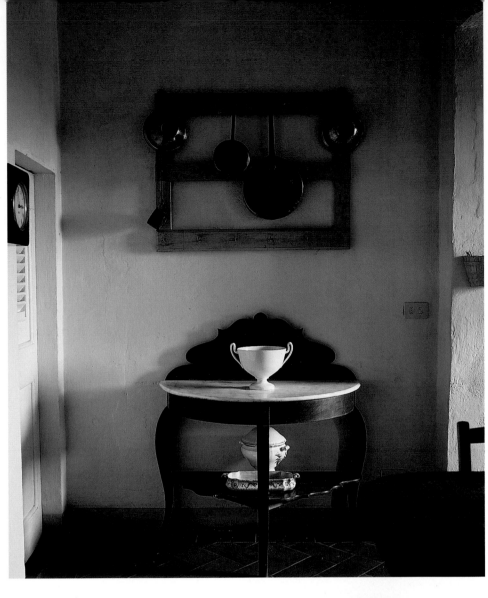

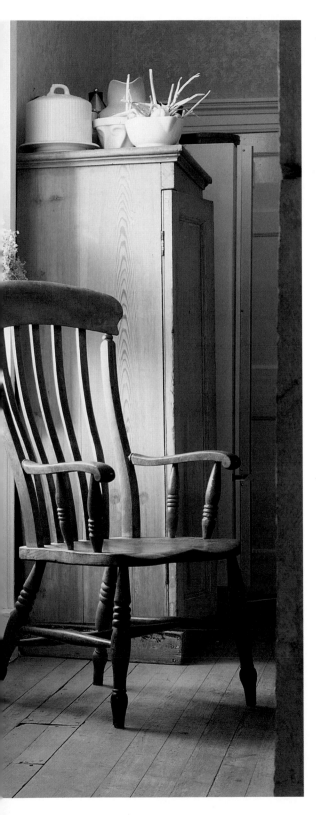

FAR LEFT *Simple elegant furnishings are historically correct for this bare eighteenth-century dining room, but avoiding clutter also creates a tranquil atmosphere.*

LEFT *This is the high-backed country chair that evolved to satisfy demands for comfort and practicality still being met today.*

RIGHT *Coffee pots of different ages line up above the sinuous curves at the back of an old range. Three metal jugs march with studied uniformity along the hotplate below.*

ABOVE *A polished side table is placed below a rough frame of hooks showing how the formality of the dining room meets the informality of the kitchen.*

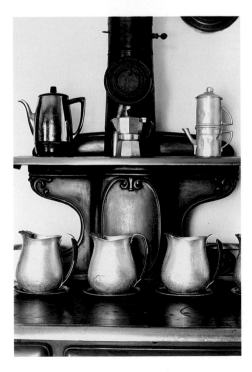

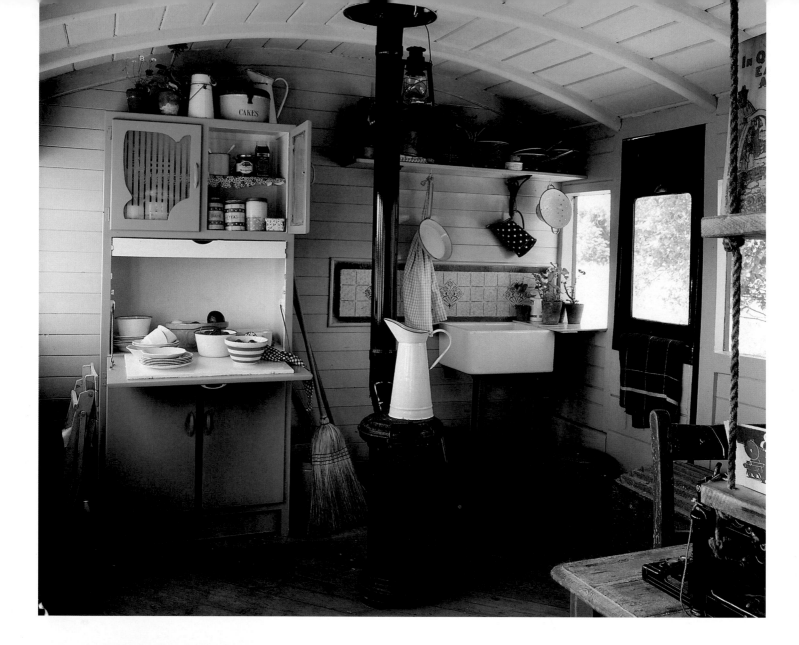

*T*he difference today is that people are choosing simplicity, and the individuality of their approach results in the creation of new combinations of old and new and quirky juxtapositions that suit their particular lifestyles. Kitchens are peppered with discreet little contrasts of simplicity and sophistication. In a one-room wooden cabin you would expect to see a kettle and a couple of plates, but not necessarily the pair of Georgian rummers or the package of good coffee beans. Apart from this, there is little room for paraphernalia—the daybed is only a step away and a typewriter takes up most of the table space. The confidence to get rid of unnecessary things and to concentrate on those utensils and pieces of furniture that are important to you for their sentimental, historic, or practical value, is a driving force in these rough but comfortable country interiors.

Comfortable, but not so rough, are the kitchens designed on a more generous scale, modern but appreciative of old things where they make sense. The starting point is a lofty room where cooking and eating are done in the same space. The aim is to keep everything quite plain and functional but to make sure that in its details and materials it uses the best quality for the job. The fittings are unfussy, the shelves

OPPOSITE PAGE *In the kitchen of a railway carriage a stand has been taken against the seamless monotony of fitted units. Salvaged enamelware buckets, kettles, and baby churns decorate the shelves; even the cream and green paintwork takes its cue from a frying pan and colander.*

LEFT *Bright red pot stands provide the perfect counterpoint for rich green walls and painted furniture. One carefully chosen object can influence a whole interior.*

ABOVE *In contrast to a bright ethnic scheme drab greens and browns point up the asceticism of this log cabin kitchen.*

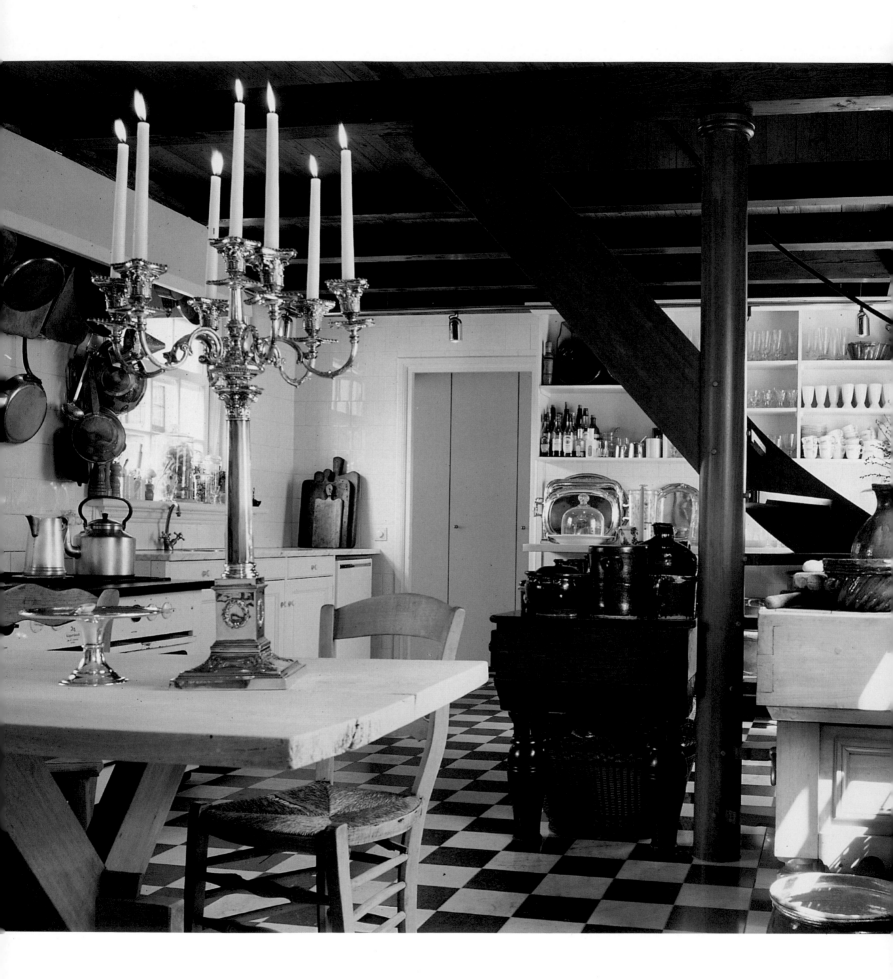

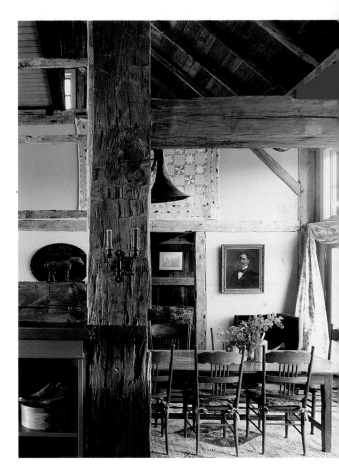

LEFT *New and old furniture, objects, and equipment are combined here in a comfortable, spacious modern kitchen that nonetheless retains many of the ideas from older style kitchens in the sturdiness of its fittings and the generosity of its design. The natural colors of wood, earth glazes, and basketware are predominant and are set off by the blacks, whites, and grays of the floor, walls, and shelving and the glint of glass and metalware. A splendid silver candelabra gives the room a sense of occasion.*

RIGHT *A dash of drama is injected into conventional layouts of furniture and pictures when they are installed in the spacious and unusual room shapes of a converted building. Here the rugged timber structure of a barn house plays host to a traditional room arrangement below— matching chairs around a dining table, a portrait on the wall and the warm colors of a Persian rug.*

of very thick, good wood, rather than a substitute that has been carefully researched and sourced. Original floorboards and skirting boards would be happily incorporated in this new scheme provided they are in good condition; otherwise a new floor of modern plain tiles or wood is laid without a second thought. Spaces might be carefully planned to accommodate particular pieces of furniture, which might be good old kitchen furniture or perhaps a side table of decidedly grander pedigree. An old cupboard or kitchen table, kicked and scruffy from years of use, is placed next to the new paintwork of a dado, highlighting its old scars and allowing an appreciation of its shape and texture. Wooden vegetable crates bearing the names of growers in an elegant typeface of fifty years ago are displayed next to a rather pompous nineteenth-century silver chandelier. Everything here is valued for itself and the humble and the grand sit happily together. The juxtapositions of old and new, modest and sumptuous, would not have been understood in the past, but now it is an expression of disenchantment with the idea of newness for the sake of newness and the thoughtless waste of a throwaway age, as well as a genuine enjoyment of the patina of much-used things.

"Individuality of approach results in quirky juxtapositions and original combinations of old and new that tend to suit particular lifestyles."

RIGHT *A spacious but low-ceilinged farmhouse kitchen owes its distinctive character to the unfashionable glossy brown of its painted ceiling which nevertheless reflects the warm colors of the fire. The same color is used on the huge fireplace surround, the dado, and a cooker hood in the corner. It is countered by an old-fashioned buttery yellow above dado level. Most modern kitchens are so emphatically bright that this atmospheric solution seems instantly appealing simply because it is different. Color schemes need to be constantly reinvented both to find fresh ideas and to escape from the powerful influence of fashion.*

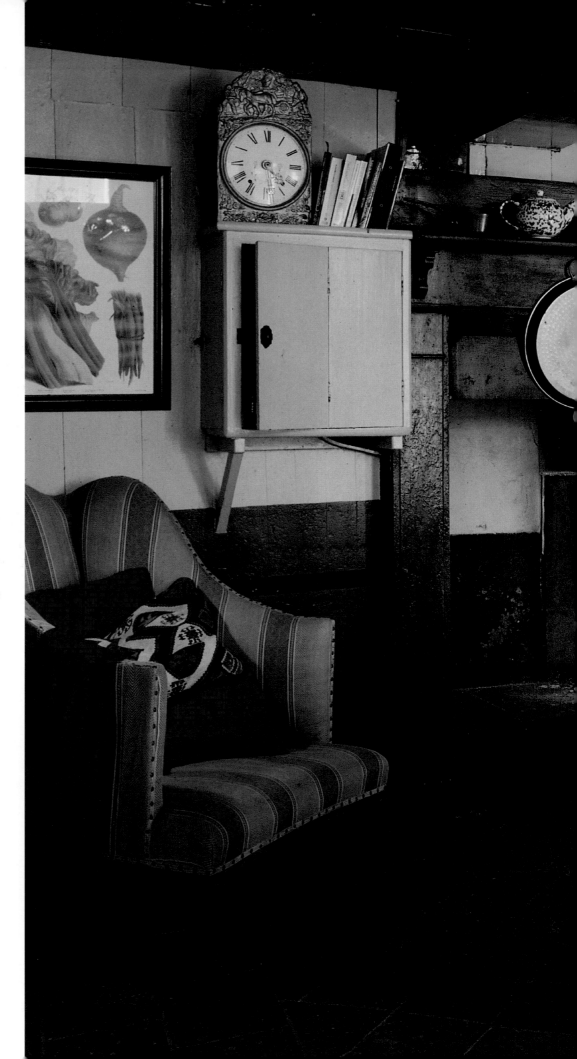

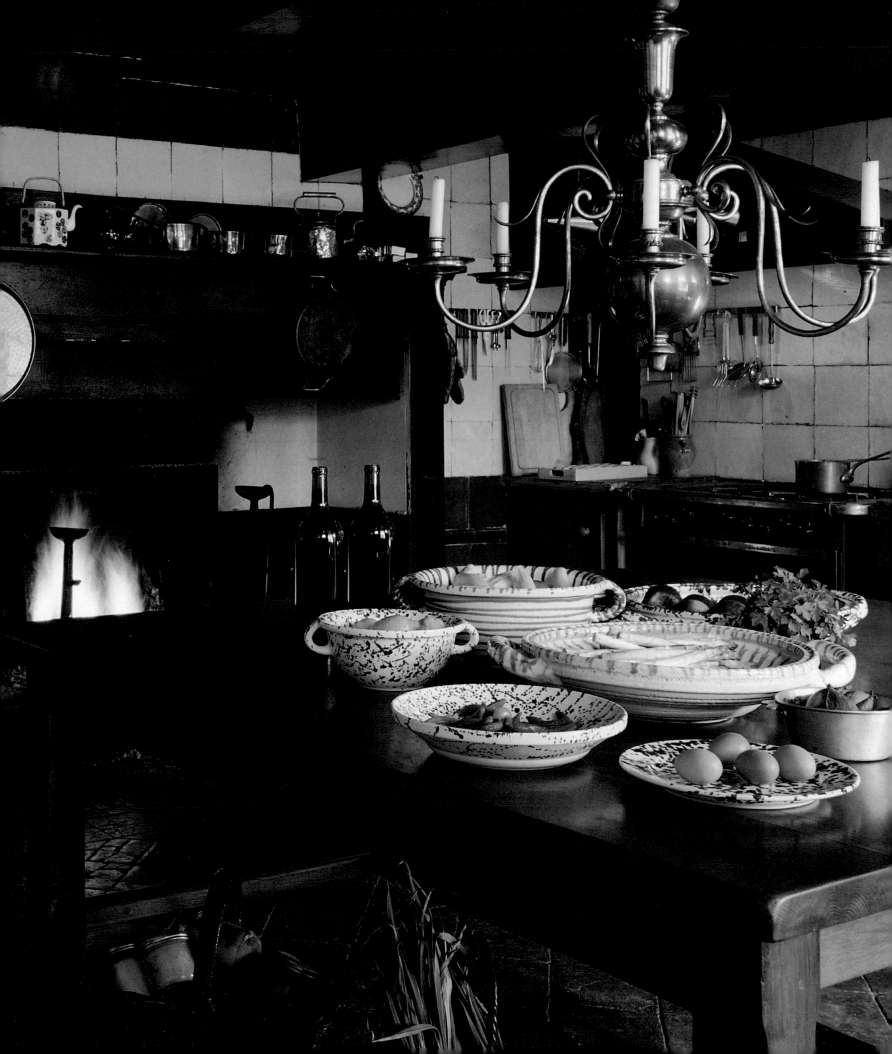

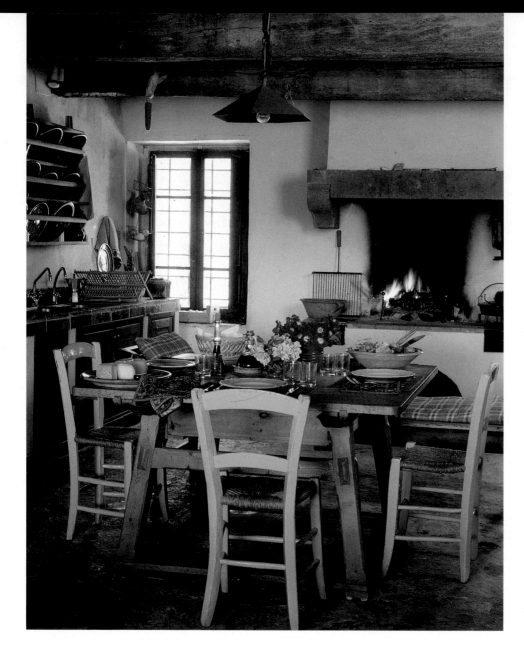

LEFT *Being able to cook fresh food* alla brace *is the chief pleasure derived from having this traditional Tuscan fireplace built on a platform. Instead of particleboard units a sturdy concrete counter has been built along one wall: the freedom to choose the proportions in its detailing means that the kichen's character is complemented rather than dominated by its fittings.*

BELOW *A fastidious householder might find this bohemian scene a little too rough and ready, noticing cobwebs and health hazards rather than the luminous colors of glass in a deliberately undecorated kitchen. Here the simple life reflects the choices of a soul whose attention is on "higher" things.*

RIGHT *An interior showing two flasks and a bowl on a trestle table in a bare room seems, like an enigmatic still life composition, to hold some meaning beyond its spare reality.*

*I*n the same way that old-fashioned kitchen furniture and equipment is beginning to be appreciated again, so too are the larders and back storerooms of an old house where they are still practical and retain their fixtures and fittings. Nothing beats slate, stone, or marble shelves for keeping food cool, and the creamy colors of tiles used in larders in the 1920s and 1930s are worlds away from the harsh whites of today's ceramics. When these larders were built, decoration for its own sake was not a priority; function was everything and a desire for hygiene above all is evident in the one-color tiling used in kitchens and larders right up to ceiling height. The overall look was simple and sensible, and is still found in the kitchens of manor houses and small country hotels in France, Germany, and Austria. In terms of decoration it was really a "non-scheme," but the combination of no-nonsense practicality and unself-conscious design created an aesthetic that seems appropriate in a country setting and that has become inspirational for recent kitchen design.

The updating of a kitchen might take its cue—in what it chooses to leave or change—from the simple but efficient designs of that time. It does not follow slavishly but picks up on the earlier priorities, so that the tubby snakes of metal

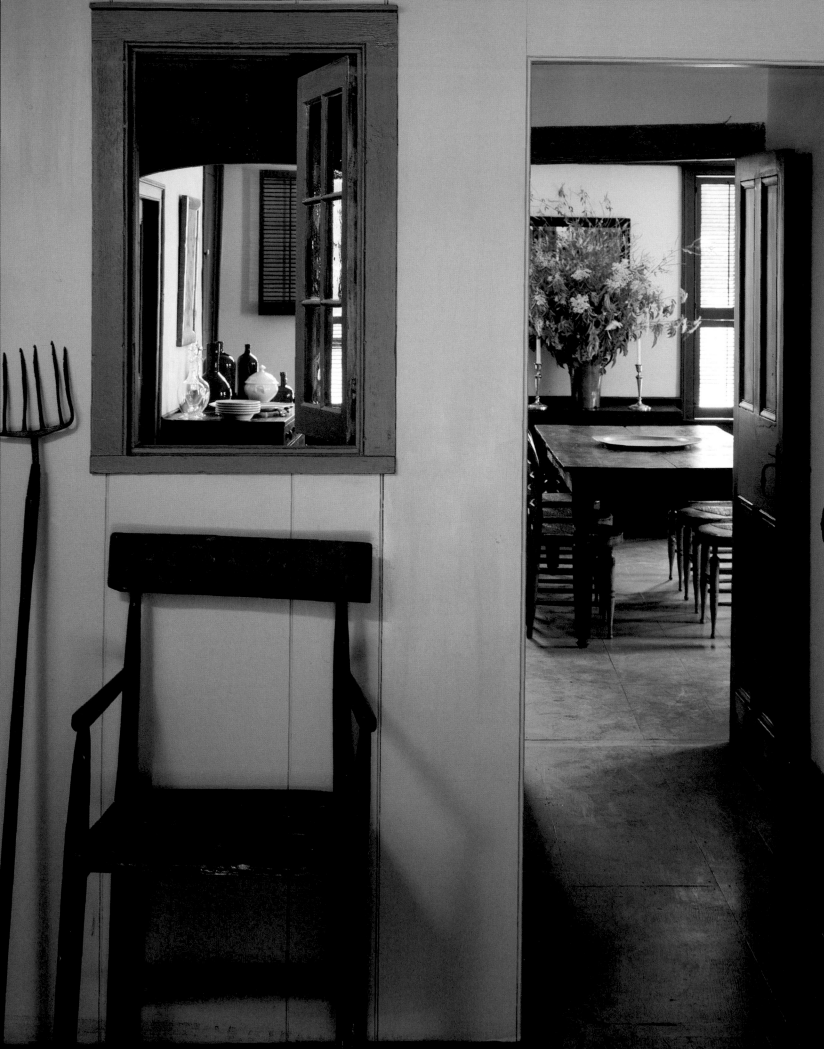

LEFT *Views through a door and an internal window in this neutral interior reveal a light-filled dining room where gray-green paint has been used to tie the architectural details together in a taut, spare decorative scheme. The furnishing of this house is not a result of the casual accumulation of bits and pieces but rather a careful filtering out of any distracting objects from a clear focused vision. The poised restraint becomes a backdrop for blazes of color in the temporary but abundant displays of glass and china on a sideboard or flowers on a table.*

RIGHT *With all the quiet browns, grays, and whites of this interior, a disciplined two-color arrangement of flowers might have been expected to complement it, but perhaps it is a mark of respect and a recognition of the vibrance of natural colors that this jug full of bright flowers should be allowed to bring the room to life so completely. The flowers seem to be teasing their surroundings for being so subdued. Contrasting with a roughly made trestle table and benches, a fragile lace curtain falls to the floor at the window adding a feminine element to this robust room.*

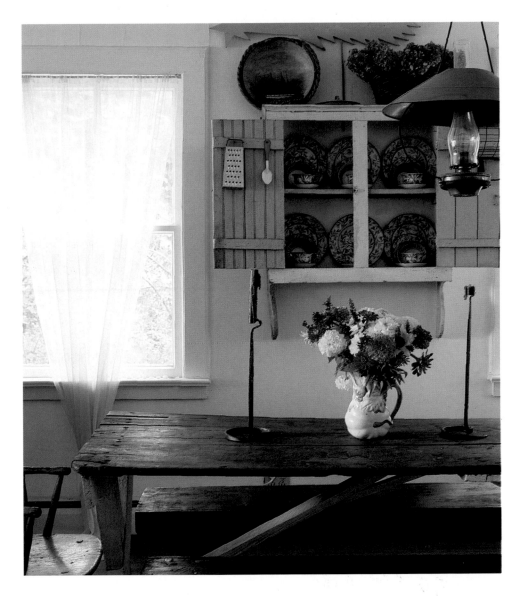

"*The new spareness is about restraint rather than minimalism, but it also embraces a lightness of touch and a sense of humor.*"

plumbing pipes that, a few years ago, would have been hidden away in elaborate boxes of clever joinery, are allowed to run purposefully toward their mysterious destinations in full view. Where plastic pipes are to be installed in a new kitchen, in contrast, they would be carefully boxed in. Pride is taken in the solid old plumbing with its wall brackets and chunky joints, whereas today's casual assembly of plastic tubes is not thought well designed enough to be on show.

Unfussy fittings that promise years of use, an absence of gimmicks and fashionable decorative touches, good materials, and solid workmanship characterize the country kitchen today. Where old or old-fashioned elements are used, it is because they work, not because they lend picturesqueness to the room.

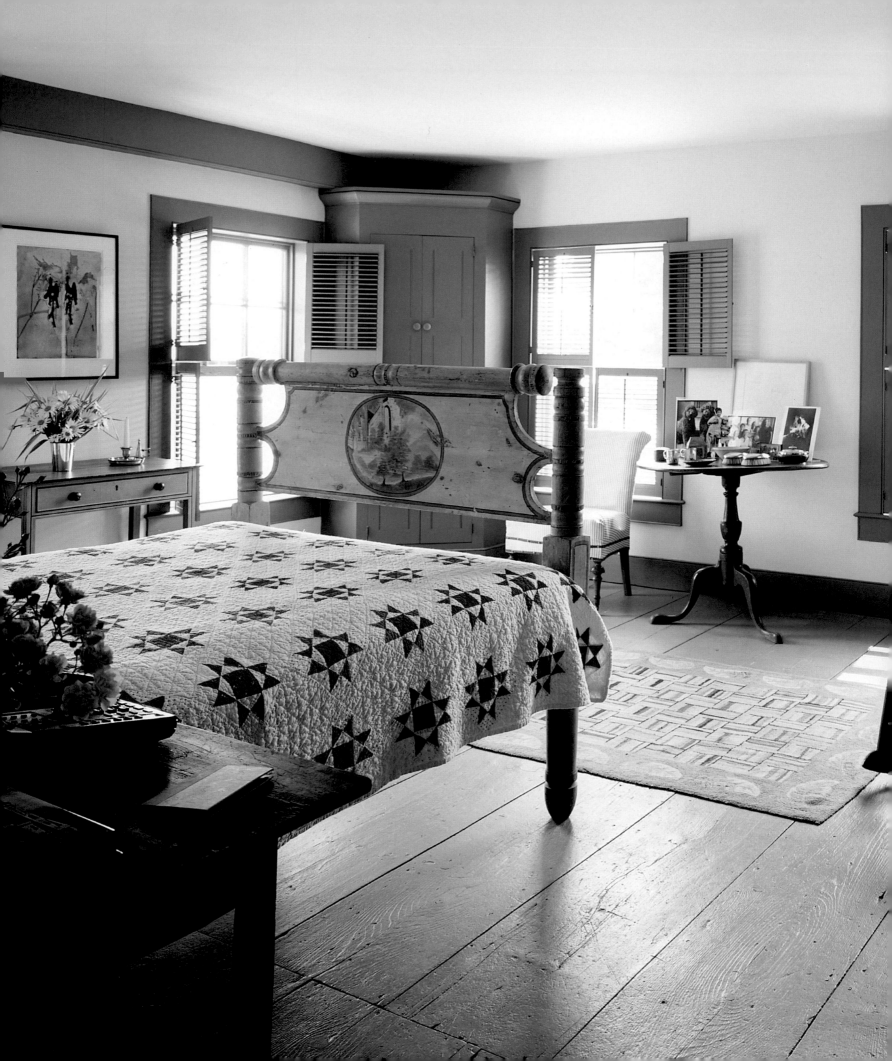

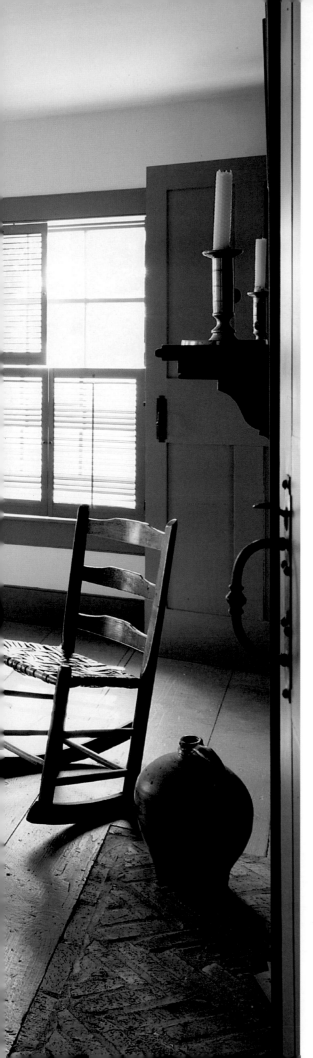

Perfect
BEDROOMS & BATHROOMS

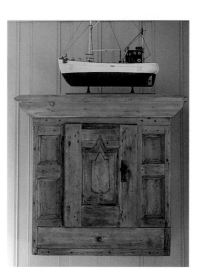

Whatever the play on expectations in a bedroom's decoration, the most important thing is that you can sleep well in it. Of all the rooms in the house the bedrooms should be the most tranquil and restful in arrangement, color scheme, and materials. There can be surprises too, but of a gentle kind: a twist here and there in a conventional decorative scheme gives a bedroom freshness, but nothing too boisterous that might threaten a peaceful night's sleep.

LEFT AND ABOVE

In a bedroom refreshingly stripped of soft furnishings, silver brushes and photographs crowd a table, reminders of family, friends, and, like the model boat above, of childhood.

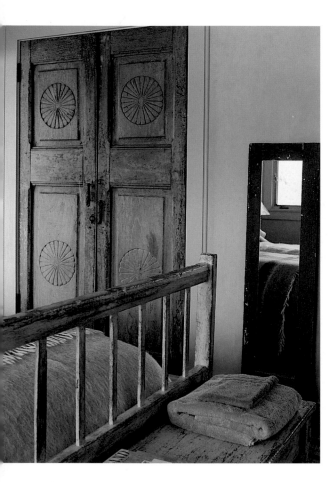

ABOVE *Distressed paintwork breaks up the strong solid greens and blues of the walls and furniture to soften the atmosphere.*

ABOVE RIGHT *Souvenirs from foreign travels provide inspiration for this strong color scheme of reds and blues. Although the door moldings and skirting board are conventional enough, they still manage to give the bedroom a distinctive ethnic look.*

FAR RIGHT *A few pieces of furniture are arranged like islands in a sea of dappled terra-cotta tiling, while a crowd of glinting silver pots and bright flowers adds a dash of drama.*

*T*he classic country bedroom of recent times is instantly recognizable today as a series of pretty clichés: a four-poster bed, a quilt, a color scheme of whites and pale pinks, yellows, or blues, and mounds of lacy cushions. This pastel fantasy is in danger of becoming a little cloying and a breath of fresh air has, in response, begun to blow through the country bedroom.

Small changes can make all the difference, but perhaps the biggest change is a switch of focus away from too many rich soft furnishings—floor-length bedside table covers, thickly interlined curtains, and elaborate pelmets—toward the spatial character of the room and its architectural features. And just as fewer soft furnishings bring out the room's essential character, so fewer pieces of interesting furniture complement it.

The traditional bedrooms of Mediterranean farmhouses perfectly illustrate the call to spaciousness, with proportions that sometimes seem to be borrowed from an opera set. In a farmhouse bedroom in Spain or Italy an antique bed of generous size, with a wrought iron or wooden bedhead, sheets of coarse linen, and rough blankets in drab colors, rests in splendid isolation in uncompromising acres of beautifully craggy terra-cotta floor. There are no unnecessary props, no matching bedside lights or bedside rugs the size of postage stamps, no lacy cushions or baskets of magazines. A cupboard of impressive size with double doors and bold carving or painted decoration stands against a wall; there might be chairs and a table used as a desk, but little more. The walls are rough textured and light floods in through a tall window. The loftiness of the room is emphasized by the exposed workings of the roof, and the browns and pinks of its timbers and tiles mirror the floor below.

Whether the room is in the most rugged farmhouse, where the walls are whitewashed stone and the door opens directly onto the farmyard, or in a more genteel country home, the furniture does not need to match the social standing of

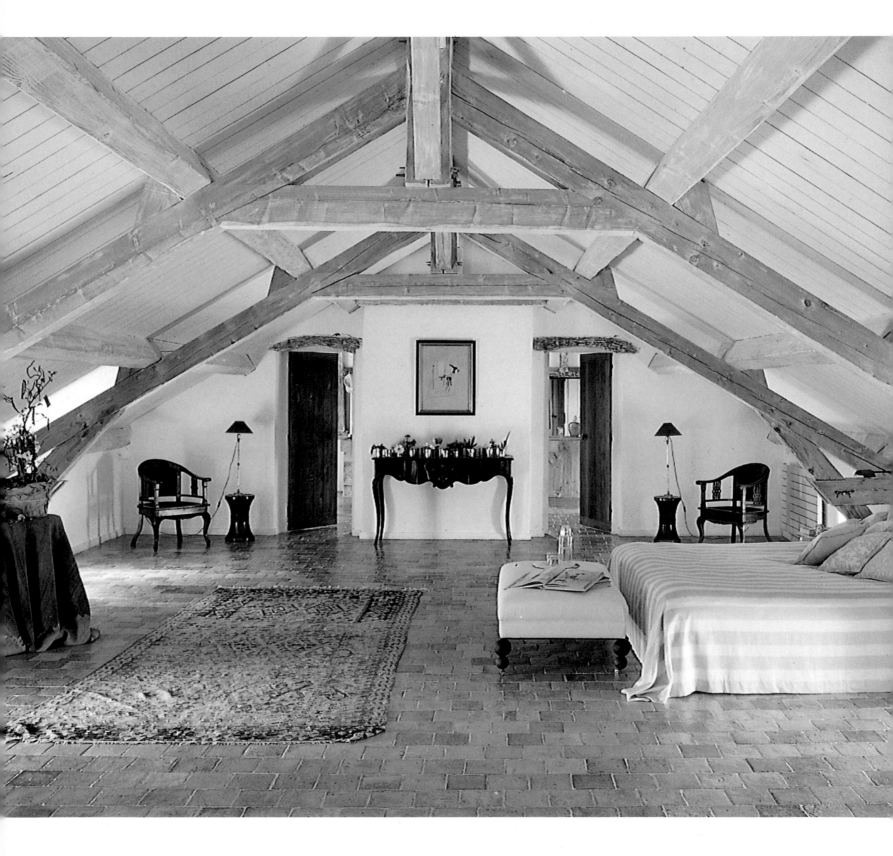

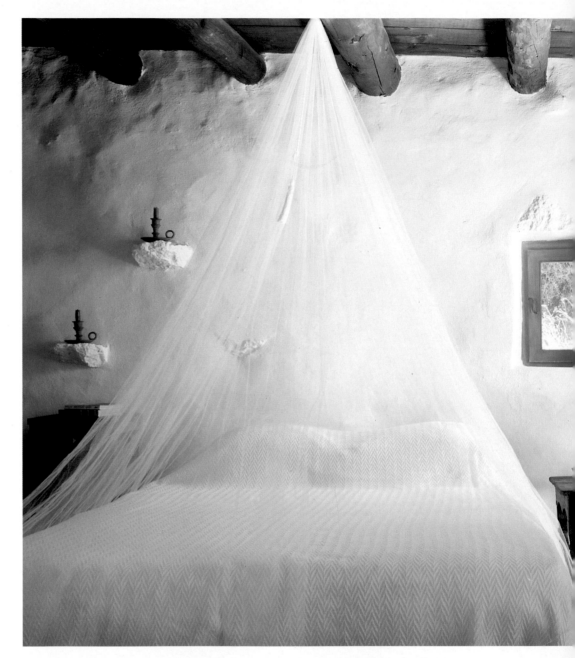

RIGHT *Hung from a sturdy log beam a delicate tent of netting provides a compelling focus in an otherwise rugged farmhouse bedroom. While a minimum of furniture and no ornament to speak of might seem uncompromisingly ascetic, the freshness of the white walls and the warmth of the wooden ceiling and wide floorboards in fact make it an inviting room.*

FAR RIGHT ABOVE *The bumps and patterns of whitewashed rough masonry walls are illuminated by light from a small window. The window-sill is a stone slab, its lintel a beam: all the structural elements in this primitive building play important roles in the decorative scheme and are enjoyed for the character of the materials. No applied decoration is needed to enhance the effect.*

FAR RIGHT BELOW *The sculptured quality of the steps, doorway, and window seat in this Mediterranean bedroom make conventional furniture seem almost an intrusion with its right angles and straight lines; but doors and windows have to be fitted into the curves and scoops of the rough plaster and the furniture follows suit.*

its surroundings to look elegant. Grand furniture sparsely arranged in a spacious but humble setting can look perfectly at home, as can humble furniture in a spacious grander setting. It is not quite a case of anything goes—a good eye for the right piece is as important as it ever was, but the old principles of well-behaved furniture that knew its place have been swept away.

This is partly because people today set up home in such a variety of country buildings, not just cottages or farmhouses; a blank canvas stands before them for an individual arrangement of rooms and decoration. In a home converted from a farm building or a mill or school house where a lofty bedroom can be created from scratch, there is scope to produce anything from a grand country house setting (which is not reproduced, but simply hinted at using country house furniture in a

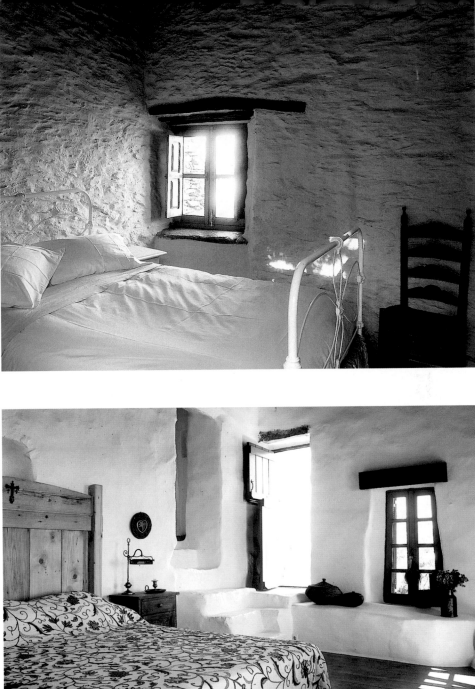

large space) to a more eccentric vision, using unexpected combinations of old and modern furniture and perhaps splashes of ethnic patterns and bright colors in the choice of fabrics against an otherwise neutral background. Where each object has different associations the mixture of messages given out confuses but delights.

The confidence to choose a bold scheme and to introduce color in an assured way is the key to a successful bedroom. Splashed onto the pale canvas of a bare bedroom whose walls, door, and window frames are washed with a single shade are the bright colors of a flowered linen—used perhaps to upholster a deeply comfortable bedroom armchair placed under the window. One or two other spots of color around the room might be provided by a single vase on a chest of drawers and a little island of colored rug in the same color range as the chair and vase, but not

"_Bedroom furniture that promises comfort in a rudimentary setting is like a civilized encampment, and a surreal juxtaposition is created as the setting becomes simpler and the bed more elegant._**"**

RIGHT _This dramatic bedroom could be in a palace or a garden building but instead of playing up to either of these notions it follows an individual course in an exuberant, personal style. An eccentric mix of furniture is combined with jugs of wild flowers in a vast undecorated space and highlighted with splashes of acid color._

FAR RIGHT _Traditional elements of simple country furnishing have been chosen for a converted train car. Lace curtains and a wrought iron bedstead are arranged alongside a trunk used as a bedside table in a jokey bedroom._

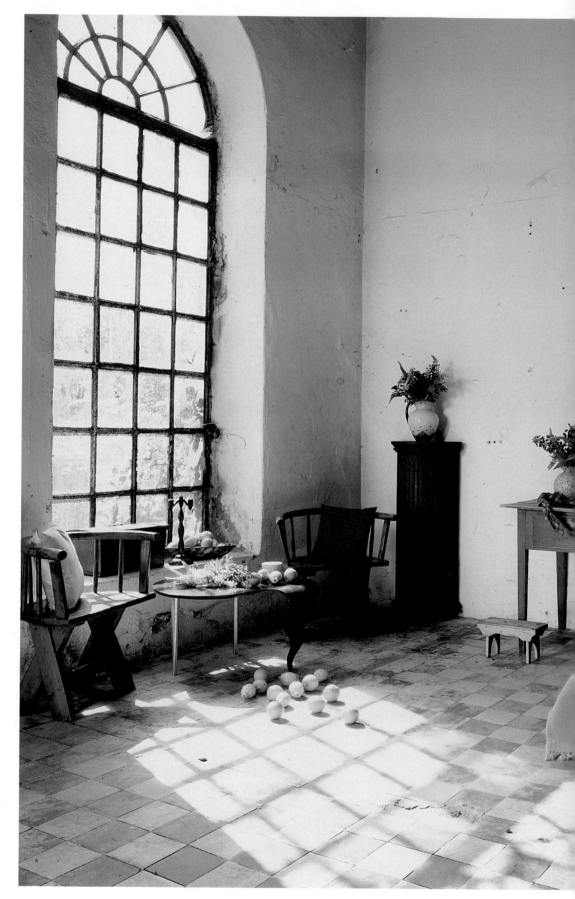

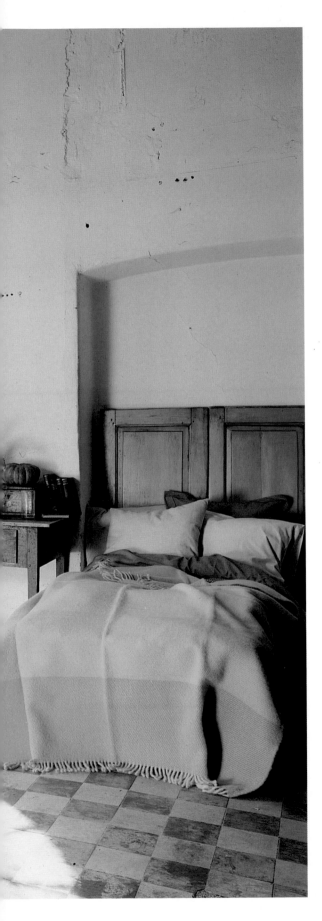

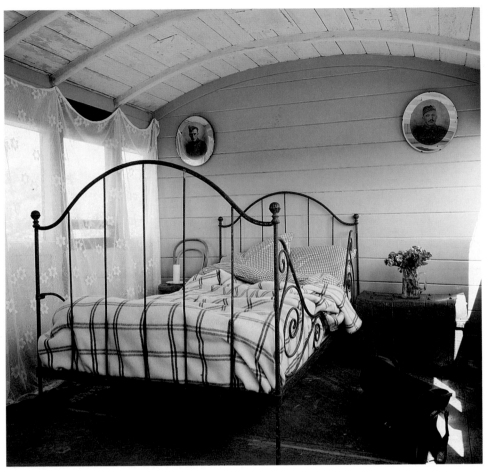

matched. An iron bedstead, the lack of ornament, and the blankness of the single color recall at first a 1920s sanatorium—all hygiene and functionalism, light and airiness. But the introduction of the gaily colored elements retrieves the room from any atmosphere of austerity or bleakness that might accompany these associations and creates something new, serene, and comfortable.

Large airy bedrooms are not always easy to create, but spaciousness is often achieved in a smaller house with careful planning and perhaps the sacrifice of a room or a rearrangement of rooms. Compromise and a certain amount of lateral thinking may turn up the perfect solution, and the help of an architect can be invaluable to suggest options that may not have been raised before. By making spaciousness a priority in the early stages of decoration, rather than having favorite fixed ideas from the beginning, much can be achieved in a smaller house.

Many people, though, are able to make perfect bedrooms, complete with all comforts, in smaller attic spaces. In the traditional one-and-a-half-storey cottage found all over northern Europe these spaces were built to be used as bedrooms.

Small roof spans make bedrooms like perfect wooden tents, with all the romance of camping and none of the discomfort. To lie in bed and muse on the craftsmanship that assembled the timber structure is one of the luxuries of a bedroom like this.

The tongue-and-groove panelling that is often used to insulate attic bedrooms can be stained or painted to create different atmospheres. Small windows that often leave these rooms dark are helped today by skylights. Top-lit rooms have a tranquil bright atmosphere that ideally suits a bedroom. Where the panelling is painted or stained a pale color—and the floorboards too—patterned rugs and cotton quilts stand out particularly well. Strong solid colors and heavier fabrics like textured wool,

LEFT *Different degrees of comfort in simple bedrooms produce quite different atmospheres. Here, instead of a scheme that complements the simple architecture, sophistication and elegance have been stepped up to provide a luxurious and cozy bedroom that makes use of every inch of space available under the roof. Toile is used for the curtains on tiny attic windows, brass reading lamps with silk-pleated lampshades are mounted on rough timber wall panels, and fitted carpet reaches into the corners of the attic to shut out any drafts.*

RIGHT *A muted color scheme echoes the restrained style of the architectural detailing in this bedroom. The plain sash windows and shutters and unfussy cornice and moldings are complemented by the tapered four-poster frames on the beds. Both are left bare rather than being drowned by heavy curtains or busy hangings; but the beds themselves are a complete contrast to this pared-down look—complete as they are with striped valances, quilts, rugs, and stacked pillows to make them comfortable and inviting.*

flannel, or blanket material work better when the panelling is stained a dark warm brown, which gives the attic bedroom the atmosphere of a cozy forest cabin on cold winter nights.

Sleeping in a room where the structure of the house is exposed, under the eaves for example, or where the plaster has been stripped from the walls to reveal the brick or stone construction, is always romantic. It is like sleeping protected in the lap of some benign creature. Perhaps more importantly, though, with the remodelling and restoration of smaller houses in the country, extra bedrooms often have to be fitted into the nooks and crannies of the existing structure. Making a virtue out of necessity has led to a real enjoyment of the structural features of a house and an appreciation of the materials, textures, and colors, which have become an important part of the decorative scheme.

"A large bed in a small room creates an inviting nestlike space to sleep in."

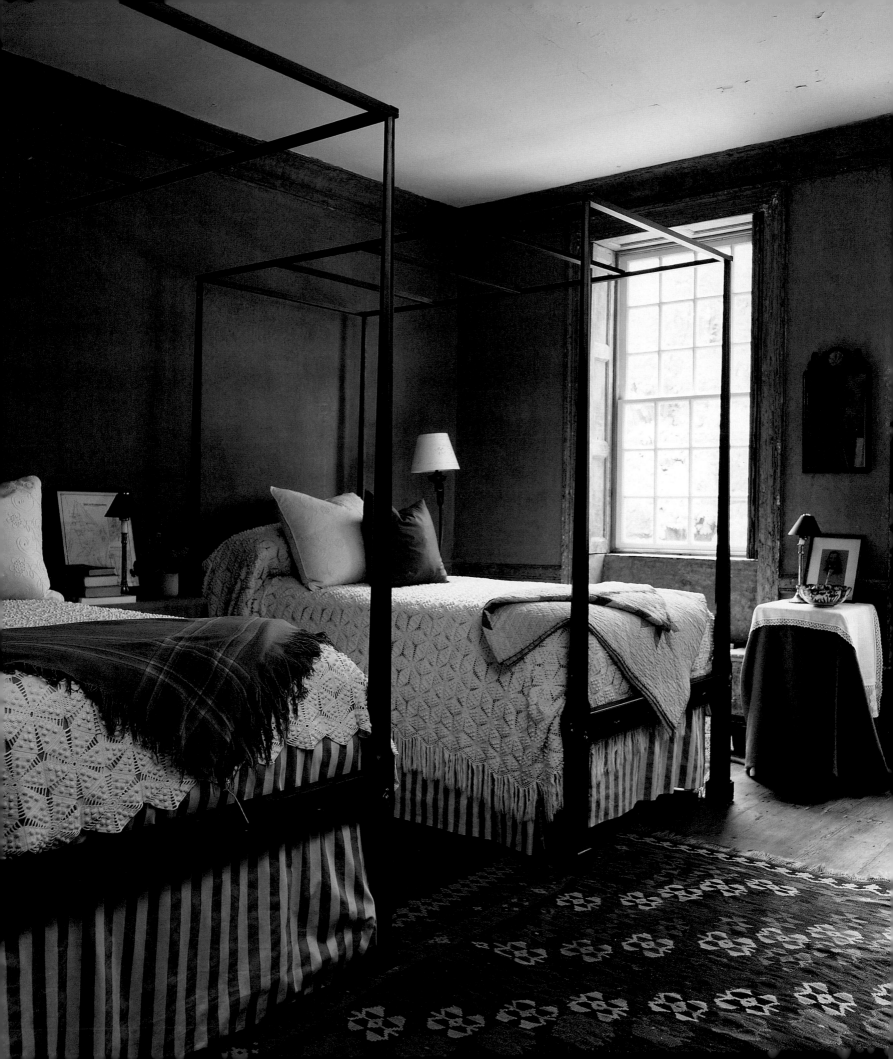

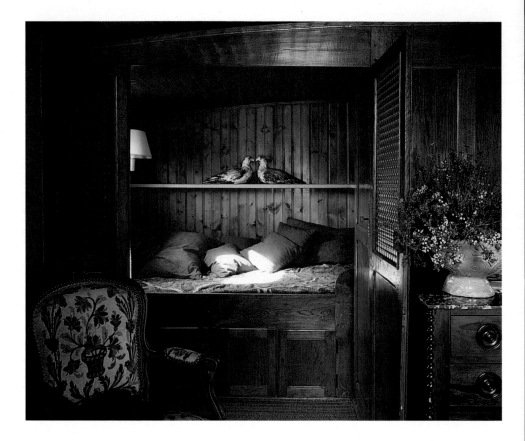

*R*ather than disguise the rough-hewn timbers or even a reinforced steel joist, rather than paper the sloping ceilings and fill in the angles of the roof space with cupboards, the country bedroom is left with its rough edges. Into this setting, in complete contrast, the most generous and comfortable bed is introduced. A large bed in a small room may take up most of the space, but it makes the room into an inviting nest. Rammed up against the wall with room only for a night table and some books this bedroom is an aerie, where you can lie in bed and feel safe and listen to the wind rustling the trees or enjoy the view from the window. The best country beds are high enough to climb into; they stand well off the ground to avoid drafts, but they also have deep mattresses that make them higher still. Good linen, generous pillows, and perhaps a bolster or a paisley-patterned eiderdown are unchanging elements in the perfect bedroom. It does not matter if any or all of these elements are old and scruffy; in fact, a worn and faded look is often gentler and more comfortable than the sharpness of the brand new.

Bedroom furniture that promises comfort in an otherwise rudimentary setting is like a very civilized encampment. As the setting becomes simpler and the bed more elegantly arranged within it a surreal juxtaposition is created, and at the extremes of this stylistic tendency are some truly eccentric bedrooms where boldness and striking

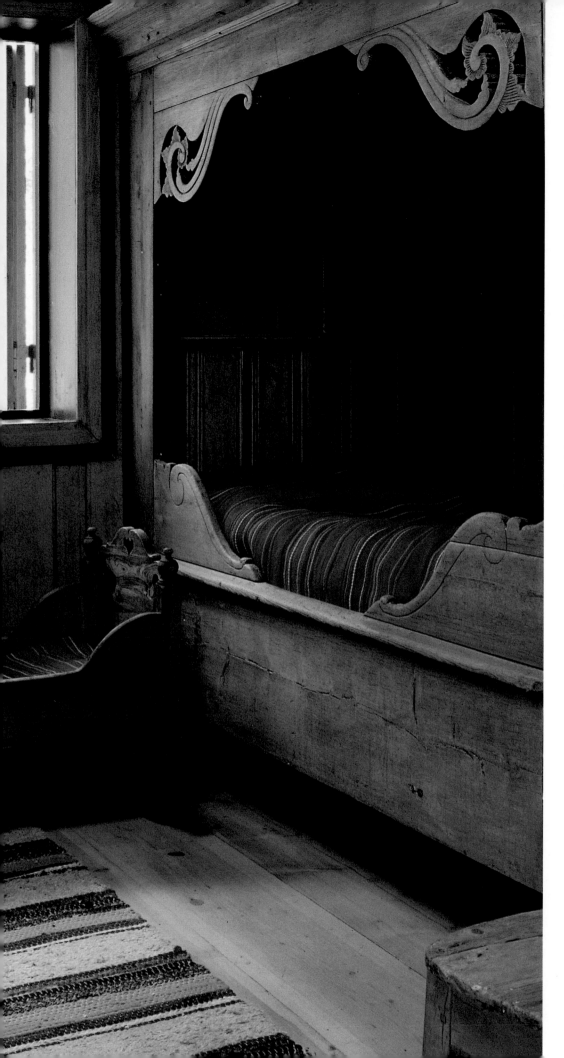

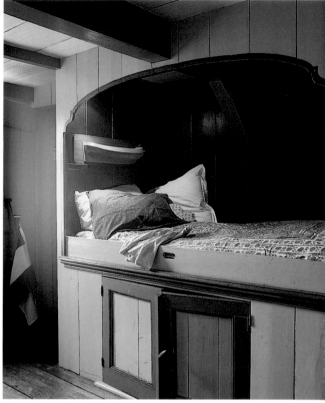

FAR LEFT *A highly varnished cupboard bed is reminiscent of the compact design of the interior of a classic yacht, bringing a hint of glamour to a rural idea.*

LEFT *Where regional furniture is used locally, architecture and interior enjoy the closest relationship. Here the furnishings fit the room in their proportions and designs and the graining and color of the wood matches those of the walls, floor, and door. Details like the simple metal door handle also follow regional designs.*

ABOVE *Framed like a picture and with a curious shutter-like door to close it away, this Dutch cupboard bed is made of broad upright planks like those used for the floors.*

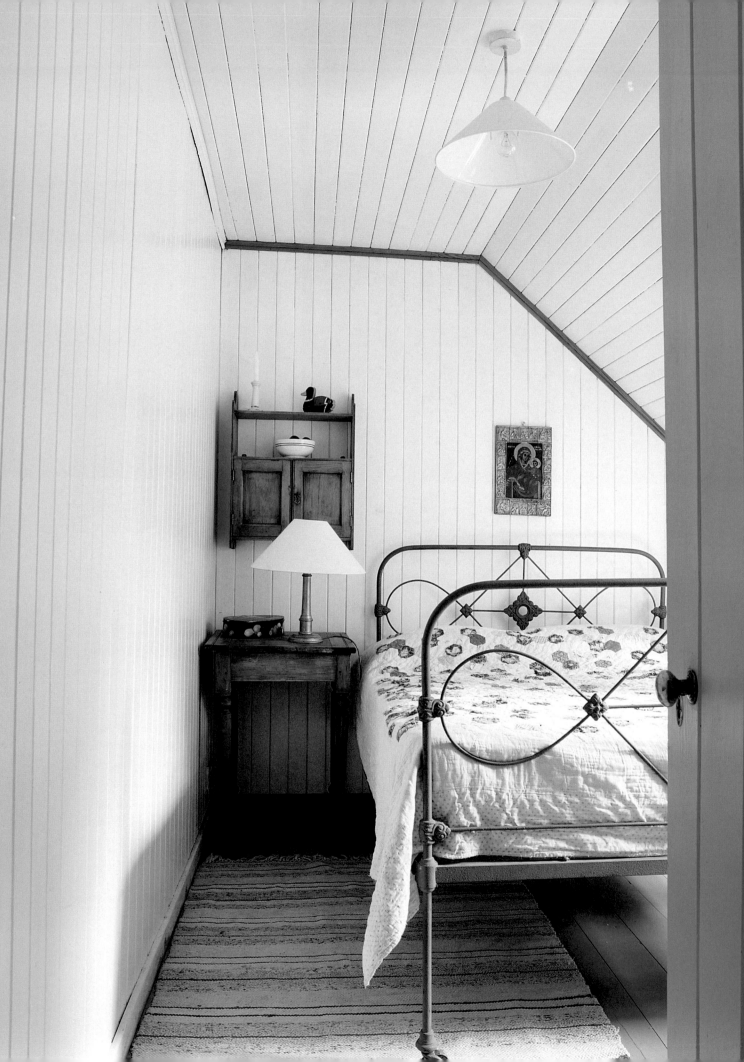

contrasts are used to witty effect. Installing delicate muslin bed hangings and a neo-rococo bedside table in a rough wooden shed gives the impression that a refugee princess has taken up residence there. To create a tranquil backdrop, the shed's interior might be stained a soft color to take advantage of the wood's textures and patterns while making a small concession to the sophistication of the furniture. Here the country look has been pared down to its essentials in one direction while being given free rein in another. Less extreme examples of this effect are bedrooms arranged in picturesque settings with more familiar furnishings: the child's bedroom in a house exotically built into rocks, with a nursery bed and teddy bears looking as if they do not think it odd at all that the walls around them are craggy cliff faces, or the railway carriage in which a simple wrought iron bedstead has been set up, with a leather trunk doing service as a bedside table and a rack of coat hooks carrying bags and hats.

A wood-panelled train car is hard to beat as a perfect country bedroom: there you can dream that you are rattling through the night on some great adventure, and the diminutive box that is your bedroom has something in common with the traditional cupboard bed. Found in Brittany, Scandinavia, and parts of eastern Europe, cupboard beds are either built into a wall of panelling that also hides other cupboards, or are constructed as movable furniture with possibly a bunk bed on top. These beds are a triumph of carpentry skills and are an example of the best fitted furniture. The painted and carved decoration on their doors is a sampler of a folk-art tradition centuries old, and the beds themselves promise warm, draft-free nights; with the curtains closed, a cupboard bed is the ultimate refuge.

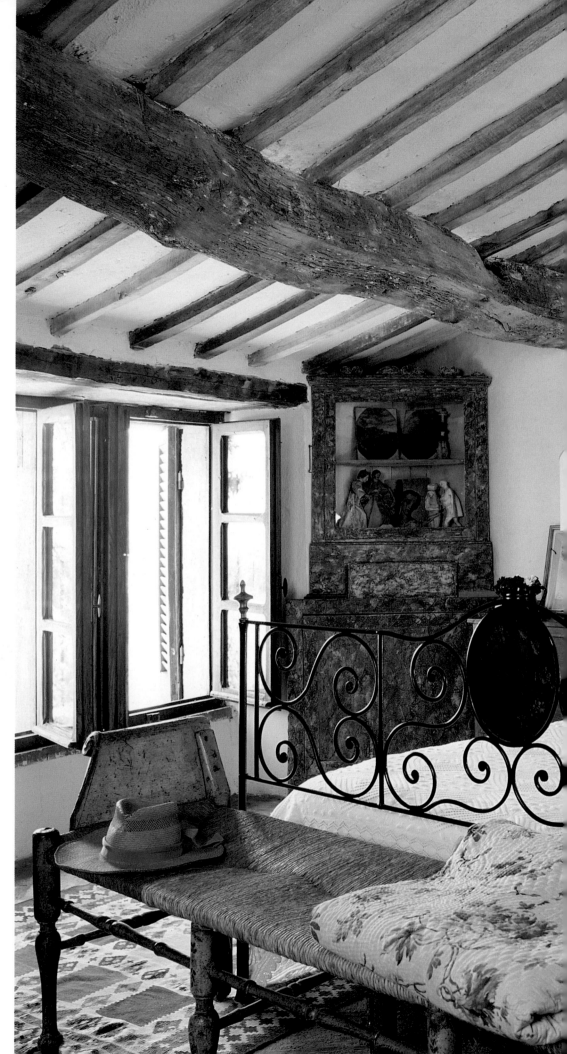

"*A bedroom with a small roof span is like a perfect wooden tent.*"

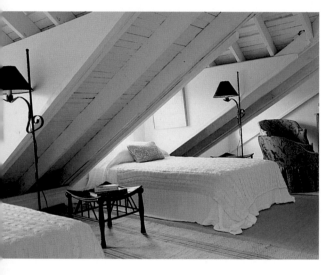

ABOVE *Lit by dormer windows and defined by the strong lines and patterns created by its wooden roof, this sparely furnished attic bedroom is still comfortable.*

RIGHT *The rough timbers of an Italian farmhouse are civilized by warm rugs and elegant furniture. Even though the room is not enormous, everything about it is of generous proportions, from the expanse of window to the size of the bed and the length of the stool at its foot.*

OPPOSITE PAGE *A wooden tent of a roof and the barest wooden bedstead make for indoor camping with a view.*

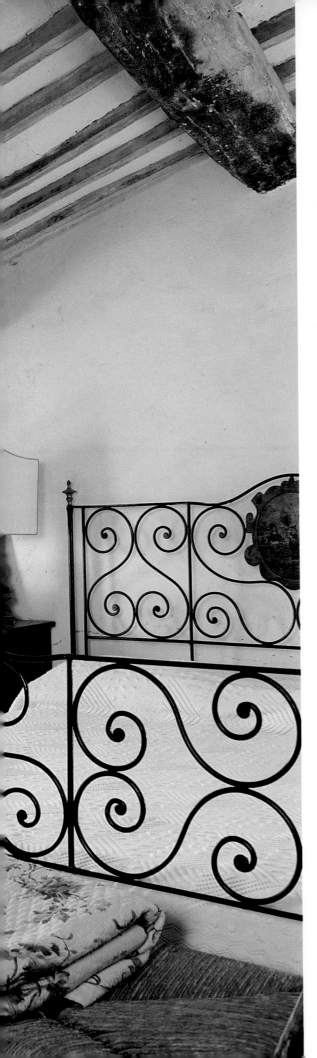

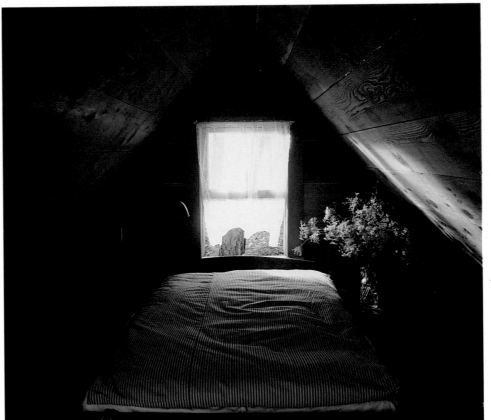

*T*he cupboard bed's open-air cousin is the cot bed. It can be the simplest box on legs—built against a wall or freestanding—and would have been filled with a rough mattress and covered with coarse blankets. It was probably the most common sort of bed in cottage homes, and would have been put together on the spot. A more genteel version, with carved posts and ends and tapered legs, is to be found in Scandinavian homes and is often used as a day bed. Worn staining on its pine planks gives it an air of informal scruffiness that a proud homeowner of generations ago would surely not have tolerated. Today this gentle fading is appreciated both for its pattern and as evidence that the bed has enjoyed and continues to enjoy a long and useful life.

Memories and associations make old things precious, and a bedroom full of treasured furniture, books, and pictures becomes a three-dimensional family album. It might include a grandmother's dressing-table set laid out as it used to be for an elaborate toilette, photographs of friends and relatives, favorite things from childhood and perhaps some well-thumbed books. The history of each object is like a piece of a jigsaw that, once put together, gives the room its special character.

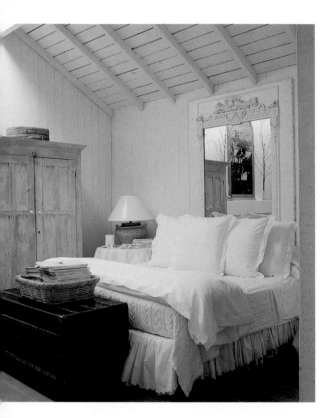

"Washed with unusual neutral colors, bedrooms look airy and serene. With plain wooden furniture and white linen they are brought to life by flowers."

*W*here one bedroom might be full of associations of friends and family, another might be decorated with things brought back from travels and incorporated in a personal interpretation of ethnic style. Mirrors from all over the world with tooled metal or carved or painted frames are one of the most adaptable elements, and are slotted into an otherwise conventional scheme to add an exotic element; textiles are usually very distinctive and are used across a wider surface area so that they can completely change the atmosphere of a room. To create a complementary backdrop for ethnic furniture and textiles, a color cue is often taken from the pieces them-selves. Choosing a bold scheme rather than a delicate hue can be very exciting, but it is also important to keep a visual link with the rest of the house to make it clear that the room fits into the overall character of the home. Architectural features like windows and skirting boards will make this link anyway, but carrying a theme too far can easily destroy the harmony of a house. The tradition of theming rooms to different countries goes back to the eighteenth century but is more usually asso-ciated with villas and grand country houses. Simpler color themes have long been a feature of English country bedrooms and refer most often to a scheme of soft furnishings. Today one-color themes seem too strict and oppressive, and can make a country bedroom look more like a hotel room where everything matches—right down to the colored lampshades.

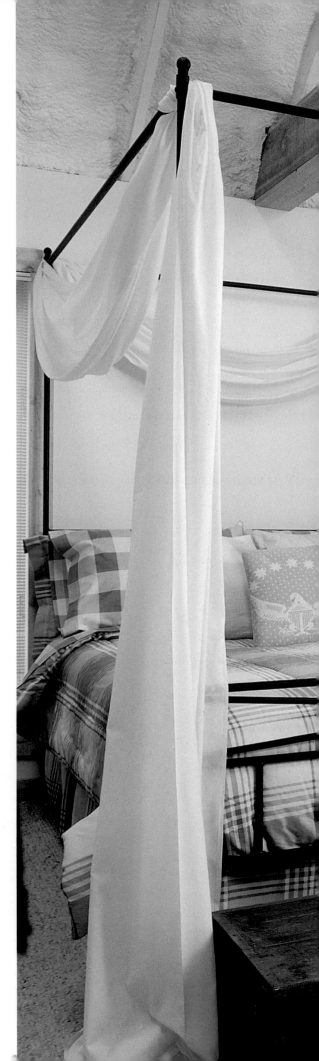

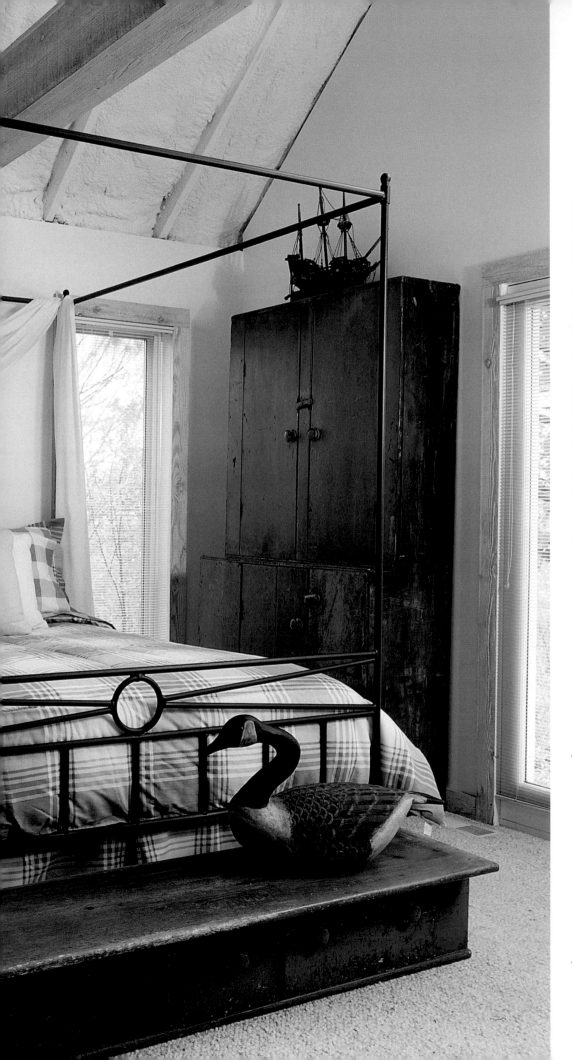

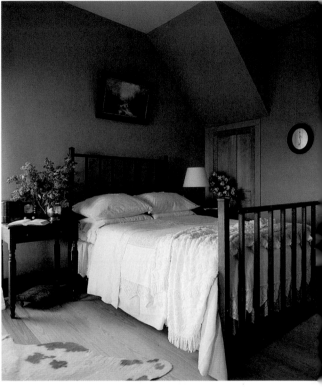

FAR LEFT *A luxuriously pillowed and inviting bed is slotted into a simple interior in which walls and furniture share neutral shades and the floorboards are left bare. The elaborate carved frame of the mirror hung as a bedhead picks up on the fineness of the bedclothes, while its cool, white paintwork fits in with the rest of the interior.*

LEFT *Fitted carpet, lots of light, and a modern interpretation of a four poster bed transform a bare, almost undecorated space into an elegant bedroom into which a dresser scarred from years of use has been placed.*

ABOVE *A slatted bedstead and traditional white bedclothes gives this room a tranquil atmosphere while a jug of lilac blossoms adds freshness to a scheme of browns and whites.*

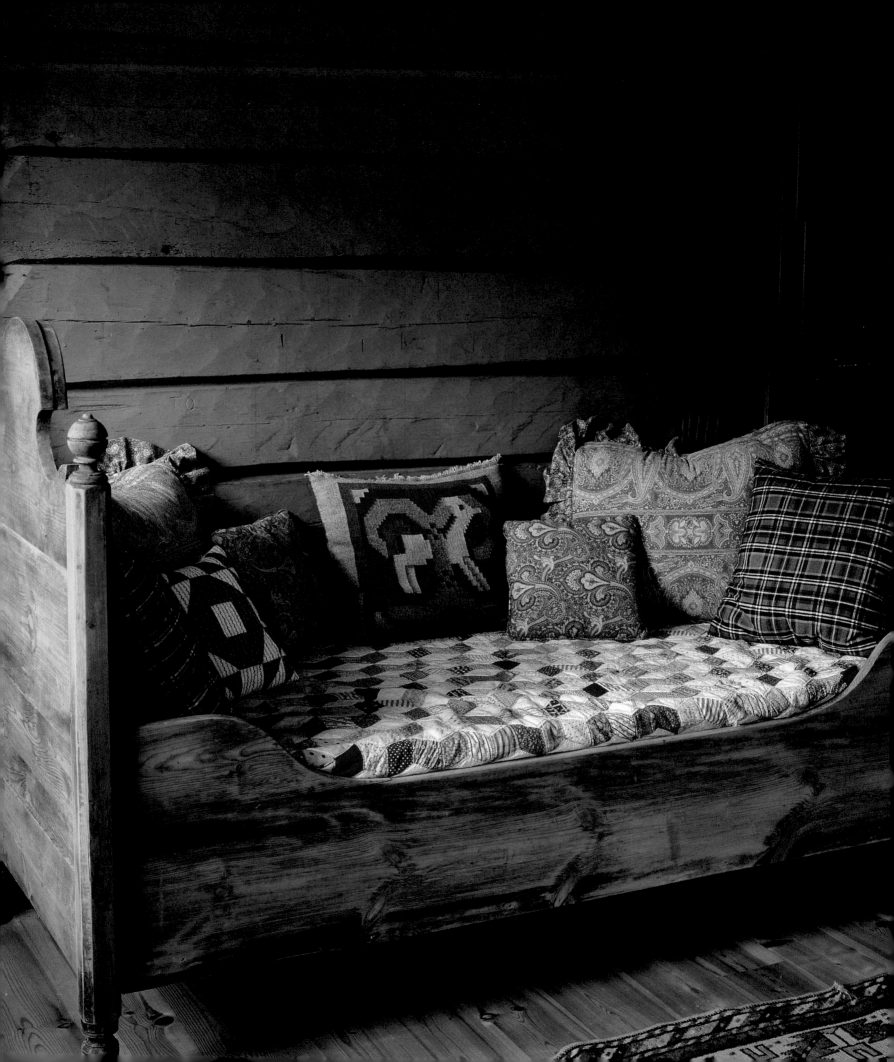

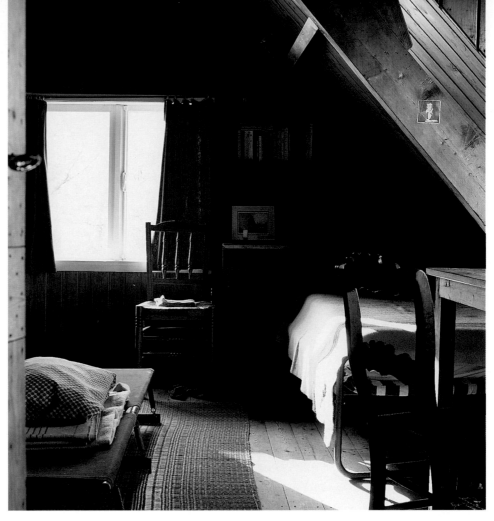

RIGHT *The unselfconscious summer-camp feel of this dark wood attic bedroom is enhanced by simple furnishings. An old-fashioned unlined textured material is used for the curtains, in keeping with the atmosphere of a warm wooden cabin, and the bold red is echoed in the canvas camp-bed, striped mattress cover and woven floor rug laid on bare, unpolished floorboards.*

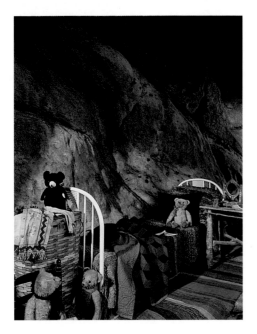

LEFT *A cheerful mixture of patterns and colors on an unpainted daybed fits with the strong blues and reds of the room. The uneven surface of the log wall and its deep dark lines are structural characteristics that also work as decorative features.*

ABOVE *The teddy bears seem unconcerned by their eccentric home in a house built into rocks. The scene recalls children's picture books where bedrooms are transported lock, stock, and barrel to faraway places.*

Two- or three-color theming works much better, but again only if it is done in a relaxed way. It is perhaps most successful where the individual elements in a room do not at first seem to fit together and appear to have nothing in common in terms of style, material, provenance, or history except a shared color range. In this situation the colors unify the room, and impose a gentle order and calm that is particularly reassuring in a bedroom.

With the return to a humbler country ideal, the Edwardians chose to dedicate rooms to particular country flowers. M. H. Baillie Scott who, like many of his generation, also designed gardens, felt the importance of retaining garden themes in the decoration and he talks about using real flowers in his schemes for decoration as well as designing them into bed covers and cushions—"not executed in the hurried modern way but done gradually as funds and time allow."

To provide a fitting backdrop for flowers, Baillie Scott also suggested that a bedroom should be finished without pattern and adornments. This idea has returned and more and more country bedrooms are washed with unusual neutral colors like lilacs, grays, the lightest browns and greens. These bedrooms are serene as they stand, with wooden furniture, white linen, airiness, and space, but they are brought to life by flowers; not in fabrics, or wallpapers, or in painted decoration, but spilling out of jugs and vases. Waking up in a comfortable bed to the smell of narcissi, hyacinths, or lilies you could be forgiven for thinking that nothing else was needed to make a country bedroom perfect.

ABOVE *There are no fancy tiles or a factory-made shower sink in this simple bathroom, and bright blue walls, toplighting, and the contrast of the white garden chair make a cool interior for a hot climate.*

RIGHT *Generous cupboards hide any clutter that might threaten the soothing tidiness of this green bathroom. A traditional roll-top tub and hoop-hung shower curtain are fitted into an alcove between the cupboards so that the whole arrangement hangs together in a symmetrical and ordered scheme.*

FAR RIGHT *A deceptively simple country bathroom where modern plumbing has been incorporated into a sophisticated scheme using natural colors and materials. It is decorated sparingly with huge, found objects to match the generous proportions of the stone bath and basin surrounds.*

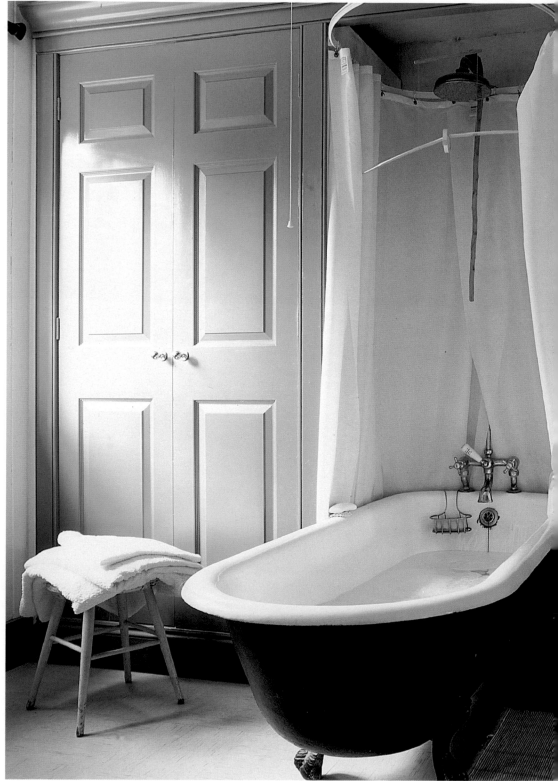

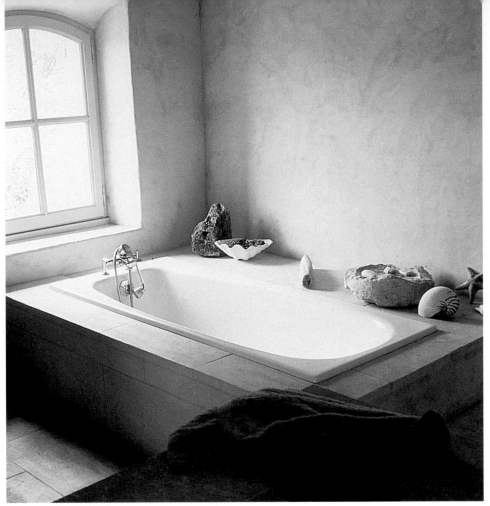

*H*owever romantic the idea of a hip bath in front of a blazing fire might seem, the reality probably relies on more manpower than most of us can muster and holds with it the distinct possibility of floods of water sloshed onto the floor. Wearing his hat and smoking a cheroot, the weary cowboy in many a western celebrated his return to civilization with a soak in one of these tanks, and nowadays in the sparest of spare country retreats it might be a necesssity, but most people make plumbing a priority even when the rest of the house has reached pared-down perfection and the bathroom itself seems almost spartan in its simplicity.

The next best thing to a hip bath for those so inclined might be a roll-top bath perched on unpolished floorboards in an otherwise empty room, giving the impression of ad hoc adaptation evocative of a time when bathrooms were being introduced into old houses for the first time, when there were no expectations about how a bathroom should look and no bathroom furniture as such with which to furnish it. This bathroom would rejoice in having the nuts and bolts of its solidly designed plumbing on show, and to save it from stark simplicity one or two grand pieces of furniture, such as a mirror and chair, might be introduced into the undecorated setting, giving it an air of neglected, informal grandeur.

For those who demand the latest in comfort a different solution is called for. Sophisticated plumbing and engineering—including the joys of underfloor heating— are installed in a contrastingly and emphatically simple country interior to ensure the utmost in warmth, comfort, and cleanliness while enjoying the rugged backdrop of an exposed architectural structure—which gives the room its character but is here

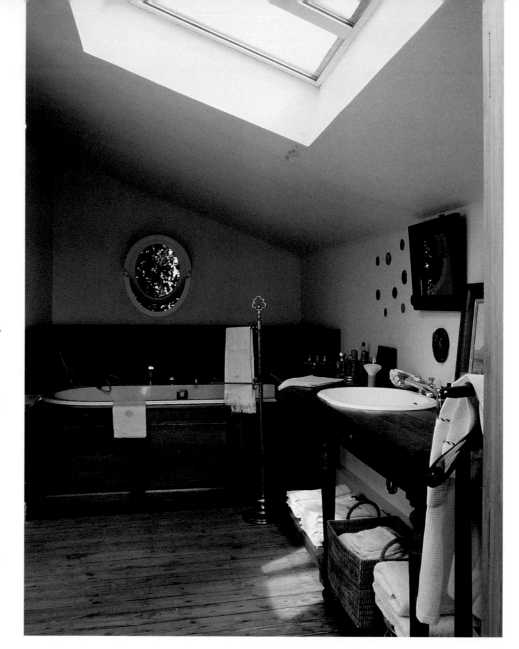

RIGHT *Although it is fitted in under the eaves, this bathroom is large and comfortable. A modern bath and basin have been used rather than old-fashioned—or salvaged— designs, but the wood panelling, antique furniture, and traditional accessories show a careful approach, and how old can be mixed with new. The subdued color scheme using buffs and browns with crisp white towels is a modern spin on an old idea.*

BELOW *Rough wood panelling is used in a careful modern design with a basin set into a generous countertop that gives lots of space for lotions and potions, candlesticks, and a big vase of flowers. The warm reds of a wall-hanging work well with the warmth of the wooden interior.*

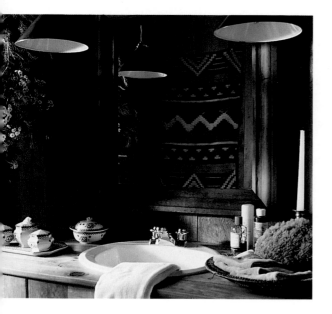

essentially just a decorative element. This is the most elaborate and expensive of country bathrooms, but it seems as effortless and simple as the adapted bathroom of before, and that is central to its appeal.

One step away from the extremes of roughness married to the extremes of comfort is the bathroom that aims for a smoother overall effect by introducing treated natural materials like polished reconstituted stone or marble for bath and basin surrounds, flooring, and walls to head height; although they do not project quite the sense of place as the original structural materials, they can be used to create the kind of tranquil elegant scheme particularly popular in France and Italy. This bathroom interprets country style through associations made by the essential texture, abstract pattern, and color of the natural materials used in the fittings or in the display of rocks, shells, and found objects, rather than by clear stylistic references.

More obviously rural in character are those bathrooms in which wood plays an important role, whether it is used as chunky horizontal planking in a room recalling a seaside beach hut or a Scandinavian sauna, or as dark wood panelling making a

bathroom resemble a gentleman's dressing room—with its select and solemn little group of the most conservative eau de cologne bottles on a traditional shaving table and the civilized but simple accessories of the discerning bather: the brushes, pumice stone, loofah, and natural sponge. Here the shining chrome of taps and towel rack gleam above the comforting swirls of old-fashioned drab-colored lino on the floor.

In the country bathroom, the decorative scheme generally follows function. Above all, the bathroom should be clean and practical and efficient, and its decoration should reflect that. Comfort needs to be generously but discreetly catered for, and any decorative elements that do not contribute to the actual practicality of the bathroom, but which are an essential part of its character, play an important but secondary role.

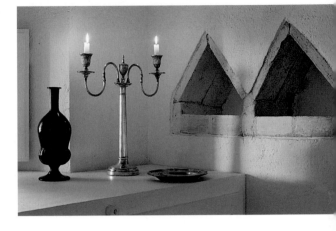

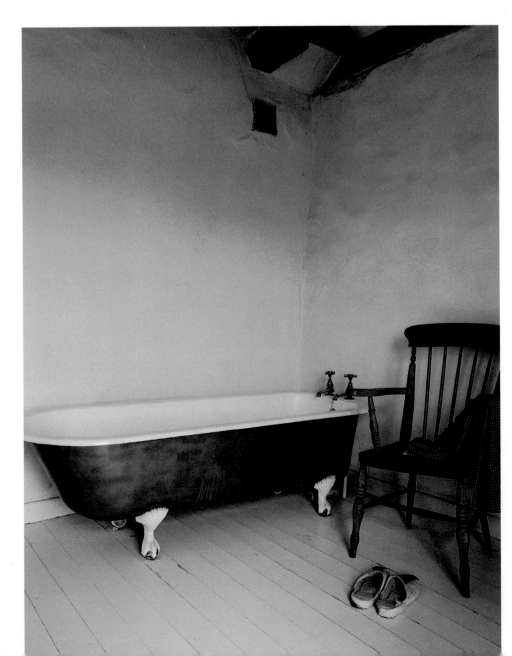

LEFT *Stripped of all unnecessary trophies and accessories this bathroom is uncompromisingly simple with its huge roll-top bath sitting on white floorboards in an otherwise empty room. The metal bath tub, a chair, and the roof timbers are like silhouettes against the white walls, spelling out the function of the room.*

ABOVE *Architectural fragments are clues to a building's previous use, and give this softly lit and sensitively modernized country bathroom great character.*

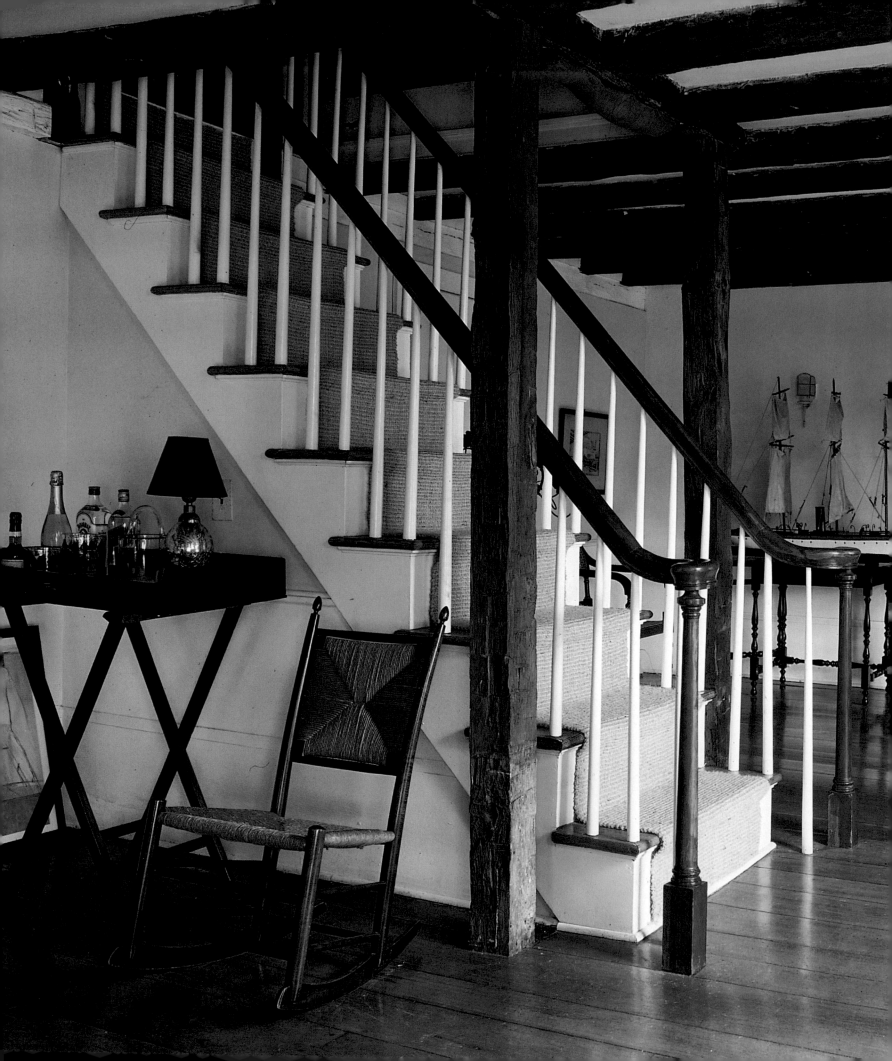

Perfect
HALLS & STAIRWAYS

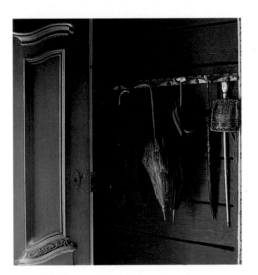

A HALL IS A ROOM LINKING THE OUTSIDE WORLD TO THE FAMILY HEARTH—AN ANTE-CHAMBER WHERE GUESTS ARE GREETED BEFORE BEING USHERED INTO THE HEART OF THE HOUSE. IT IS WHERE OUTSIDE EQUIPMENT, CLOTHES, AND BAGGAGE ARE SHED TO PREPARE FOR DOMESTIC ACTIVITIES, SO IT BECOMES A SORT OF MANAGED AND EVER-CHANGING DUMPING GROUND. ITS DECORATION MARKS THE CHANGE IN MOOD FROM OUTDOORS TO INDOORS, AND INTRODUCES THE THEMES AND ATMOSPHERE OF THE REST OF THE HOUSE.

LEFT
A spacious hall, with highly polished
floorboards and furniture placed around
the walls, recalls the entrances of grand
country houses—without the formality.

*I*n houses with porches and outer hallways the threshold is an unclear line, underlining the close relationship of the house with its setting. Flagstones used in a porch or up the garden path continue into the hall of the house, and logs are stored to dry just outside the door and brought in to another resting place in a log basket before being carried to the fire.

Logs for the fire, keys for the door, letters waiting to be mailed, flashlights for the dark trek at night to close up the greenhouse, fishing rods, and other sports gear are all found in the hall in picturesque chaos or in careful order. The hall is a busy place with doors leading off it, perhaps a passage through to the back of the house or the staircase—a defining element of its function as a point of departure.

A hall often provides a viewpoint for looking into other rooms, or even through one room into another whose light and colors, furniture, and fireplace are framed in the doorway. It needs to have a strong enough decorative scheme to balance what can be glimpsed beyond, but its character must not be too overbearing or the other rooms lose their interest and power to encourage exploration.

"A hall provides a viewpoint for looking into other rooms, whose light and colors, furniture, and fireplace are framed in the doorway."

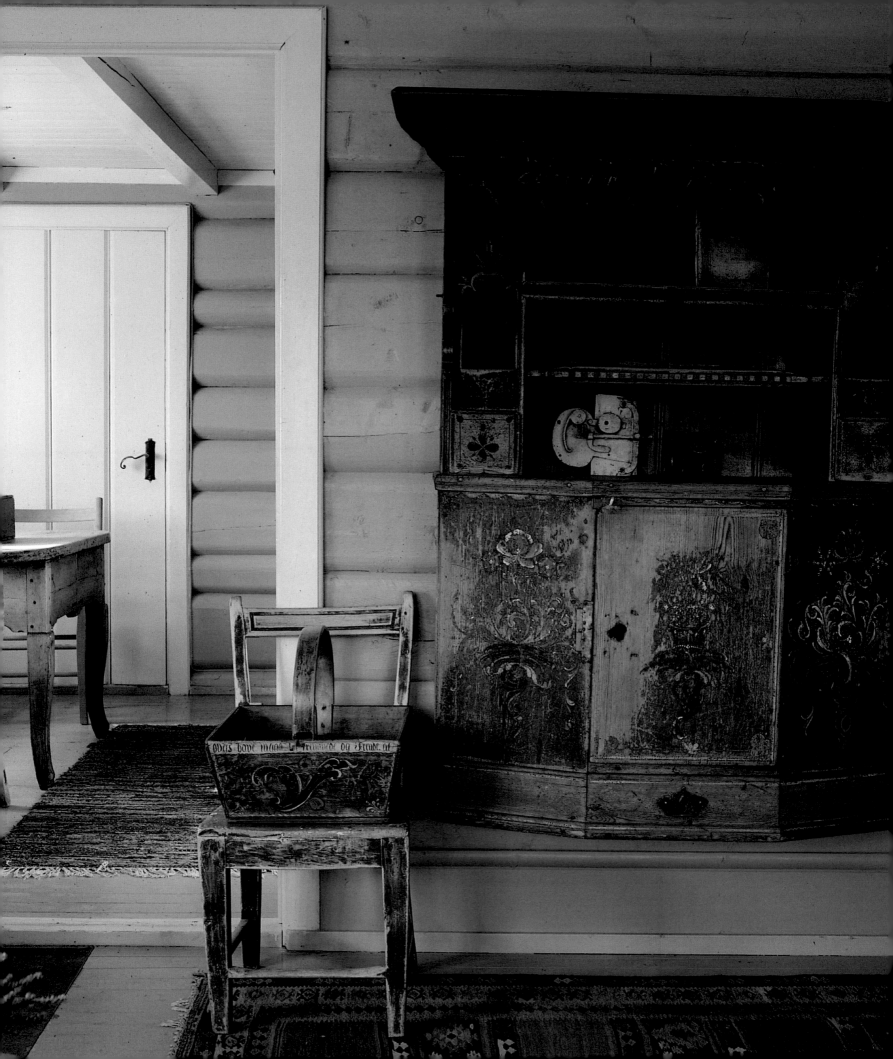

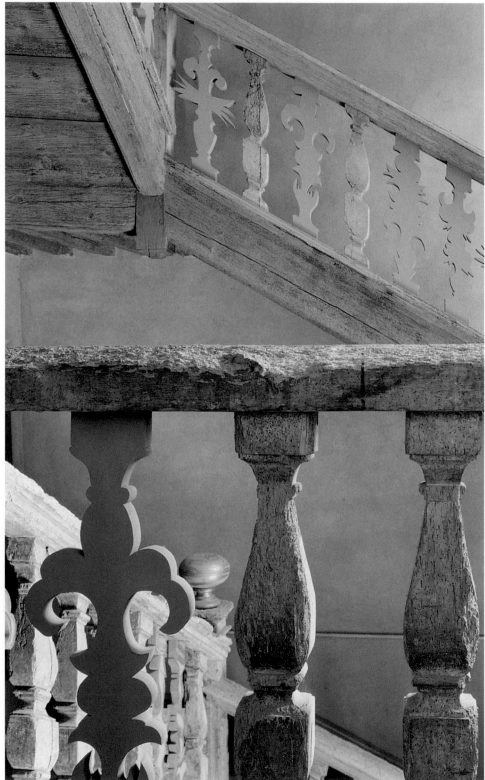

ABOVE *Balusters climb the stairs in groups of three, providing a gentle rhythm in this cottage hallway, which needs no pictures or hall furniture to improve it in any way. Picked out in green they stand out from the creamy white of the traditional tongue-and-groove panelling and the chocolate brown of the stair treads. Only the banister rail and pyramid-topped newel posts are left bare and their wood-grain patterning lightens the effect of the solid colors. Bags and coats decorate the space as effectively as any pictures or ornaments.*

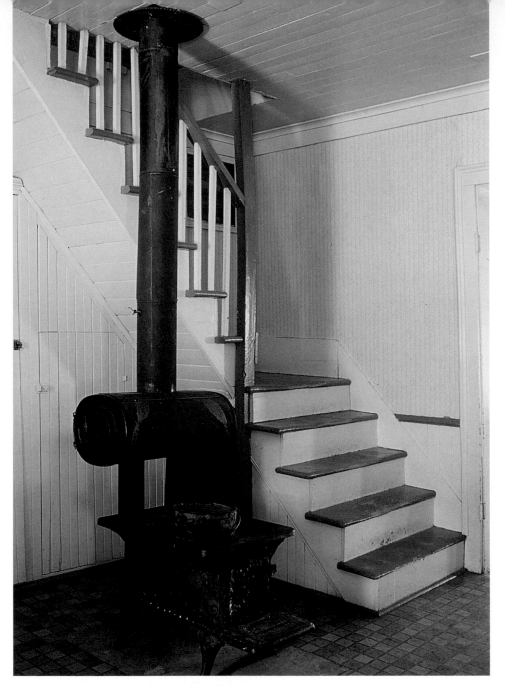

FAR LEFT *Gnarled balusters rescued before they crumbled away to dust are given new life when interspersed with the sharp profiles of modern ones whose asymetrical designs strike an upbeat note in this antique wooden staircase. Painted gray and carved as two-dimensional supports, they are neither pale imitations of the old nor stark functional fill-in pieces. They have a decorative interest of their own and the bare walls of the stairwell provide a golden backdrop for both old and new silhouettes.*

LEFT *A traditional wood burning stove stands in the barest hallway to allow its detailing and stout design to be appreciated from all angles; this way, too, its heat can radiate from this central point in the house. A bright canary yellow provides the perfect—if unexpected—backdrop. Traditional stove designs often work better than new-fangled models and should be given a chance to contribute a hint of the past before they are finally thrown away.*

*D*epending on the style of the house, a hall might be informal or formal. An English gentleman's house would have a formal entrance with an elegant staircase as its architectural showpiece. The craftsmanship that went into the carving of the newel post and balusters and the engineering that went into the staircase construction were as important as anything else in the house and the first thing that visitors saw. The rest of the hallway would have been conceived as a fitting partner for the staircase with a good floor, cornices, and perhaps arches over passages leading onto it. An elegant order might be imposed upon the odd shape of the stairwell walls, with panelling or moldings dividing up the space.

The more formal the hallway and the more finely detailed its architectural decoration, the more deferential today's decoration has to be.

In more modest cottages and farmhouses all over northern Europe and North America, staircases range from varieties of open-ladder types, or stone steps, to

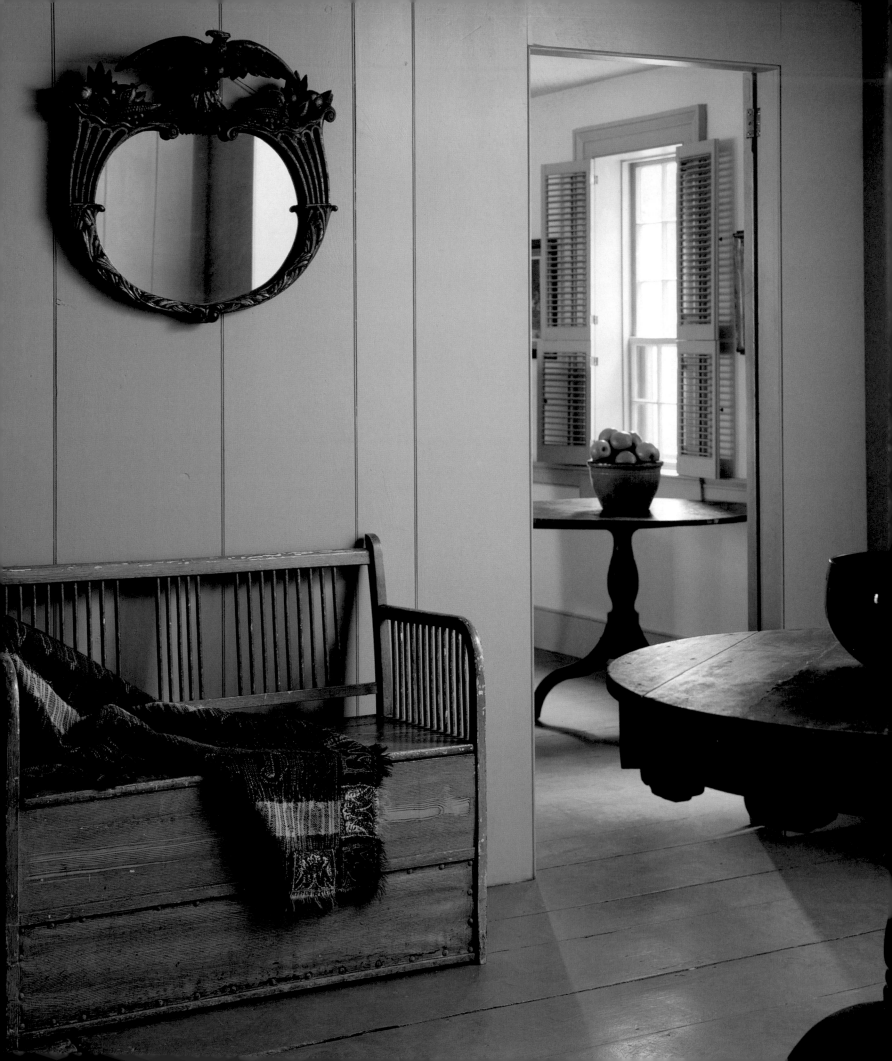

LEFT *A mixture of traditional hall features and modern ideas are brought together to create an interior of contrasts. An unusual version of tongue-and-groove panelling made of thick and thin planking provides an elegant but minimal design for the walls, and instead of more conventional door surrounds a discreet groove molding outlines the doorway. There are no skirting boards here but they reappear in the room beyond and wide floorboards painted battleship gray in both rooms provide a unifying link. A simple but elegant country hall bench sits below a contrastingly sophisticated mirror, framed with elaborate cornucopias and surmounted by an eagle.*

RIGHT *A corner of a hall has been turned into a study by the simple expedient of close-hanging a group of prints to define a wall area and placing a desk and chair below it. Box files and a tub of pens share the space with a miniature obelisk, and they all fit in with the subtle browns and grays of the room's coloring. Limiting the color range of the chaos on most desks might seem a challenge but elegant storage is the solution.*

"*The hall is an introduction not only to the house but also to the personality of its owner, whose interests are reflected here.*"

simple wooden designs. Wooden staircases today might be left bare, or alternatively they might have just their risers painted to match balusters or walls, or they might be painted all over. Bare staircases are popular, but life is quieter in a small house if a stair carpet is fitted down its center and attached, perhaps with stair rods. If carpeting is being chosen purely for practicality, with other floors left bare except for occasional rugs, dark rough-woven stair carpet can be laid so that it does not become a distracting feature. Stone staircases, though they may seem cold, often look best when they are left completely bare.

The stairwell itself provides the biggest stretch of uninterrupted wall space in the house and is ideal for hanging a tapestry or pictures so that the hall becomes a gallery. Treated like this the hall is an introduction not only to the house but also to the personality of its owner, whose interests are reflected here.

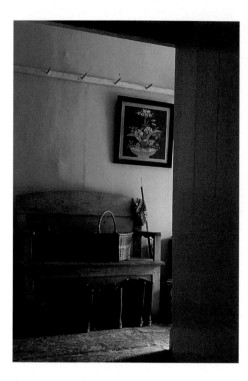

ABOVE *The pitted grays of flagstones are a traditional and practical feature of country hallways. Stone floors can also be a link between the hall and the setting of the house. Boots and a fishing rod point to the country activities enjoyed by this household and a picture is a colorful afterthought.*

RIGHT *In this light modern interior the demarcation between hall and living room could not be more emphatic: stone flooring in the hall and blond wood beyond. A doormat between the rooms makes the hall seem, for practical purposes, an extension of the garden rather than the introduction to the house.*

FAR RIGHT *The hall as garden room: different themes emerge to reflect the interests of the owner and here a console table is used as a glorified plantstand.*

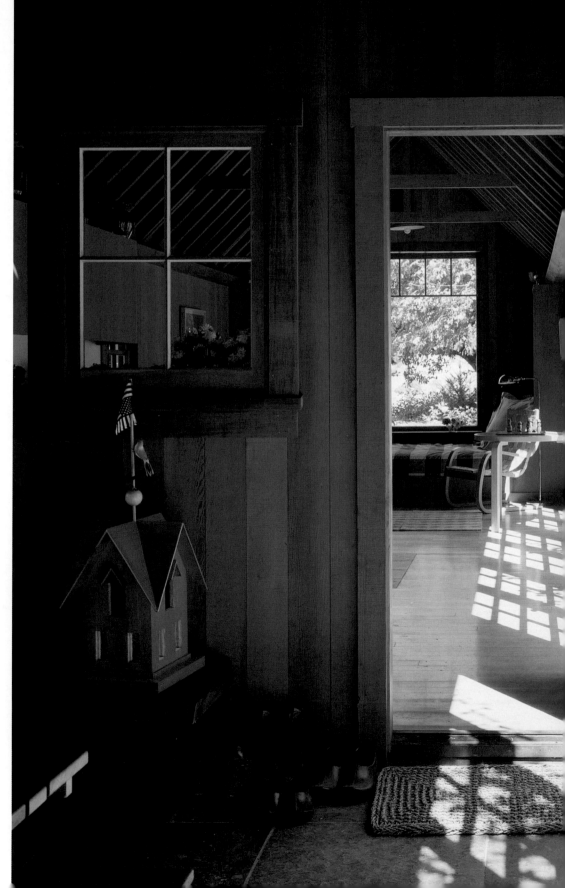

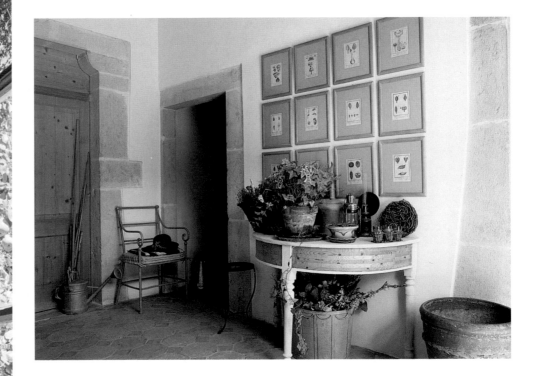

*M*any country hallways are humble affairs: just a simple narrow passage with no distinguishing features. Where some might be filled with the usual paraphernalia of country life, others might highlight this functional space by leaving it completely bare and unpunctuated. An atmosphere of mystery is created in a hall devoid of ornament and relieved only by glimpses through doors of other rooms. In a warm climate a stone stair might curve out of sight between walls of solid color, leaving the visitor alone in the cool silence to wonder. Such a solution focuses attention on the hall's essential character, its floorboards, paving or tiles, the color and materials of its walls, and the little details of doorknobs and finger plates, hinges and key holes that suddenly become important elements of its decoration.

While some halls are just simple narrow passages, others are spacious enough to be used as living rooms. The latter are often quite masculine in atmosphere with a large fireplace or wood-burning stove, chests for tables, and comfortable sofas or high-backed wooden settles. The floor might be flagged to cope with outdoor boots and wet dogs, and ornaments are likely to be robust in character: barometers, clocks, or sporting trophies, rather than elegantly displayed porcelain. This is not a polite parlor in any sense but a jolly country room, where you might welcome in carol singers for cocoa and no-one would feel the need to stand on ceremony.

In the warmer climate of South Carolina the front doors of the planters' elegant houses traditionally open into the main parlor, but where the winters are colder there is often an inner door as well as the front door to keep out drafts. Heavy

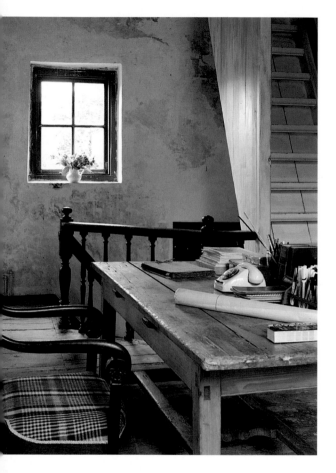

screens covered in tooled leather or dark heavy velvet are sometimes used to perform the same function. Another traditional way of solving the draft problem is to hang very heavy wool (like loden) as a curtain on a pole across the front door, as is done in the country churches of Germany and Austria. Fumbling through the thick folds of a rough drab-colored curtain for the door handle, you really feel that you are leaving the warmth for the chill outside.

Unusual neutral colors work very well in halls and dividing the walls up with a painted or actual dado, which runs up the stairs, can help to define and bring order to what can be a rather muddled architectural space in a little country cottage. A neutral color that echoes, in slightly lighter shades, the honey colors of a stone floor, or complements the wooden staircase and door frames, enables splashes of color to be used in picture mounts, rugs, or flowers on a hall table. Some subdued but stronger colors like buffs, creamy browns, and chalky maroons recall the colors of the back-passage areas of grander country houses, and although these were originally chosen for their practicality in not showing the dirt, they can also be good colors against which to hang pictures. The lighter neutral colors create a slightly more elegant atmosphere, while strong reds, greens, and blues look more exotic. Color schemes often have strong associations even while they succeed in creating something new and different, and inspiration for them can come from anywhere, from a piece of material, from a glimpse into the hallway of a house seen from the street, from the endpapers of a book, or from pictures. Combinations of two or three colors that in the abstract appear unsuited to each other suddenly seem to work when spotted together in an unlikely setting.

"An atmosphere of mystery is created in a sparely furnished hall where attention focuses on its essential character."

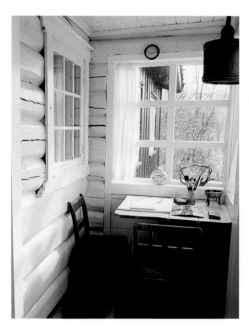

FAR LEFT *A staircase landing becomes a study where a large table fits neatly into the space between rooms. The undecorated space is a striking contrast to the crowded desk.*

LEFT *Lit on two sides, a cubby hole overlooks the garden and makes a little studio protected from the weather.*

RIGHT *Painted furniture plays an important part in this interior, where a chair is painted the same color as the wall against which it stands, and the soft green of a wooden desk is continued in the bedroom furniture beyond. Its atmosphere is calm and light, rather than oppressively schematic.*

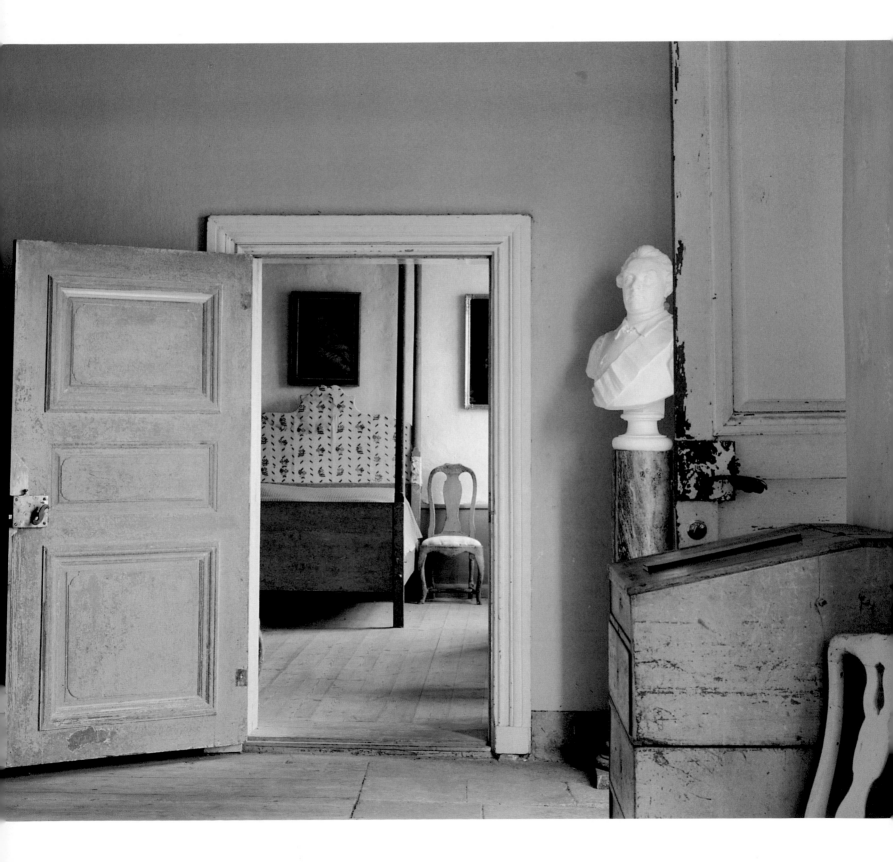

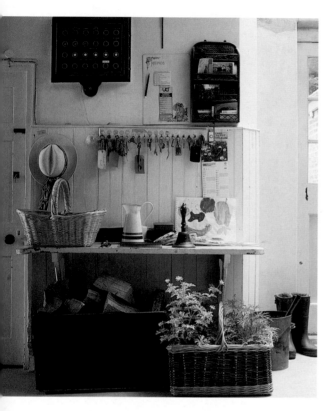

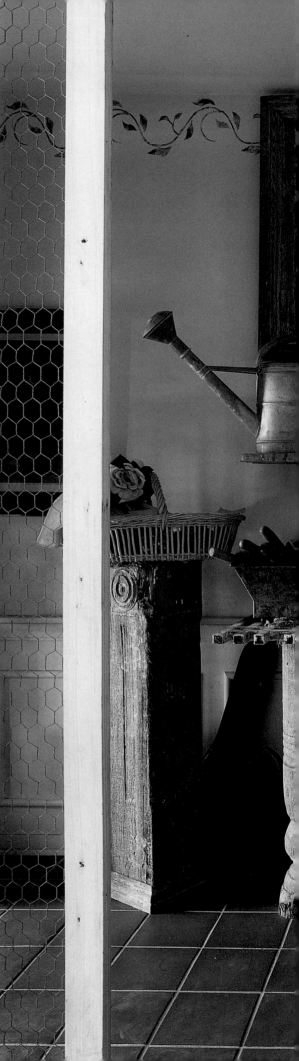

LEFT *A cheerfully uncontrived jumble of paraphernalia shows the hall as a picturesque and ever-changing dumping ground. High ceilings, a proper old butler's table, and a bell system linked to all the rooms of the house are typical of an English country house. The back quarters of these houses, once the exclusive preserve of servants, possess their own elegance that stems from their spaciousness, simple decoration, and solid fixtures and fittings.*

RIGHT *A quirky interpretation of conventional hall arrangements becomes an eccentric still-life using disparate elements. Mimicking a grand console table, a wooden slatted table-top has been placed on two carved wooden legs in front of an elegant dado. A box of tools, a silver teapot, and some framed lace take up most of the space.*

A scheme that plays it safe with lighter neutral colors and leaves bolder color to the furnishings is less likely to date quickly than a bright and exciting new combination, but there is a difference between playing it safe and going for the lowest common denominator, which produces a bland, characterless interior. A scheme of quiet colors needs to be chosen as carefully as the loudest design.

Introducing a vibrant color scheme into an otherwise conventional hall arrangement jolts it out of complacency. Conversely, when a conventional backdrop plays host to a witty arrangement of furniture and objects the results are successful too. It is a difficult game to play because anything too planned can look self-conscious or plain foolish, but there is no substitute for a sure eye and a genuine interest in the architecture, furniture, and ornaments being juggled.

The saddest thing you can do to a hall is not to use its front door. Many people unthinkingly get into the habit of using a back door, and gradually the front door loses its point and the hall becomes a useless passage that shows signs of being unloved and seems to miss the bustle of activity. Abandoning the front door affects the external elevation and garden planting schemes no longer highlight its importance as the front entrance. The house's orientation changes and with it something is lost, unless the change is carefully planned and thought out within the overall decoration and arrangement of the house.

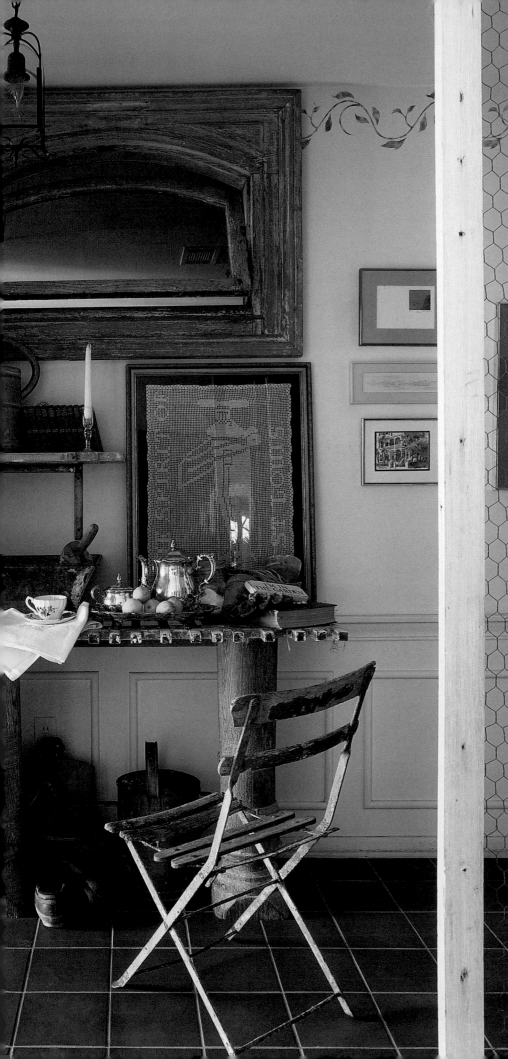

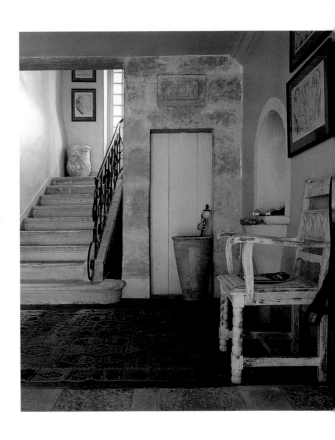

ABOVE *The honey-colored stone of this Italian hall provides a dappled backdrop for the few pieces of furniture and pictures and its uneven surface animates the interior. A carved date panel above the door, stair tread moldings and a niche punctuate the walls and underline the importance of stone. Soft gray walls provide a neutral foil, and red mounts around two groups of architectural prints put the final touch to the whole.*

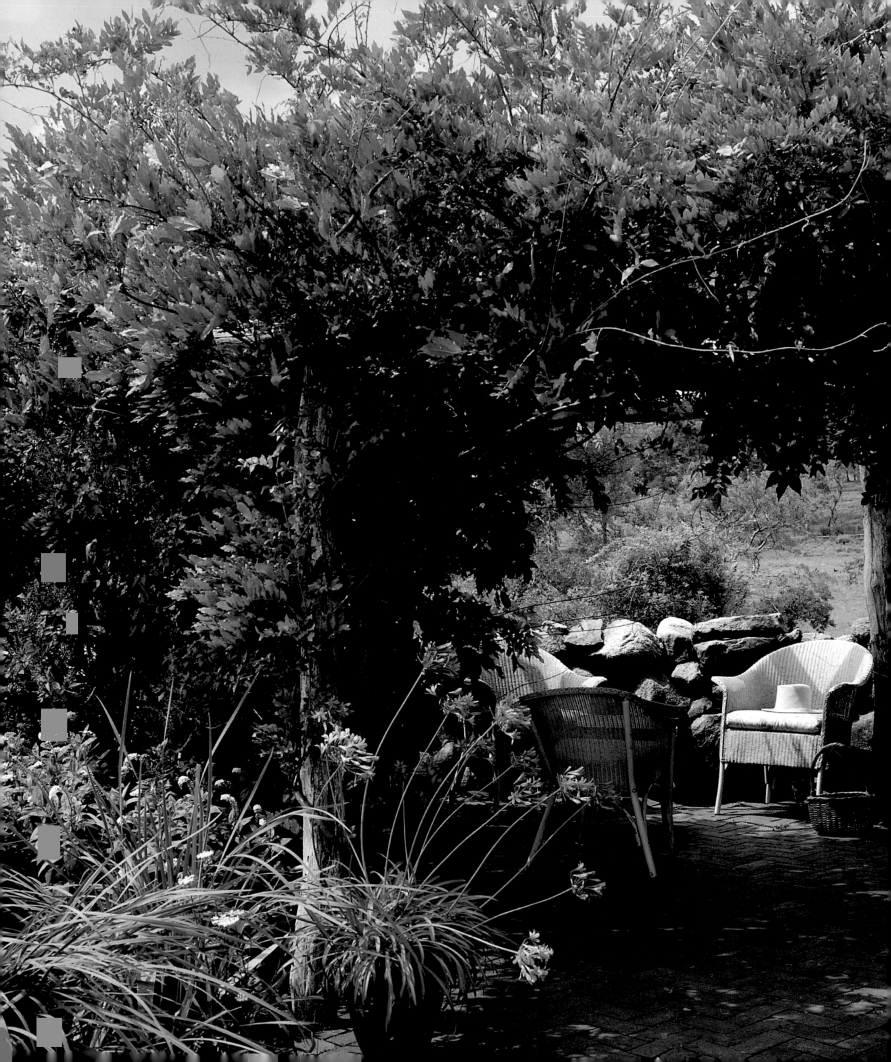

Perfect
OUTDOOR ROOMS

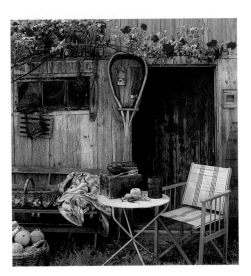

*S*O MUCH OF THE JOY OF COUNTRY LIVING COMES FROM SPENDING TIME OUTDOORS THAT

OFTEN PEOPLE FOCUS MORE ON THE CREATION OR RESTORATION OF A GARDEN, THE CARE

OF AN ORCHARD, OR THE BUILDING OF A SUMMER HOUSE AND THE LAYING OUT OF A

SHELTERED COURTYARD THAN THEY DO ON THE INTERIOR OF THEIR HOUSE. *O*THERS PREFER

TO STEP OUT INTO WILDER SURROUNDINGS AND TO LIVE IN A NATURAL LANDSCAPE WHERE

WOODLAND OR FIELDS, SCRUB OR DUNE REACHES RIGHT UP TO THE BACK DOOR.

LEFT AND ABOVE
*Agapanthus guards the entrance to a
shady outdoor room with a view beyond
the garden wall, while colorful
impedimenta sits outside a shed.*

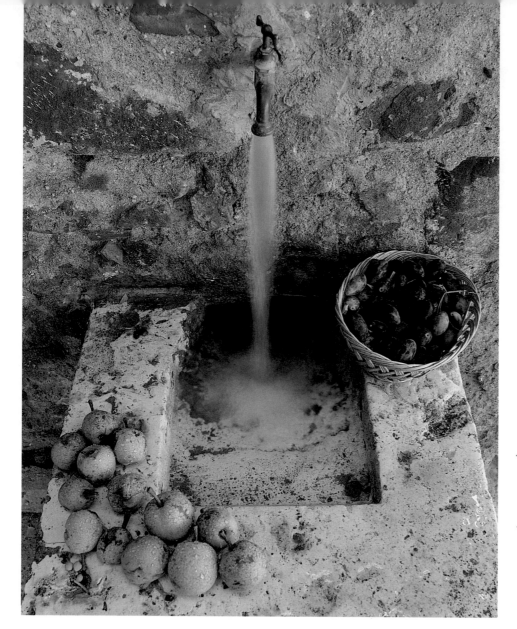

*F*ormality and informality in gardens and in the layout of the buildings immediately around a house in the country have always taken turns to be in fashion. Combined in different measures, they have been the most distinctive themes of garden history all over the world. In the development of every style, an element of informality in a formal garden, or vice versa, expresses something slightly different. Informality might be championed as an expression of respect for nature, or as enthusiastic acceptance of its wildness, or out of romantic impulse. Formality on the other hand might be the result of careful husbandry, a love of balance and symmetry, or simply a restraining hand. Managed unruliness and elegant formality both require intensive labor but of a kind so good for the soul that, for many, gardening is the only therapy to counteract an otherwise stressful life.

Embracing nature without having to put in the hours of toil also has its supporters in an approach that might be called anti-cultivation—anathema to anyone with gardening ambitions. It involves dismissing completely the idea of planting protective garden hedges, or building brick walls or a picket fence to mark out your private patch of territory and guard your home life from the uncertainties of the big wide

"Everyone draws energy from a garden's tranquillity, and in the design of a garden special vantage points are introduced to provide cues for reflection and enjoyment of its views."

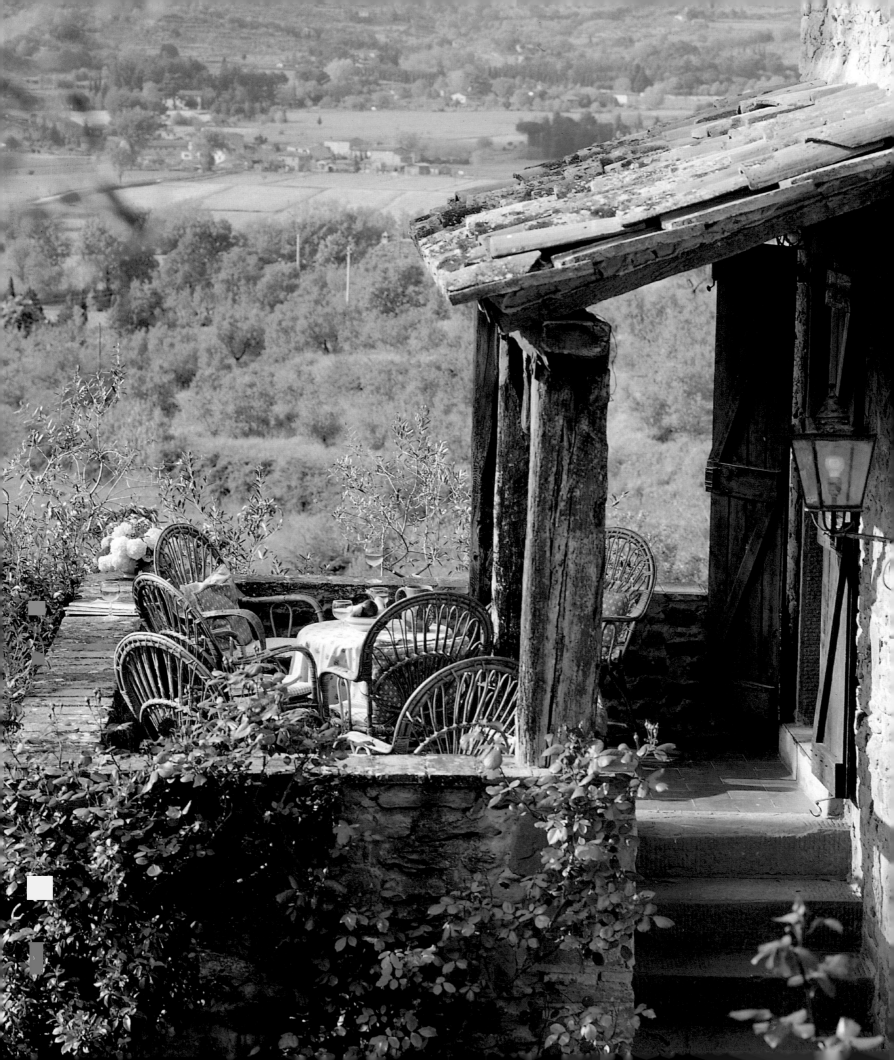

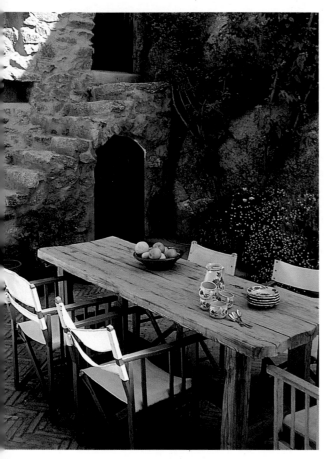

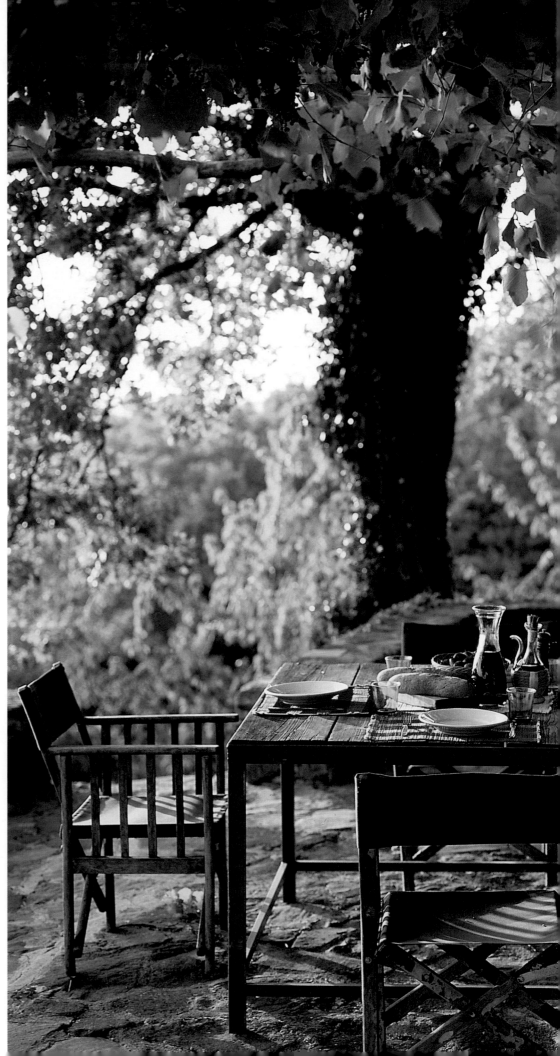

ABOVE *A private courtyard sheltered by a dramatic cliff with plants tumbling down its bumpy face provides a picturesque outdoor eating area.*

RIGHT *A tree filters sun and breezes on this terrace, while a surface of red stone retains the sun's heat well into a summer evening providing comforting, natural "underfloor" heating.*

FAR RIGHT *Half-indoors half-outdoors, this terrace is open to the elements on one side and enclosed with a window on the other. Different solutions evolve to cope with the demands of particular microclimates.*

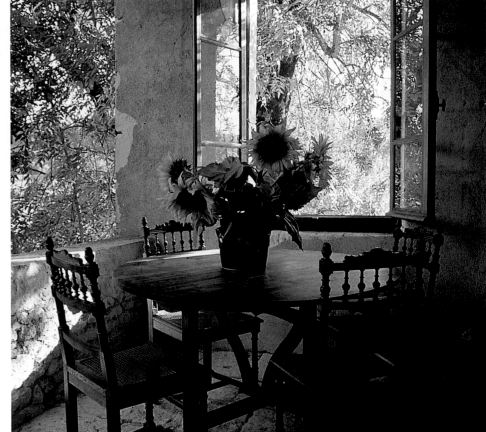

world. It involves cutting the ties with a tradition of taming the land and working the earth and, instead, it welcomes the wilderness in. The instinctive nurturing of a plot of land is exchanged for a less possessive appreciation of one's surroundings.

This idealism is more appropriate in some places than in others. A house in an isolated woodland clearing or on a sandy dune, or even one on an unspoiled hillside, can be ruined by a garden that has been brutally tacked on, whereas a garden on a village street that shares its boundaries with neighbors also shares a history of cultivation and this should be respected. The uncultivated surroundings of a converted farm building need the most sensitive intervention to prevent them looking suburban, and it is sometimes more striking to leave the tangled grasses and scrubby trees and at most to introduce more indigenous wild grasses and flowers.

Sensitivity to the integrity of the landscape setting—whether managed or wild—guides the choice of approach, but the "let it be" garden is also an expression of a fearlessness and an openness of mind and heart, and a genuine enjoyment of the countryside. In some ways too it expresses a nomadic freedom from the responsibilities of settling down, and thus appeals to restless souls.

BELOW *Most verandas have a lean-to roof design but this one is like a self-contained cabin open on three sides. It is fully furnished as an outdoor living room with a bench running along the length of the back wall covered in sprigged cotton cushions and pictures on the wall. An openwork balustrade is like a fence between the veranda and the meadow beyond. Deep overhanging eaves give it the character of a garden summerhouse.*

RIGHT *Verandas vary in design from country to country. Here a Long Island house has a shingle back wall and no balustrade dividing the furnished platform from the garden. Rocking chairs and swing seats are often of local design and catch every whisper of breeze and during the hot weather beds may even be moved outdoors.*

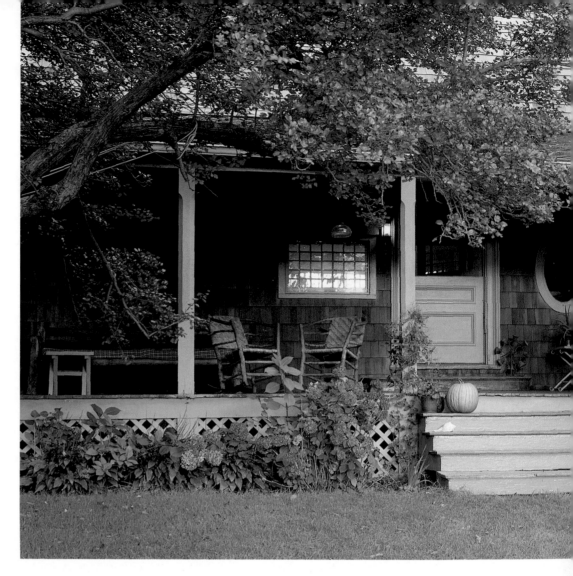

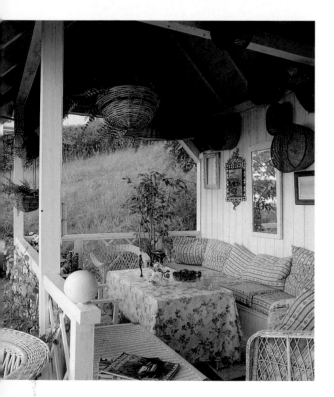

*T*he most successful gardens are often those that find a middle way, where nature and the gardener appear to jostle affectionately. The former gives way here to allow some imaginative underplanting of a clump of trees while the gardener sometimes allows picturesque incursions by wild undergrowth at the outposts of a plot. Here boundaries blur so that the garden blends into the wildness beyond, and its vulnerability is underscored by the speed with which nature reclaims territory.

Even this good-natured picture is an illusion, though, because it is the gardener who chooses where to allow the mutiny. It will not be tolerated in the middle of a deep and carefully orchestrated border, nor in the inviolable calm and order of the kitchen garden, where a return to the traditions of careful husbandry has been fuelled by a growing distaste for intensively farmed produce and an appreciation that home-grown vegetables and fruit eaten in their season and fresh from the plot always taste best and are obviously better for you.

The warm glow of justifiable pride induced by the sight of neat rows of potatoes and onions, lettuces and feathery leaved carrots, beans trained up wigwams of wooden stakes, or the tips of asparagus peeping out of the soil on a spring morning is one of the greatest pleasures for a country gardener. Planted out to delight as well as to provide a home-grown harvest, the vegetable garden shows how humble plants can produce a stunning display enclosed in beds edged with workmanlike

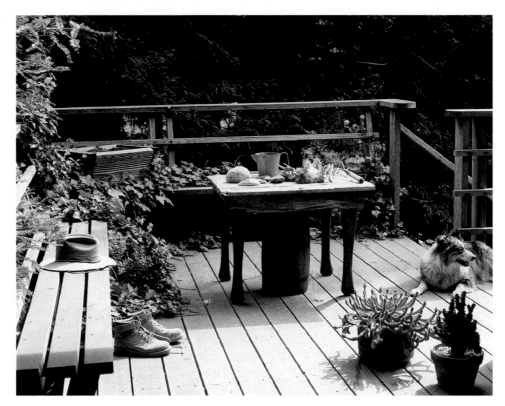

wood planks as if they were giant vegetable crates. Paths of gravel or beaten earth, soft pink bricks laid in a herringbone pattern, or simple flagstones unify the layout like a sort of horizontal scaffolding.

The threat of having this hard work ruined by birds and rabbits produces a varied and often comically defiant array of home-made devices: nets like webs draped over fruit bushes and cages of wood and wire protect the precious crop, while drunken scarecrows who do not look well-dressed enough to stand guard over the tidy rows glower into the middle distance. The gardener often seems to lose his sense of the garden's dignified elegance when it comes to bird and rabbit deterrents, and a surreal folk-art aspect gives this corner of the garden an unselfconscious jollinesss which can make sophisticated planting schemes elsewhere seem almost humorless by comparison.

Nearby, the gardener's refuge is his potting shed, perhaps a picturesquely ramshackle affair with a rainwater barrel and cold frames against it. Stacks of very plain but weathered terra-cotta pots and worn wooden-handled tools show evidence of years of use. Here, as in the kitchen, some of the newfangled garden gadgets have been weeded out in favor of traditional tools that have lasted longer and have done their job efficiently for generations. They have a quiet aesthetic of their own derived from simple good design and solid materials.

ABOVE *Chunky wooden planking makes a solid deck, and its nautical associations are echoed in the design of the wooden railing and stairway. Instead of deck chairs there is a garden bench and a wooden planter, and instead of sea spray, foliage seeps into every crevice. Open to the elements the deck is an ideal outdoor room for milder climates and for gardeners who are happier with leisurely pottering than with back-breaking toil. It is a peaceful spot looking out into the treetops with just the birds—and a dog here—for company; it is a place for quiet reflection.*

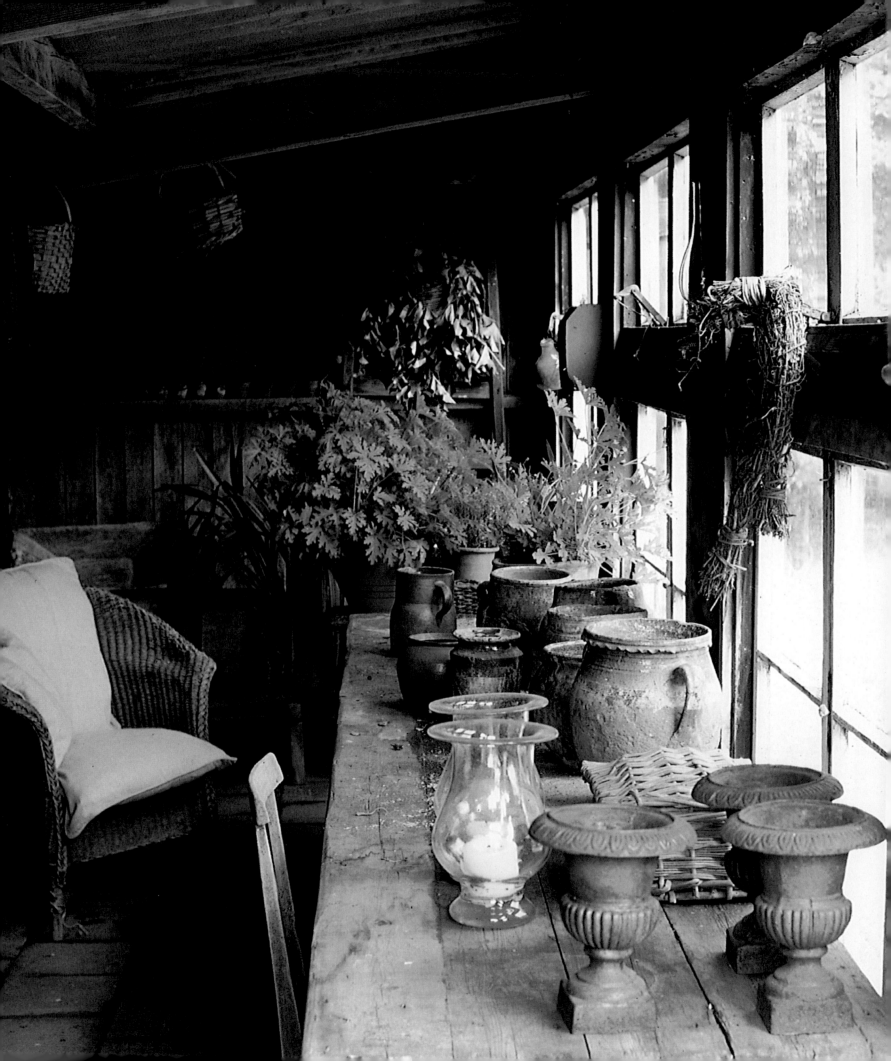

LEFT *A low-ceilinged potting shed-cum-flower room has a gardener's bench running along one side under greenhouse windows. Instead of seed trays and heaps of soil, however, there are vases of every size whose colors and shapes make a wonderful display. Baskets for indoor bulbs hang from the roof and a cushioned cane chair promises relaxation as well as work.*

RIGHT *More of a greenhouse than a conservatory, this outdoor room has been tacked on to a clapboard house. Unlike many modern conservatories, which have highly polished floors and bright white prefabricated frames, this has a gentleness that is derived from the color of its bleached wood frame and furniture and rough floor. A decorative but functional slatted bench, a stack of cane supports and two old watering cans make an unself-conscious display which is part of the appeal of this plant lover's den.*

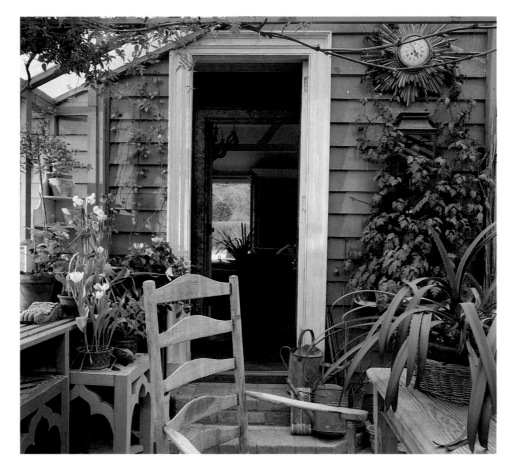

"The traditional contents of the potting shed have a quiet aesthetic of their own, derived from simple good design and solid materials."

*T*he fastidious order of the vegetable garden is often countered by a scatterbrained mess in the potting shed, showing where the gardener's priorities lie, but the keen handyman has a quite different lair whose toolshed and workbench are paragons of neatness. All the mysterious equipment for a hundred projects is fixed like displayed butterflies on a wall of brackets and loops and holes, and each tool has its allotted place. Graduated families of chisels, spanners, screwdrivers, and little drawers of bits and bobs are part of a functional display that illustrates the creativity celebrated here.

The outbuildings around a house in the country provide little vignettes of the talents and skills of the owner of the place, and form an architectural index of the sort of life led here. A clapboard boathouse with a shingle roof, an applestore with its wooden slatted shelves and musty smell, a log store with its scarred wooden horse and beautifully stacked chunks and slivers of winter fuel, all combine to help to define the special character of the place.

Livestock have their own homes, which can be either picturesque or utilitarian. The architectural history of the doghouse is as rich as one could wish and full of

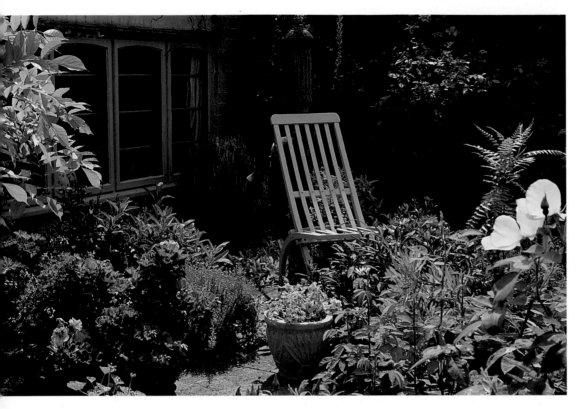

inspirational ideas to suit the most discerning hound. Rabbit-hutch history is perhaps a little more mundane, but in a movable tent of chicken wire and wood the family rabbit is as happy as can be, with supper carefully prepared and laid out by the younger members of the household should it feel disinclined to forage for itself. The threat of foxes influences the external design of a henhouse giving it the look of a high security shed, but inside bizarre props are installed to entertain and encourage the prima donnas who live here to do their stuff. During the day the outdoors is their patch and chickens can be proprietary about a large area, scratching in the dirt and exploring all the outbuildings.

Altogether quieter neighbors are bees, whose hives form what at first appears to be an arbitrary line up in the orchard. Beehives have a fascinating folk-art tradition of decoration, particularly in Slovenia, where the panels are painted with stories of bears and devils carrying off the precious crop while a tubby peasant woman scrambles after them with a pitchfork.

For the less active country dweller, or the artist who has retreated here to work, there might be a garden studio used for writing or painting. It occupies the quietest and prettiest part of the garden, with an inspirational view beyond the domain of woodland or valley, river or hill. Some people find it difficult to work at home and rent an outbuilding on a neighbor's farm. The little shed gradually acquires the

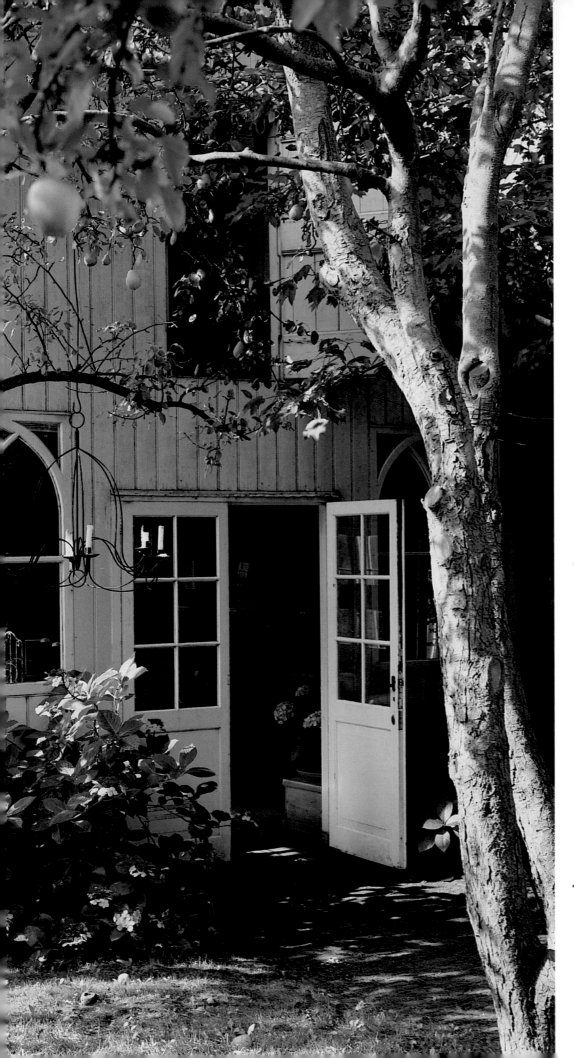

FAR LEFT *There is hardly any space to sit in this cottage garden, where you might feel like an intruder among all the horticultural activity. An idle hour spent here would refresh the weariest visitor and the profusion of scents and colors would revive the senses. Pinks and greens dominate the scene contrasting with the blue frame of a long, low cottage window and the clean lines of a wooden slatted garden chair.*

LEFT *Free rein is more often given in the design of a studio or garden house than elsewhere, making it an enchanting place to write or paint or put up guests. Here among the trees is a picturesque wooden garden house with gothic windows, double doors into the garden, and a metal chandelier hanging from a branch—to provide light for an al fresco supper.*

"The most successful gardens are often those that find a middle way between formality and informality, where nature and the gardener appear to jostle affectionately."

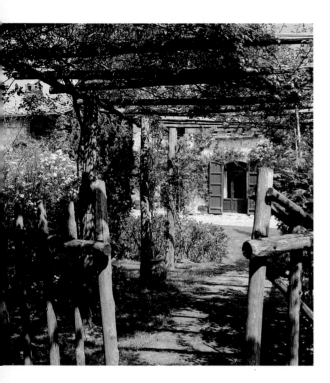

LEFT *Although the path from the garden gate to the front door is short and straight the ramshackle fence and informal pergola make it a delightful ramble under climbing, spreading branches with a view of a clear pool of sunshine in front of the house. Garden structures made from weather bleached timbers blend readily into the planting scheme of a garden.*

RIGHT *A hill top belvedere like a castle rampart commands wide views over the surrounding countryside that shimmers in the sun. A solid parapet contains a spreading terrace paved with terra-cotta. Pots of geraniums and overhanging trees enliven its plain lines, while a table and chairs take up the only available shade.*

necessary paraphernalia for working and an odd selection of inspirational talismans: a favorite cup, a particularly comfortable chair, and other bits and pieces make their way here. The unselfconscious accumulation, which combines primitive conditions with an occasional indispensable luxury from a more sophisticated world, makes an intriguing and engaging scene.

It is not just artists who seek seclusion and inspiration in a garden; everyone draws energy from its tranquillity, and in the design of a garden special vantage points are introduced to provide cues for reflection and enjoyment of its views. In the eighteenth century these may have been pavilions—with views up the slopes of Vesuvius to the menacing tip of the volcano and in the other direction out over the Bay of Naples—or they might have been neo-classical temples overlooking English lakes carefully engineered by man rather than nature. By the beginning of this century garden vistas were generally designed on a more domestic scale in the compartmentalized gardens still popular today. In a series of garden rooms defined by hedges, belts of trees, or walls, the gardener is able to create different schemes within one garden, with formal and informal plantings along a variety of themes. Vantage points command views along walks or through these garden rooms, providing opportunities for contemplation, conversation, and living outdoors.

To furnish these vantage points, garden seats of wood or stone under arches of foliage are more likely to be found today than the cool pavilions of two hundred years ago. A bench at the end of a woodland walk, a clapboard summer house

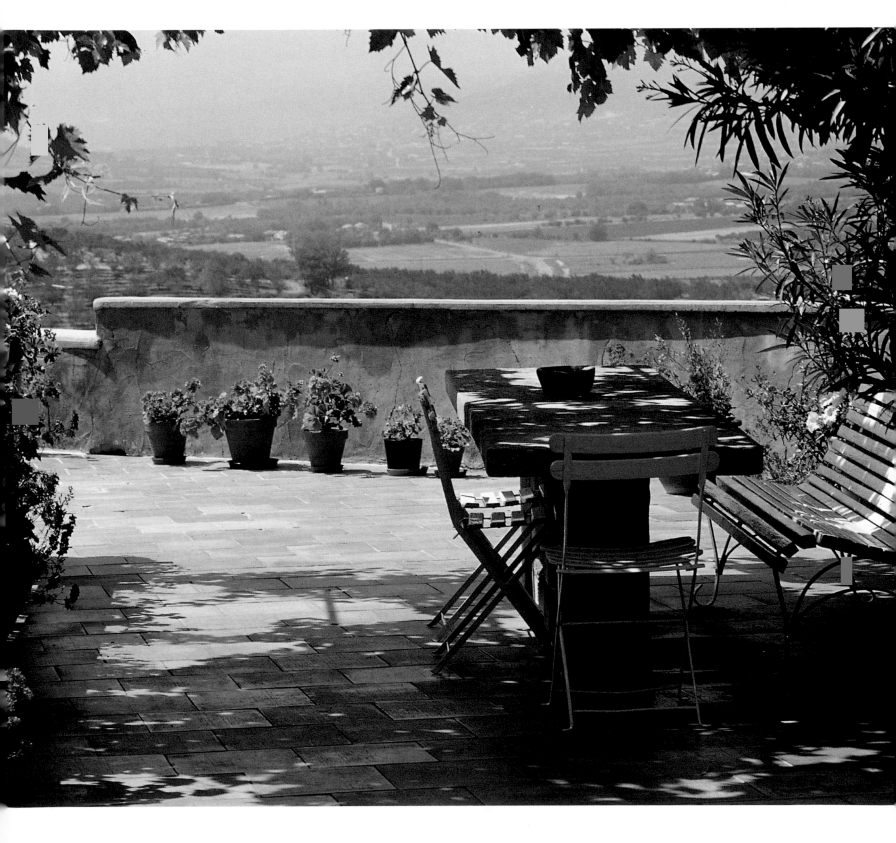

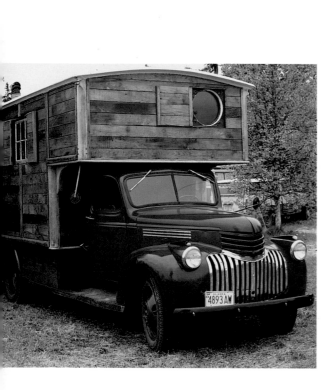

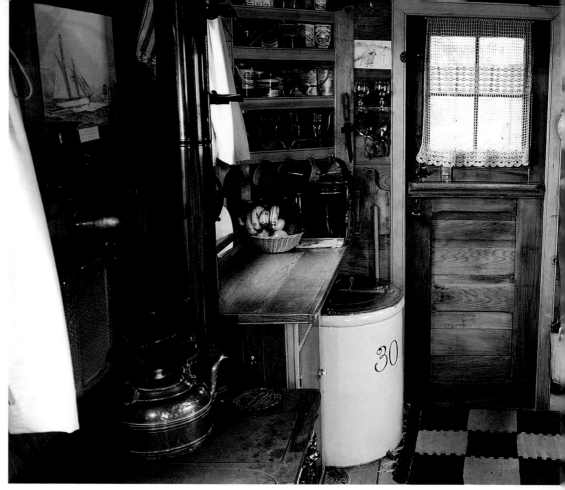

ABOVE *The freedom of the open road and nautical elements are combined in this 1940s American fire-engine—an outdoor room with a difference—which has been converted by a meticulous and talented carpenter into a modern romantic's mobile home. The cabin on wheels is clad in red cedar that perfectly complements the red driver's cab and the grinning chrome radiator. The porthole above lights a bunk bed and there are also shuttered windows at the sides and a stubby chimney on the roof.*

ABOVE RIGHT *Inside the fire-engine traditional wooden-handled carving and carpentry tools are hung in canvas and leather pouches. Opposite, in a galley kitchen, the same intensely ordered approach to compact storage and display is adopted. This quirky interior is the fruit of years of collecting everyday things—not just for their historic or decorative interest but for their practical value and clever design too.*

designed in the 1920s with a revolving base, which can be moved round to catch or avoid the sun, or a hammock swinging lazily in an orchard can all be the focus for summer picnics. Eating outdoors is one of the simplest and purest pleasures of being in the country, and lugging baskets of provisions to the children's favorite den on a hot afternoon is amply rewarded by an enforced spell as a hostage in their fantasy wilderness.

These ad hoc sites for outdoor living are answered in hotter climates by permanent fixtures: a shady veranda on an Australian farm with its corrugated-iron roof, or the piazza of a South Carolina planter's house with its Charleston-made joggling-board benches from which you look out at clouds of wisteria, magnolia trees, and live oaks dripping with silver-gray moss. Porch furniture history provides the most delightful designs for outdoor rooms and every warm country has its own traditional swing-seats and lounging chairs. In Mediterranean gardens eating out under a vine- or cane-covered terrace is the only way to catch a summer breeze. A long table laid for an extended lunch for family and friends looks so inviting that it could be set out anywhere, but the perfect outdoor room is under a spreading tree next to an old farmhouse miles from anywhere.

Just one magnificent tree makes a garden special: a towering copper beech, a mulberry tree, an ilex, a cedar, or a tulip tree observed through the seasons becomes an old friend and a bench set under it or around its trunk is a favorite dawdling spot. A stretch of grass fringed by huge trees is like a clearing in a wood, and although tree surgery and lawn cutting are the less glamorous and more expensive aspects of this idyll, its pleasures far outweigh these disadvantages.

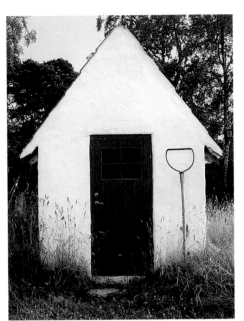

LEFT *A shed buffed up to a brilliant white stands up to its knees in tall grass. It might be a store or perhaps a peaceful den with a comfortable armchair and the essential tools needed for a few hours of writing, painting, or quiet reflection.*

BELOW *Grainy wood bleached by the elements provides a backdrop for old tools hung from pairs of long nails in a shed wall. The traditional design of the tools' wooden handles is simple and comfortable to use like the chunky little swivel stopper on the door. They have an appeal that is missing from the hard materials and solid colors of some of their modern equivalents.*

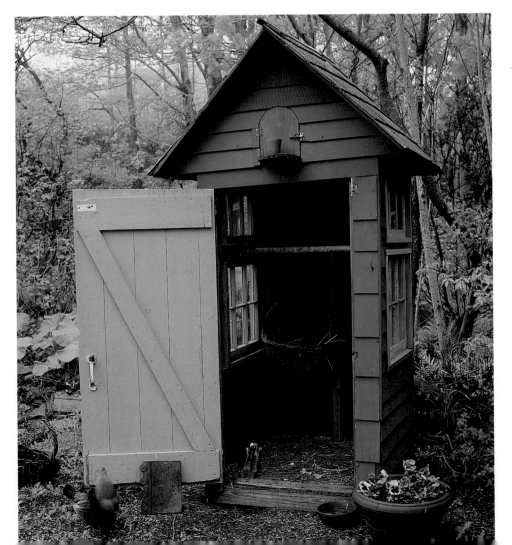

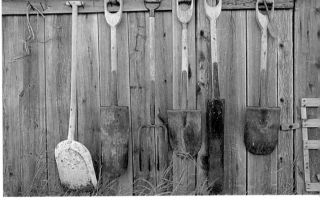

LEFT *A hen house like a sentry box contains all sorts of considerate features to cajole its occupants into laying their eggs. Its eccentric blue and pink livery is more reminiscent of Easter eggs than speckled hens and the straw-filled basket makes a picturesque nest. It is a traditional clapboard farmhouse in miniature, with farmhouse door and windows and flowers in a pot, against the backdrop of a woodland setting.*

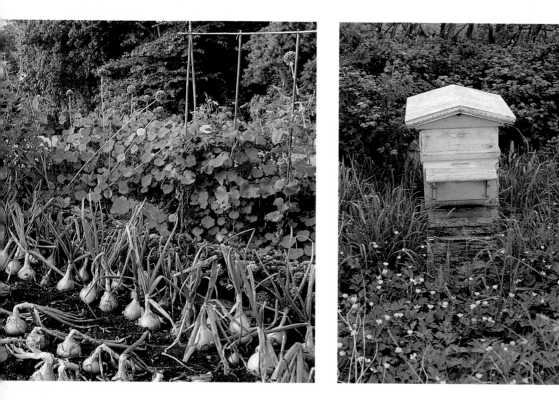

*T*erraces and courtyards close to a house provide a more contained outdoor room that can be furnished—with a slight shift in key—as if they were interiors. A sofa is replaced by a swinging seat with a cherry-red canvas canopy and buttoned and piped cushions, which look as if they were designed for a yacht, while cane or wood tables and chairs make up the scene. The use of containers for shrubs and annuals makes gardening portable and pots are moved round to furnish these outdoor rooms; they decorate terrace parapets, take center stage at the end of a vista, or frame a distant view. Pots are changed to suit the seasons and moved from indoors to outdoors to mark the beginning of spring, rekindling the relationship between house and garden after the winter.

The convents and monasteries of southern Italy had the right idea about outdoor rooms. Living an enclosed life, these communities often boasted a closed courtyard garden or cloister, with its central well and formal planting, and terraces or a pergola overlooking a dramatic sweep of countryside or coast. Views down into the deep valleys of the Amalfi coast are punctuated by the terraces of lemon trees and vines until the eye reaches the craggy shoreline and the blue-green sea. The feeling of distance from the hurly-burly of everyday life is palpable. Some convents had roof-top gardens with a distant view framed in the arch from which hung the convent bell. All these gardens provide the perfect place for cool walks, quiet reflection, and prayer—as essential today as they have always been.

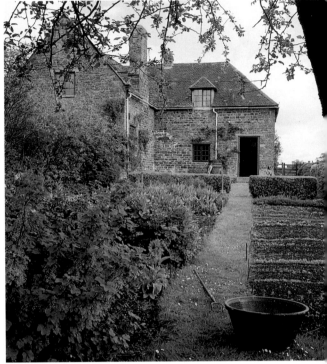

FAR LEFT *Few things make a homeowner prouder than to be able to produce home-grown food on a little plot. The hard work all seems worth it when plump vegetables appear. Bee-keeping requires knowledge and intuition, and though hives may seem to the outsider to occupy out-of-the-way positions on the fringes of woodland or garden, it suits the bees perfectly.*

LEFT *Gardeners use some odd-looking devices to encourage their crops: inverted flower pots on stakes and whirligig bean poles make this jaunty corner a joyful spot.*

ABOVE *Down tools: a hoe and a giant ceramic basin lie abandoned on the path, their earthy colors and shapes making them look quite at home as furnishing for this outdoor room.*

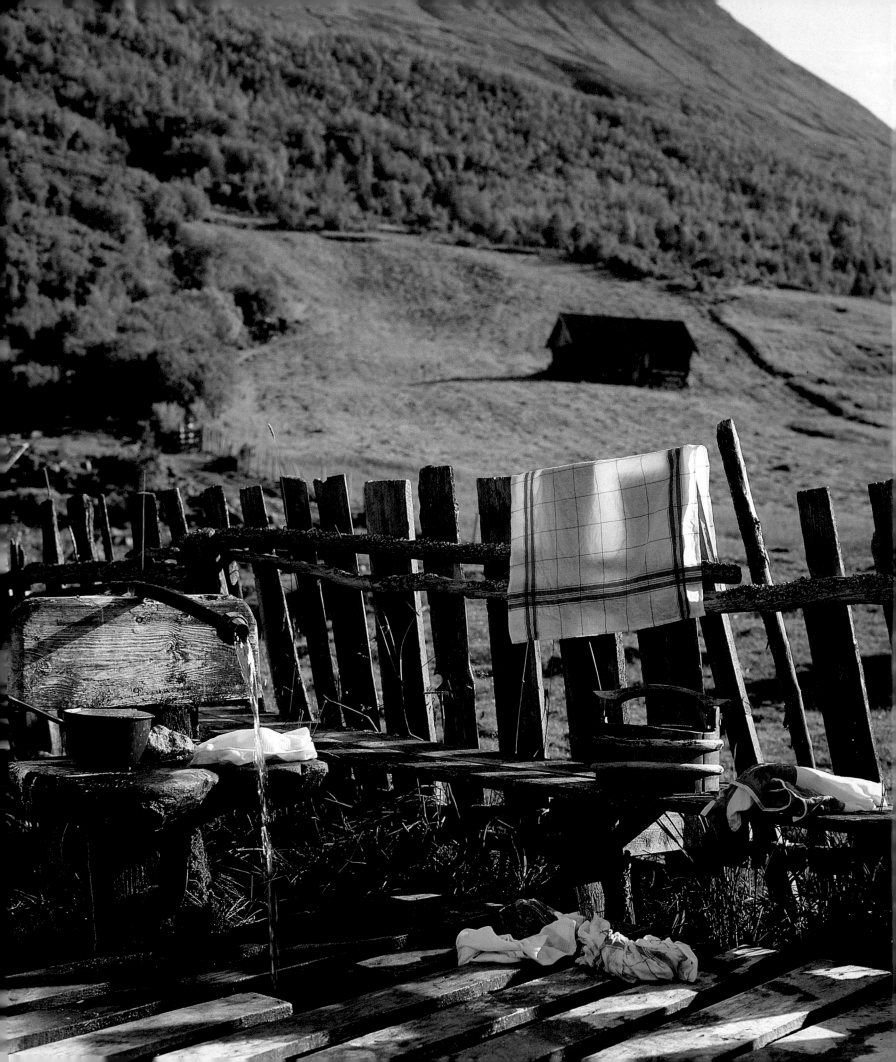

" *The perfect outdoor room has far-reaching views of the surrounding landscape and a palpable feeling of distance from the hurly-burly of everyday life.* **"**

LEFT *Borrowed from nature, this little patch is really only a tiny bite of the surrounding hillside. It has been domesticated not with careful cultivation but with rigged-up running water, a washing slab and duckboarding. The rickety fence keeps nothing out or in and its charm lies in its picturesque irregularity.*

RIGHT *The outdoor room* par excellence*: a bird house in the treetops has splendid views in every direction and still manages to enjoy some protection from harsher weather conditions. Natural materials have been used and modern architecture has devised the latest design solutions, no doubt informed by the expert opinion of ornithologists. The perfect getaway in which to live in peace and at one with nature.*

*I*n less hospitable terrain a garden has to be wrested from nature, making its shelter and tranquillity even more startling. At Lindisfarne on the northeast coast of England, Gertrude Jekyll created a tiny garden a few hundred yards from the romantic castle remodelled in 1903 by Lutyens for Edward Hudson, the owner of *Country Life* magazine. On scrubby, salty, low-lying pasture she built a beautiful but simple stone-walled enclosure which provided shelter for a formal layout. Instead of being an extension of the house, the garden has become a special diversion, requiring a purposeful trot across the windswept space to discover its enchantment.

An enchanting garden is a precious thing—a self-contained world of its own—and keen gardeners spend their lives straining toward this perfection of atmosphere. Success lies in a complex cocktail of happy chance in its siting and setting, simple and sophisticated taste blended together, knowledge and skill, and an individual inventiveness that brings a fresh twist to conventional ideas. As in the arrangement of the interior of the house, the past provides as much inspiration as is required, but taking things a step further or adjusting them to a modern way of life produces new solutions for the outdoor room. Clean-cut or blowsy, formal or informal, pocket-sized or park-sized, a garden is just borrowed from nature for the twinkling of an eye and its very fragility makes it the most poignant element of the home in the country.

INDEX

ACKNOWLEDGMENTS

Publisher's Acknowledgments

We would like to thank the following photographers and organizations for their permission to reproduce the photographs in this book:

1 Nina Dreyer; 2-3 David George; 4-5 Todd Eberle (Designer: Jeffrey Cayle); 6-7 Hotze Eisma; 7 right Ianthe Ruthven (Designers: Alfred Cochrane Associates); 8 left Peter Aprahamian; 8 right Arcaid/Julie Phipps; 9 Jeff McNamara; 10 Ianthe Ruthven (Designer: Amanda Douglas); 11 Peter Woloszynski/The Interior Archive; 12-13 Ianthe Ruthven (Architect/owners: Nicholas Groves-Raines & Kristin Hannesdottir); 13 right Jean- Pierre Godeaut (Stylist: Catherine Ardouin) / Marie Claire Maison; 14-15 Joe Cornish; 15 right Georgia Glynn-Smith; 16 above left and below right Simon McBride; 16 above right John Miller; 17 Simon McBride; 18 Photograph: Hickey Robertson (Jacomini), from Southern Accent magazine; 20 John Miller; 21 Joe Cornish; 22 John Miller; 23 Richard Waite; 24 Patricia Aithie/Ffotograff; 25 David George; 26-27 S & O Mathews; 27 right Marianne Majerus; 28-29 Solvi Dos Santos; 30 Jessie Walker; 31 Richard Felber; 32 left Solvi Dos Santos; 32-33 Nina Dreyer; 33 right Solvi Dos Santos; 34-35 Fritz von der Schulenburg/The Interior Archive; 35 right Solvi Dos Santos; 36 left Peter Woloszynski/ Elizabeth Whiting & Associates; 36-37 Mads Mogensen; 36 right Nina Dreyer; 38 Todd Eberle; 38-39 Paul Ryan/International Interiors (John Saladino); 40 Tim Beddow/The Interior Archive (Nicky Samuel); 40-41 Simon McBride; 42 left Richard Bryant/Arcaid/(Architect: Michael Wilford) courtesy: STO AG; 42-43 Paul Ryan/ International Interiors (Jo Naham); 44-45 Simon McBride ; 45 right Jean-Pierre Godeaut (Maison Maurice, Alsace); 46-47 John Miller; 47 right Fritz von der Schulenberg/The Interior Archive (The Ulster American Folk Park); 48-49 Simon McBride; 48 left Ianthe Ruthven; 50 Julie Phipps)/Arcaid (Architect: Chris Cowper/Cower Griffith Brimblecombe Associates, Whittlesford, Cambridge); 51 Todd Eberle; 52-53 Paul Ryan/International Interiors (Ina Garten); 54 above Hotze Eisma; 54 below John Hall; 55 Richard Waite; 56 C. Simon Sykes/The Interior Archive; 57 left Richard Felber; 57 right Ianthe Ruthven (Architect/ owners: Nicholas Groves-Raines & Kristin Hannesdottir); 58-59 John Miller; 59 right Fritz von der Schulenburg/The Interior Archive (Ann Vincent); 60-61 Ianthe Ruthven (Gene Garthwaite); 61 right Michael Mundy (Greg Munoz); 62 Ianthe Ruthven; 63 John Hall; 64 left David George; 64-65 Lars Hallen; 65 right Michael Mundy/Greg Munoz; 66 left Paul Ryan/International Interiors (Gerry Nelissen); 66-67 Paul Ryan/International Interiors (Gerry Nelissen); 68 Paul Ryan/International Interiors (John Saladion/Casdin); 69 above Jean-Pierre Godeaut (Maison Maurice); 69 below Simon McBride; 70-71 Rodney Hyett/Australian House & Garden Design Magazine; 70 above Ianthe Ruthven; 71 right Simon Brown/The Interior Archive; 72-73 C. Simon Sykes/The Interior Archive (Nicky Haslam); 72 left Ianthe Ruthven; 73 below Todd Eberle; 73 above Mads Mogensen; 74 above Richard Waite; 74 below Richard Waite; 75 right Nina Dreyer (Edvard Munch); 75 left Solvi Dos Santos; 76-77 Paul Ryan/International Interiors (Gertjan van der Host); 77 right Scott Frances/Esto; 78-79 Fritz von der Schulenburg/The Interior Archive; 80 below Tim Beddow/The Interior Archive; 80 above Simon McBride; 81 Ingalill Snitt; 82 John Hall; 83 Hotze Eisma (McCabe); 84-85 John Hall; 85 right Solvi Dos Santos; 86 left Hotze Eisma; 86 right Ianthe Ruthven; 87 Jean-Francois Jaussaud; 88 above John Miller; 88-89 Paul Ryan/International Interiors (D. & V. Tsingaris); 89 below Paul Ryan/International Interiors (D. & V. Tsingaris); 90-91 Nina Dreyer; 91 right Richard Waite; 92 Richard Felber; 93 Paul Ryan/International Interiors (John Saladion/Casdin); 94-95 Kari Haavisto; 94 left Solvi Dos Santos; 95 right Hotze Eisma (Boek, Netherlands); 96 Ianthe Ruthven (Architect/owners: Nicholas Groves-Raines & Kristin Hannesdottir); 97 below Hotze Eisma; 97 above Ingalill Snitt; 98-99 Simon McBride; 98 left Paul Ryan/International Interiors (Lee Mindel); 99 right Richard Felber; 100 left Fritz von der Schulenburg/The Interior Archive (Dot Spikings); 100-101 Jessie Walker; 101 right Richard Felber; 102 Solvi Dos Santos; 103 right Hotze Eisma; 103 left Jessie Walker; 104-105 Simon McBride (K. Brown); 104 left Gilles de Chabaneix (Stylist: Catherine Ardouin)/Marie Claire Maison; 105 right Alexandre Bailhache (Stylist: Catherine Ardouin)/Marie Claire Maison; 106 below Michael Mundy; 106 above Louzon/Stylograph (Stylist: C. D'Avella); 107 above Fritz von der Schulenburg/The Interior Archive (Francesco Miana d'Angoris); 107 below C. Simon Sykes/The Interior Archive; 108-109 Paul Ryan/International Interiors (Jo Naham); 108 right Solvi Dos Santos; 110-111 Solvi Dos Santos; 112 left Kari Haavisto; 112 right Eric Morin; 113 Gilles de Chabaneix (Stylist: Daniel Rozensztroch) /Marie Claire Maison; 114 John Hall; 115 Simon McBride; 116-117 Mark Darley/Esto; 116 left John Miller; 117 right Simon McBride; 118 above Hotze Eisma; 118 below and 119 Solvi Dos Santos; 120-121 Peter Woloszynski/The Interior Archive; 120 left C. Simon Sykes/The Interior Archive; 121 right Fritz von der Schulenburg/The Interior Archive; 122-123 Solvi Dos Santos 123 right Marie Pierre Morel (Stylist: Catherine Ardouin)/Marie Claire Maison; 124-125 Simon McBride; 124 left John Miller; 126-127 John Miller; 126 left Paul Ryan/International Interiors; 127 right Hamish Park/Insight Picture Library; 128-129 Hotze Eisma; 128 below Solvi Dos Santos; 129 right Richard Waite; 130 Hotze Eisma/Ariadne; 131 Fritz von der Schulenburg/The Interior Archive; 132-133 Hotze Eisma; 132 left Marianne Majerus; 134-135 Annet Held/Arcaid; 134 left Fritz von der Schulenburg/The Interior Archive (Emma Bini); 136 left Greg Powlesland; 136-137 Greg Powlesland; 137 left below Fritz von der Schulenburg/The Interior Archive; 137 right Ingalill Snitt; 137 right above Ingalill Snitt; 138-139 Mayer/Le Scanff /The Garden Picture Library; 138 centre Hamish Park/Insight Picture Library; 138 left Juliette Wade (Shucklets, Oxon); 139 right Richard Felber; 140 Nina Dreyer; 141 C. Simon Sykes/The Interior Archive.